SHOWS OF FORCE

Power, Politics, and Ideology

in Art Exhibitions

TIMOTHY W. LUKE

Duke University Press Durham and London 1992

Third printing in paperback, 1999
© 1992 Duke University Press
All rights reserved
Printed in the United States of America
on acid-free paper ∞
Library of Congress Cataloging-in-Publication Data
appear on the last printed page of this book.

To Ed

CONTENTS

Acknowledgments ix

Introduction: Situating Art and Critical Discourse in
Contemporary Political Contexts 1

I ENVISIONING A PAST, IMAGINING THE WEST

1. George Caleb Bingham: Contested Ground 9
2. Frederic Remington: Riding into the Sunset 27
3. Frederic Edwin Church: Earth First? 40
4. The West Explored: How the West was Won, or Why Is the Winning Westernized? 52
5. Georgia O'Keeffe: Ideology and Utopia in the American Southwest 68
6. Frank Lloyd Wright: In the Realm of Ideas 79
7. American Impressionism—California School: "California Dreamin'"? 91

II DEVELOPING THE PRESENT, DEFINING A WORLD

8. Japan—The Shaping of Daimyo Culture, 1185–1868: The Ironies of Imperialism in the Empire of Signs 107
9. Made in U.S.A.: "The Pride is Back"? 119

10. Ilya Kabakov: Soviet Life 137

11. Hans Haacke: Unfinished Business 152

12. Sue Coe: Pure War in the Zero World 169

13. Hispanic Art in the United States: "This Is Not a Barrio" 178

14. Roger Brown: Tracing the Silhouettes from the Shadow of the Silent Majorities 189

15. Robert Longo: The Ecstasy of Communication 200

16. Culture and Commentary: Riding the Hoverculture 213

17. The Politics of Images: Art Criticism as Cultural Criticism 227

Notes 235

Index 247

ACKNOWLEDGMENTS

Art exhibitions are elaborate and expensive works of political theater. They have their own special unique rhetorical styles, social teachings, and cultural agendas. I have always been interested in the political subtexts of such aesthetic productions, particularly when they are staged in museum settings, and this book develops my readings of several art exhibitions in their cultural, economic, political, and social contexts during the late 1980s and early 1990s. Over the past five years, I have been visiting, and then writing about, art shows for *Art Papers*, which is a nationally recognized, regionally based journal of contemporary art published in Atlanta. Each of the chapters in this book first appeared either as extended review essays or short critical articles in *Art Papers*, and they are reprinted here in revised form with permission. Without the supportive encouragement of Glenn Harper, the editor of *Art Papers*, this book never would have come together; along with Barbara Schreiber, an associate editor of *Art Papers*, he provided many helpful editorial suggestions. I thank them both for all of their efforts.

At the same time many other people aided me with their comments and criticisms of this manuscript, including Ben Agger, John Bokina, James Der Derian, Suzi Gablik, Gerard Toal, Florindo Volpacchio, and Stephen K. White. In addition to putting up with my unending fascination with art shows, my wife, Kay Heidbreder, read and reacted to every chapter, contributing many important insights. I also sincerely appreciate the work of Lawrence J. Malley and Jean Brady of Duke University Press, who guided the review and editing of this manuscript with constant consideration, great skill, and strong support. Kim Hedge, Terry Kingrea, and Maxine Riley in the Department of Political Science at Virginia

Polytechnic Institute and State University did all of the word processing with tremendous patience and efficiency, for which I am very grateful. And, finally, my great-uncle, Edward B. Voegele, who has been an artist and a student of art for much of his life, also made a big contribution to this book, first, with his ruthless but humorous criticism of everything that exists, and, second, with his care and concern for all that I have done. I very happily dedicate this book to him.

INTRODUCTION

Situating Art and Critical Discourse in

Contemporary Political Contexts

This book is a collection of politically grounded critiques about art. It refuses, however, to fool around in polite metatheoretical terms with abstract questions surrounding "the politics of aesthetics" or "the aesthetics of politics." Instead, it subversively reexamines how cultural mythologies and political power are expressed in the showing of artworks by museums. Hence, these studies relentlessly ask how particular displays of artwork can be seen as political texts rife with conflicted rhetoric about the ideologies of the present. Art exhibitions in the last analysis are elaborate and expensive works of educational theater with their own special rhetorical agendas and peculiar political teachings. And, for this reason alone, they merit thorough investigation.

Plainly, a lot of art writing in the 1980s and 1990s frequently has alluded to "the power" or "the political" in artworks. But what is this power? How is it expressed? What are its limits? Why does it work? Such direct political questions are rarely raised much less addressed or answered in most of these discourses, because many art critics almost never thread their way out of the rhetorical sloughs of more formalist or historical styles of aesthetic criticism. Trapped in the muck of inappropriate categories, very few art writers escape with useful insights from the discursive ooze of genre, style, or school that bogs down their search for the political dimensions in art. Rather, they tend to chase both real politics and serious aesthetics farther back into the swamps of formal analysis until both of these subjects simply slip under the surface of deadly metatheoretical quicksand. Consequently, we need a new, more critical approach to understand how power, politics, and ideology operate in art exhibitions.

Ultimately, everyone must recognize how artworks are being harnessed as new powerful motors for starting economic development and social revitalization in contemporary capitalism. Most consumer commodities today, for example, are moved in the marketplace only to the extent that carefully coded aesthetic presentations can endow them with greater value than those apparent qualities displayed by their competition. Similarly, encouraging artists to practice their craft and art galleries to pursue their trade has proven to be an effective strategy for sparking economic growth throughout many neighborhoods, towns, and cities since the 1960s. In many cities across America, therefore, corporate elites and city fathers no longer only push public policy designs for new industrial zones to build innovative lines of manufactured goods to sell in various outside markets. Instead, they also collaborate on mapping out new "arts districts," "arts centers," or "arts complexes" to facilitate the production and consumption of artworks, which might, in turn, revalorize these urban areas' decaying industrial and slumping service economies by developing fresh generations of aesthetic commodities.

Urban revitalization, economic redevelopment, architectural rehabilitation, and cultural renewal, then, all are being fueled by new aesthetic/political codes denominated in artistically enhanced sign values. Gaining control over art's symbolic codes is an important form of power. And securing command over the definition, application, and interpretation of these aesthetic codes becomes a source of conflict during today's increasingly frequent struggles over the aestheticization of everyday life. Tremendous financial support is allocated systematically to the arts, because so many arts now are the primary mode of generating images of our volatile collective values. Without the arts, in fact, much of modern living itself would be impossible.

Within this social and economic setting, art becomes unhinged from its former modernist stance as an avant-garde resistance against the prevailing logics of power and money. Artists ranging from Hans Haacke to Sue Coe to Roger Brown still try to disclose the workings of commodity fetishism, but they ironically must do so through fetishized aesthetic commodities. Trapped within the

same flow of ever-changing signs, artists and their works must submit to the same necessities of commodity production as virtually all other producers and their products. In the 1980s, the art markets emerged as highly organized exchanges whose volume, prices, and overall direction were monitored with all the precision of global markets for pork bellies, gold bullion, or winter wheat. Artists like Frederic Remington or Georgia O'Keeffe become specialty niche products, much like Hispanic art or California seascapes, to be moved as "product" to buyers with certain demographic market profiles. The art of particular decades, ethnic groups, regions or nations then is repackaged as ethnography, political rhetoric, or cultural norms for contemporary audiences both to consume and desire in accord with the prevailing codes of value currently carrying the images to them.

Of course, my critical interpretations of art exhibitions in this book are completely contestable. Such critiques of artistic representation as well as the reading of museum exhibitions as political texts are no more than textual representations themselves. Others undoubtedly would hear somewhat different voices or see other lights in viewing each of the exhibitions discussed in the coming chapters. They are left, however, to tell of their experiences elsewhere in their own way. Yet, in recognizing that one might listen and look for other voices or different lights, it becomes clear that all narratives are somehow ideological. I endorse plural interpretations in general, but I do not approve of neglecting the frequently dismissed political dimension in artworks and art shows in the name of pluralistic openness. Allowing any interpretation to serve as well as any other, even as it ignores salient political conflicts or overlooks intense ideological contradictions, is yet another instance of allegedly critical tolerance aiding and abetting the dynamics of domination. So everyone now is on notice: by following the rhetorical tracks in any art exhibition's narratives, which may be themselves stalking ideologies or stealthy metanarratives floating inside an artist's works, all of our critiques inevitably track new ideological footprints over the others already on the trail.

These studies of art and art exhibitions also elaborate aspects of my vision of critical theory against the horizon of contemporary

American society. By drawing from, but not completely conforming to, the critical projects of Marx, Adorno, and Marcuse, as well as Barthes, Debord, and Baudrillard, I illustrate how artistic codes and aesthetic displays can create new currents of social, political, economic, and cultural meaning. Baudrillard characterizes the making and manipulating of meaning as "semiurgy," and these critiques can be seen as studies of the semiurgic qualities of art exhibitions. And, as these meanings are forged, I will consider how they might provide new ideological assets for those who control the symbolic codes for producing these flows of meaning.

Ultimately, critical theory is an alternative way of seeing and a politicized form of knowing that deploys an ironic awareness, reflexive thinking, and historical knowledge to create fresh insights about the nature of social domination. With this new critical awareness, people might find and exploit opportunities for their own enlightenment and emancipation through critical reasoning. By becoming attuned to the cultural, economic, and psychological grounding of the audiences it addresses, critical theory also must engage itself politically and socially at revealing how mystification, domination, and authority are generated out of the psychosocial production and consumption of meaning. In speaking to the lived experience of people ensnared in a sophisticated gridwork of symbolic codes, critical theory might spark a new awareness of what must be done and how to do it. This requires adhering to a systematic radical critique of class, group, and individual inequalities to discover how power, position, and privilege work through ideology to sustain the given social order. The diverse particularities of individual, group, regional or national life are never entirely eaten away by the acids of exchange sloshing through the channels of global markets. Hence, the peculiar variations in everyday lived experience can be addressed directly at the immediate local level, especially as they surface, for example, here in different individual art showings. Looking at art exhibitions along all of these intersecting lines of social conflict affords critical theorists a unique opportunity to consider many of the ideological processes behind every individual aesthetic show of force.

Nonetheless, my critiques are much more than mechanistic

Marxist reductions of art to economics. Art can be understood through political narratives, and politics can be reinterpreted in aesthetic terms, but both of these interpretive turns must be taken without reducing either one to the other. As indicators of political contradictions or expressions of cultural conflicts, artworks can be decoded critically as special communicative media in the discourses of political theory or unique icons in the mythologies of cultural value. By moving beyond merely aesthetic discourses about the much-vaunted autonomy of the art object, the attributes of school style, or the issue of aesthetic beauty, my analysis examines the diverse ways that art can be displayed for particular audiences as part of the social reproduction of contemporary systems of power in the United States. Admittedly, my analyses are neither perfect stylistic accounts nor fully exhaustive formal interpretations. Instead, my readings go beyond the traditional codes of aesthetic critique to do something more unusual, namely, a tough investigation of the political implications in apparently apolitical art shows as well as a thorough reconsideration of the aesthetic displays in obviously inartistic politics.

After piecing together these fragile fragments of insight about art, values, and power, the rudimentary outlines of my questions about art's place in the contemporary late capitalist era begin to take shape. Within its patterns, how do the various aesthetic texts discussed here fit into political contexts? What roles might art and politics play in the maintenance and elaboration of contemporary culture and power? Given the mobilization of aesthetic production to manage everyday life in today's states and societies through images, illusions, and icons, the following studies raise then attempt to answer some major questions about particular artworks as they have been displayed in specific contemporary political contexts. More directly, these critiques ask what social or historical conditions might resituate aesthetic texts in emancipatory or repressive political assignments within the frameworks of modern culture? Why does art sometimes work for, and at other times work against, social movements for political change? What rests behind the tendency of even politically acute critiques in contemporary art to be sucked into the whirlpool of corporate capitalism's culture

industries? In the face of these colonizing dynamics, how can individual autonomy and collective agency be enhanced, even if the rebellious sentiments that invoke them are initially encoded in the shapes, strokes, and structures of art?

By recognizing how artworks gain meaning only through critical interpretation and open exhibition, my critiques explore the semiurgical politics shaping both their exhibition and interpretation. The individual chapters of the book, then, are divided into two thematic sections. The first, "Envisioning a Past, Imagining the West," combines several studies of art exhibitions that examine in one way or another artworks about or from the American West, because this kind of art has enjoyed such a tremendous revival during the Reagan-Bush era. Although these exhibitions usually show artwork by artists from the nineteenth and early twentieth centuries, their rhetorical styles of display as well as their aesthetic modes of communication clearly express contemporary political agendas as they envision "the past" and imagine new representations of "the West" through showings of art. The second section, "Developing the Present, Defining a World," focuses upon more recent artists from the post-1945 era. In these exhibitions, the art displays often attempt to develop politically charged understandings of the present, which, in turn, struggle to define the changing contemporary world as well as art's various roles within it. While every work of art is potentially important, the many actual ideological uses of artwork, as revealed in the larger cultural, political, or social context behind these various museums' art showings, now will come into sharper focus in each of the critical analyses that follow.

ENVISIONING A PAST,
IMAGINING THE WEST

I

1. GEORGE CALEB BINGHAM

Contested Ground

Big corporations and major banks, as we are told by the public relations departments of many firms, are always available to perform good works for the general welfare. Given the tendency to define "the general welfare" as the economic and cultural interests of their middle class and upper middle class clients, who bravely continue to purchase corporate products of dubious worth and leave their personal fortunes on deposit with crumbling American banks, these "good works" frequently take the shape of subsidies for cultural spectacles to soothe the mental mutilation that these same customers endure in the jungle world of contemporary American markets. Since corporate capital today increasingly is national or even transnational in scope, then the pay-outs for this community service multiply at even sweeter rates of return if the impact of such good works can be felt in more than one locality. These good works continually can be touted, as though they were the firm's most reliable indicator of altruistic intentions, at every turn in the corporations' or banks' public relations campaigns. Finally, if these efforts and expenditures also can be dedicated to a revalorization of the corporation's existing logos of everyday symbolic display, then the corporate image managers score an almost transcendently perfect coup.

Boatmens Bancshares, Inc. of St. Louis, Missouri, which condenses its commercial self-image into logo form as a classically styled Mississippi steamboat, plainly penetrated deep into these sweet realms of complex symbolic associations in its recent sponsorship of the most comprehensive review of George Caleb Bingham's painting since the 1930s. Working in unison with the St. Louis Art Museum as well as two other St. Louis-based firms, the

May Department Stores Company and the Monsanto Company, this major regional bank pulled together an impressive display of Bingham's paintings about life on the Missouri frontier for viewing in St. Louis and Washington, D.C.[1] Given Bingham's fascination with jolly Missouri River flatboatmen and rugged Missouri frontiersmen carving a new world from the wilderness, the desire of Boatmens Bancshares, Inc. to be seen by St. Louis investors/art patrons and Washington decisionmakers/art audiences as jolly, enterprising souls in today's wild capital markets and dangerous financial frontiers was well worth the investment. Through an elaborate and expensive display of nineteenth-century Missouri art, then, a major bloc of corporate banking capital enlisted some of its St. Louis area customers and the National Endowment for the Arts in an extensive public relations campaign dedicated, in part, to the reaffirmation of the symbolic manna in its historically suggestive name and logo.

Exhibitions like this one raise fascinating questions. When it comes to the Old West or frontier America, what is the past? How can we envision it? When does it end? Why does it begin? By what means do today's discourses turn what perhaps "really was" into what we *want* it to be so that we might redefine what we are, or were, or will be? Quite often, as this and other exhibitions illustrate, choosing particular artistic images and then privileging them as the authoritative aesthetic traces of "what really was" becomes a definitive stratagem of manufacturing such memories. In the quest for a visual record to document the social history of the West, Bingham's paintings often were chosen as exhaustive representations in his own time; yet, they also have been privileged by later generations as some of the most authentic images for validating our concepts of what the past "actually" was. This past, in turn, usually has been reconstructed as such not to give a truly new understanding to the past, but rather to reinterpret periodically the meaning of the present and future in America since the crises of the 1930s.

Why has Bingham served these purposes? After his death in 1878, Bingham's standing in the art world outside of Missouri was virtually nil. However, his unique image of everyday frontier life was resurrected and revalidated in the 1930s, thus providing foun-

dation for making a special statement about where the New Deal state and society had once come from. In the midst of the Great Depression, the St. Louis Art Museum staged a major retrospective show of twenty-eight works by Bingham, which toured a year later to the Museum of Modern Art in New York with great success. During the intervening decades Bingham's reputation has continued to deepen and develop as his images have been seized upon to represent some of contemporary America's best visualizations of its democracy, frontier roots, and westward expansion. For a newly urbanized and largely industrialized modern society under the administrative watch of a centralizing national bureaucracy, Bingham served several ends. On one level, his works explore the artificial reconstruction of untamed natural places as settled civilizing spaces, showing how the frontiersman's confrontation with nature remade both into something new. On a second level, his depiction of simple technologies of wind, water, and steam power under the control of ordinary settlers comfortably obscured the serious loss of personal autonomy and collective liberty implied by passively accepting the benefits of technocratic industrialism in modern cities. Likewise, on a third level, his works subtly express Whiggish suspicions about the corruption and carnival implicit in popular electoral democracy, which modern industrial elites eagerly could exploit to enhance their own power, privilege, and position as the actual practices of real democracy decayed into mass media spectacles. Yet, on a final level, Bingham's work is even more interesting inasmuch as it reached immense national audiences during the 1840s and 1850s in the form of mechanically reproduced engravings, which were sold by subscription as cheap paper prints. As a result, as Walter Benjamin suggests, the artistic function of his images increasingly became incidental to the spectacular ideological functions played out in this new style of exhibition.

Benjamin first marked this transformation in art by contrasting the cult value versus the exhibition value of art works at their points of reception. Whereas painting once served almost exclusively cult values in auratically charged rituals in secluded privacy, the mechanical reproducibility of paintings made it possible to totally reorganize the nature and conditions of art's reception; thus, as

Benjamin notes, "with the different methods of technical reproduction of a work of art, its fitness for exhibition increased to such an extent that the quantitative shift between its two poles turned into a qualitative transformation of its nature." And, by the same token, as art is quantitatively revalorized by its quantitatively expanded exhibition value, "the work of art becomes a creation with entirely new functions, among which the one we are conscious of, the artistic functions, later may be recognized as incidental."[2] For example, in seeking to support his family and build a career as an artist, because he could not survive by painting auratically charged portraits to fulfill the cult values of frontier Missouri households, Bingham ironically typified how the influence of painting can shift as it begins to be produced for its new mass exhibition values via mechanical reproduction.

Although George Caleb Bingham gained his fame as a Missouri artist, he was born in Virginia's Shenandoah Valley on March 20, 1811. Bingham's father was a farmer and miller, but lost his land and mill in 1818 after a series of poor business decisions, which spurred him to move his wife and six children to Missouri in 1819. There Bingham intently watched the colorful spectacle of small town politics and Missouri River traffic that later preoccupied him as subjects in many of his paintings. After considering a career in law or the ministry, he turned by 1831 to the calling of art as he began painting portraits of local people in the small towns up and down the river. Much of Bingham's life work actually was portraiture—done starkly and directly in the style of his own self-portrait, which was the initial image introducing viewers to this show. Though he was technically accomplished in the use of light, color, and texture, the forms and lines of his work nonetheless openly ring with many simple folk or naive realist indications of a self-taught artist. Yet, his original do-it-yourself style was well adapted to his clientele and the setting in which he lived and worked.[3] Always restless, Bingham traveled in 1838 to New York and then later to Philadelphia, where he lingered at the Academy of Fine Arts to study more closely the highly stylized genre paintings of Emanuel Leutze and William Sidney Mount. Excited by the prospect of making a living from such styles of painting, Bingham placed his

now lost *Western Boatmen Ashore* (1838) with the Apollo Gallery in New York and did six other genre pictures, which also are now all lost, for the National Academy of Design show in New York. These efforts proved to be a serious personal gamble and major financial setback, because no commissions resulted from the showings. With no income rolling in from this sort of painting, he returned to doing portraits again. Eager to improve his situation, he moved to Washington in 1840 at the suggestion of his mentor and paternal guide for much of his life, James S. Rollins, who also embroiled him in Whig party politics. Living in Washington from 1840 to 1844, which included brief stints in Petersburg, Virginia and the Shenandoah Valley looking for commissions, Bingham returned to Missouri to paint genre scenes full-time after a second trip to Philadelphia's Academy of Fine Arts in 1843 convinced him of the real possibilities for financial gain in doing this kind of painting.[4]

For a time, this new professional strategy worked, because Bingham hooked up with the American Art-Union in New York during 1845. This organization agreed to buy examples of his genre painting, and then engrave the images for sale as cheap prints to its mass market membership. The largest sum that Bingham ever received for any one painting was $350. Nonetheless, this kind of money soon gave Bingham a certain financial security, and the mass distribution of his works in the form of cheap paper prints widely publicized him and his vision of the American frontier.[5] By the late 1840s Bingham was winning recognition in New York art markets as the most definitive artistic witness of Western life. Similarly, by the mid-1840s, Bingham was being written up by the Missouri press as "The Missouri Artist," following his very positive reception in New York and its popular press as an important "Western" artist. Rather than doing realistic landscapes of the West, however, Bingham painted idealized genre scenes from everyday life along the Missouri and Mississippi rivers. Instead of documenting what he saw as it actually was, he painted what he knew his audiences in the East wished to see, namely, his own highly romanticized remembrances of how the West used to be. Missouri was the West, even though it was fracturing in the 1840s and 1850s into divided

fragments pulled at cross purposes between the North and the South. Hence, his images both provided a mystifying aesthetic veil thrown over the sectional conflicts of his day as well as an alluring vision of the interests that the North or South might control in winning domination for free or slave labor in the West.

Bingham's artistic agenda ranges far beyond merely painting an objective chronicle of frontier life. His goals are baldly ideological, boosteristic, and mystifying. Rather than representing the West as it is, he casts it as perhaps it was, or at least as he believed his audiences wished it to be remembered. Casting it not as a site of exploitation and conflict, he draws it instead as a sylvan Jeffersonian experiment in face-to-face democracy, small-scale enterprise, and adventuresome free men all struggling to make America what it had become in his own day. His river and landscape paintings played out actively as promotional imagery for America's Manifest Destiny. In these images Bingham presents the frontier and frontier society in the terms he knew many wanted to blindly buy into; that is, as ever expansive, free, open, and liberating.

Bingham's paintings, then, have been and are much more than historical illustrations. Their perpetual citation and celebration over the past five decades has transformed them into ideological icons, which anxious minds fiercely cling to for that perfect impression of authentic memory. The memory, which is but an artificial, two-dimensional idealization of fictional moments from the illusory frontier, in turn becomes "historical reality" for all who seize upon its images to ground their sense of "a past" or "some past" as "the past" or "our past." Hence, when Bingham's works are celebrated as a painted archive of American social history, one must be on guard, resisting the implicit call to accept or transform such displays in art museums into a sanctified articulation of American civil religion.

Several of Bingham's images, for example, might be read as an epic road map of Anglo-Saxon America working its will upon the North American continent. In this respect *The Emigration of Daniel Boone* (1851–1852) is an excellent case in point. Its gaze solemnly stares upon Daniel Boone leading a party of white settlers from the settled East into the unsettled West, bringing with him civilization,

technology, and progress in the form of white women, white workers, and white society. Traversing a rough rocky trail between two opposing arrays of dark, craggy cliffs, the Boone party in the foreground is bathed in bright light, very much like the strongly lit background of the already civilized East where they started. Yet, on either side of the trail, tangled broken trees, untamed forests, dark clouds, and circling birds suggest the promise and dangers of the unsettled West. In front, Daniel Boone leads a white horse carrying an almost madonnalike woman, or his wife, Rebecca Boone, riding sidesaddle as she and the horse are lead by this great pathfinder. To his left, a tough grizzled-looking scout holds his rifle at ready, while gazing intently ahead, much like Daniel Boone and the lady on the white horse. To Boone's right, another pioneering male rests a moment to adjust his moccasin as his dog warily watches the wilderness. Behind this prepotent advance party, which is set in the painting's foreground as a strong triangular mass, the other settlers follow in single file, including another younger woman, or Boone's daughter, on a black horse, more armed men, a man with an ax or mallet, pack horses and cattle all the way back to the horizon. Unlike his depiction of carefree Mississippi boatmen, this image represents the solemn relentless advance of an entire civilization, bringing all of its technology, economy, domestic order, and political system with it into a new land. The painting works on many levels as a complex coda of Jeffersonian democracy and agrarian freeholding in the American republic, unfolding from its founding to the Civil War as an imperializing irresistible force. Here are the timeless champions of an entire way of life passing through the wilderness, waiting to remake it and themselves in an epic confrontation of nature with American society.

Yet, as the Boone party and other settlers file out into the West through passes and draws in the Appalachians, Bingham also paints images of the savage otherness awaiting them in the dark thickets or on the cliffs above in *The Concealed Enemy* (1845) and *Captured by the Indians* (1848). The Indian is portrayed as a menacing antagonist, but his unseen prey is left undepicted because, in a sense, it appears in many of his other canvases. It could be Daniel Boone and his party, it could be the fur trader and his son, it could be jolly

boatmen, or it could even be other Indians. *Captured by the Indians*, on the other hand, illustrates the early American's classical horror story of captivity as a white woman with her small son—perhaps someone like the woman on the white horse once led by Daniel Boone—rest at night in the forest under the guard of Indian braves in war paint. Yet, the image is ambiguous. The peace of the scene does not suggest violence on the Indians' part or much resistance from the woman. Does the Indian blanket over the woman and the boy's bare feet suggest care and concern for the white captives? Or perhaps even some clear personal ownership or an obvious sexual tie between the awake, alert brave and the white woman? Is the woman's attitude of prayer one of hope for some future rescue or one of despair over accepting her plight? The pioneers or farmers who came into the wilderness with her now are absent, gone or perhaps even dead, leaving her to submit to the Indian's apparently subhuman demands.

The initial reacculturation of whites in the West by the Indians shows up powerfully in Bingham's masterpiece, *Fur Traders Descending the Missouri* (1845). Set against a natural paradise of thick forest, rushing water, and open skies, it nonetheless shows man seeking to master nature through technology and will. Chained in the canoe's bow, a pet bear stares at its reflection in the water as it sits a captive of the trader. Likewise, the fur trader's obviously halfbreed son sits atop a bundle of furs with a duck that he apparently has just shot with his rifle. While many of the forms are Indian, the motivating substance of the fur trader's power is white, European, technological; that is, the spreading networks of modern global capitalism as it worked its effects through the markets of St. Joseph, Kansas City, or St. Louis. The white man's markets drive the trader to trap for furs in Indian territory, yet his Indian canoe carries his take back to white urban civilization for the money that sustains him in pursuing his wild way of life. Again, here we see a new syncretic culture emerging as the fur trader and his son begin the process of remaking the West under the ambiguous gaze of the painting. Is this view focused from the bank or another canoe? Is it that of *The Concealed Enemy* or *The Jolly Flatboatmen*?

Actually, these images, much like Bingham's visions of Missouri

River life and its commerce, were already tremendous anachronisms in the 1840s and 1850s in most of Missouri. Yet, memories of Indian ambushes and tales of abducted white women echoed through popular American mythology from the Europeans' settlement of the Eastern states and Old Northwest prior to Missouri's statehood. Likewise, tales of new abductions and ambushes came back to Missouri from the Rocky Mountains, the Southwest, and the Great Plains. Thus, Bingham was able to exploit what he knew were his audience's deepest fears and strongest prejudices in portraying Indians as stealthy assassins or kidnappers. On one level, the psychodrama of *Captured by the Indians*, for example, bundles together many of the conflicting cultural contradictions held by white male Americans about women and the Indian in frontier American culture. Yet, on another level, *The Emigration of Daniel Boone,* in addition to being a paean to Jeffersonian democracy, also can be seen as the fearsome object of a terrified stare by the Native Americans glimpsing these storm troops of a civilization that swore "the only good Indian is a dead Indian."

Much has been made during the 1980s about how the Old West "really" was not as we know it.[6] That is, the grandiose myths of American expansion are no more than that: myths. The New West school of thinking admits this simple truth, and has begun talking about the silences, looking into the shadows of the other side, listening to the hushed voices, and articulating a new discourse about the Old West that is both new and old. Yet, one need only look at the paintings of George Caleb Bingham to see the origins and formations of many of the Old West's most basic myths. As spaces of representation, Bingham's paintings have been and still are tremendous ideological inventions for symbolically constructing new understanding of the West with their sophisticated codes of everyday life and suggestive signs of face-to-face democracy. Here, in these imaginary landscapes, one reads the signs and plans for conquering the frontier, settling and making it safe for new spatial and cultural practices. The imagined rises from the experienced, but then the experienced often is remade to conform to such aesthetic discourses of the imagined.

The invocation to "Go West" in American culture always has

rested upon utopian images of what "going West" will disclose or deliver to those who still remain "back East" but are contemplating the big move. [7] Aesthetic representations of the West's natural places as well as the frontier society's newly constructed civilizing spaces served as mobilizing forces to draw settlers out of their everyday routines in the East and into the project of transforming the West. Bingham's work, as much as any other of his time, attractively summarized life in these border zones between the frontier and civilization, wilderness and settlement, "Western" nature and "Eastern" society as they collided along the Missouri. Several contextual factors came together in the 1840s and 1850s to advance this myth-making process: Bingham's need for a steady, dependable income above and beyond his portraiture work, the Eastern urban audience's fascination with new images of the West, and the mass distribution of cheap engravings based upon genre painting by organizations such as the Art-Union of New York. Bingham's paintings were, on one level, genre studies of everyday life along the Missouri during the early to middle decades of the nineteenth century. Yet, on another textual level, they are also visual manifestos of the new sense of place and space forming with the ideology of Manifest Destiny. Thus these imaginary landscapes, riverscapes, and townscapes are more than paintings: they became and remained normative guidelines for reshaping the lands, rivers, and towns they represent.

Bingham's fur traders and jolly boatmen, for example, are themselves signs of a new global economy recasting and reshaping raw nature as products and resources. Beneath the fur trader's son are bundles of globally defined and internationally demanded commodities that the market "needs," setting the fur trader and his son in motion and putting them at these sites. Underneath the jolly boatmen are the finished goods or raw materials of national markets, drawing these men out to work and play in the reconstitution of wilderness from frontier into settlement. Bingham simply captures in paint the shapes and surfaces of these grand cultural shifts and new economic substances, remaking the "primitive" zones of unsettled West into new "civilized" cities, towns, and farms.

Like Mark Twain's writings about life on the Mississippi, Bing-

ham's river paintings are probably what many art audiences re-
member most vividly today about his work. Again, like Mark
Twain's most memorable characters, Bingham's best figure studies
are discovered on the river among its trade in raw materials and
finished goods going up and down the waterways. Studies like
Boatmen on the Missouri (1846), *The Jolly Flatboatmen* (I) (1846) and
(II) (1877–1878), *Lighter Relieving the Steamboat Aground* (1846–
1847), *Raftsmen Playing Cards* (1847), *The Wood-Boat* (1850), *The
Trappers' Return* (1851) or *The Jolly Flatboatmen in Port* (1857) are all
frozen flashes of everyday life. They work so well because each
captures and returns one's gaze as if the canvas could transport one
back through time and space in instantaneous journeys of ideologi-
cal awakening. Bingham's composition puts the viewer there on the
bank, just alongside or astern, and right on the prow, inviting the
eye into the scene to affirm its momentary perfection and acute
accuracy. These images are summations of an era, a culture, a mode
of production, already dying or near death in Bingham's own time,
but grasped imperfectly and forever in Bingham's vision. Moving
through time and space, the rivermen always are living in, by, and
through nature, but at the same time reconstituting it as capital in
the industrializing, modernizing Missouri economy.

The appropriation of space for the production of capital is the
essence of frontier settlements. Taking territory and occupying it
with new structures, practices, and peoples of capitalist exchange
were the ultimate goals of America's westward expansion. Al-
though Bingham basically was a farm boy, who grew up on the
relatively settled spaces of the Shenandoah Valley and Missouri
River basin, much of his artistic oeuvre represents how white,
male, Anglo-Saxon America appropriated the "wide-open spaces"
of the West, transforming them into "civilized places." While the
diverse contacts between the West as a space and Americans as
a diverse, multicultural people constantly remade the myths of
America, the aesthetic imagination of these struggles also con-
tinually remade the West as a poetic space, region of desire, or
contested place.

Bingham's imagination propounds extensive mythologies of
space and place that fixed the spaces of desire and places of wants.

From these constructions, perceptions and experiences were transformed. The forbidden spaces of wilderness gained personal discursive form in representations of new land uses, new built environments, new social interactions, new social spaces. And, from these changed cultural perceptions, changing personal experiences result by producing new transportation, housing, communication, and trading systems at changed social sites in the flow of people, goods, and money. The flatboats and canoes are more than romantic traces of the Old West; they are the new global economy's modernizing containers of meaning, power, and value, reshaping everything they pass through on the way to and from the settled zones to the wild regions. They draw an initial grid of commerce and exchange; squatters and migrants then fill in the spaces between, which finally lays a foundation for the civilized towns and households to occupy afterward. Bingham's paintings clearly were invitations in homespun composition and color to Easterners to "Go West" in the 1840s and 1850s. Depicting a mode of direct, face-to-face democracy from the then distant golden age of Jefferson and Jackson, Bingham illustrated a mythological way of American life innocent of abolitionism, sectionalism, and industrialism even as these destructive forces gripped Bingham's audience east of the Mississippi.

Bingham saw the commercial value of doing paintings dealing with the democratic practices of his day; and, through the mass production system of the Art-Union, he carefully idealized several representations of ordinary Americans' alleged genius for democracy. Yet, at the same time, there are obvious subtexts and apparent counterpoints that simultaneously anchor and contain this popular faith in Bingham's images as sympathetic propaganda for the common man exercising his right of self-government. Such images recast the West as well as America at mid-century minus the contradictions and conflicts of sectionalism, abolitionism, secessionism, and republicanism. It is a vision of the people willing, speaking, acting to choose one from among themselves, who always will be held in ironic suspension, as their leaders choose to will, speak, act on their behalf.

Bingham's career as a frequently failed Whig politician plainly shows up in the political paintings with their simultaneous celebra-

tion of and consternation at Jacksonian democracy. The partisan gaze is apparent in several of these works, ranging from his peculiar vision of democratic voting to his particular definitions of election debate. These ideologies, nonetheless, still have impact. Their influence even today pulls at many contemporary Americans' idealized visions of their electoral democracy back to the original Jeffersonian/Jacksonian standards set out in Bingham's paintings of county politics in Missouri. Works like *The County Election* (1851–1852), *Canvassing for a Vote* (1851–1852), *Stump Speaking* (1853–1854), *The Verdict of the People* (1854–1855), and *Country Politician* (1849) continue to appear in government textbooks to serve as ideological ballast for the civic education of new generations of Americans.

In his *Country Politician* and *Canvassing for a Vote*, Bingham brings democracy down to face-to-face, one-on-one, retail politics as the roving candidate works to get his message out to the voters. Both portray essentially the same characters in largely the same poses, both lit from the frame's right in intensely bright light. *Country Politician* is an interior scene of the politician working on two voters seated next to a potbellied stove. As he counts out his points on his left hand, the seated listeners take in his appeals, but a third standing man faces the wall, reading a poster about an upcoming circus, warming his backside on the stove, and putting his silent posterior into the midst of the others' heated political discussion. Similarly, in *Canvassing for a Vote*, the same politician is back—this time outside on the sidewalk during a pleasant summer day. Three voters listen to his spiel, one of them the same portly pipe-smoking gentleman from *Country Politician*. Yet another man ignores it all, staring into a shop window, signaling perhaps his contrary loyalties and oppositional vote. And, a sleeping dog snoozes through the whole episode, suggesting Bingham's sardonic doubts about the politician's spirited appeal to his constituents.

Stump Speaking illustrates one of democratic theory's cardinal concerns—an open appeal by candidates on the campaign trail to the voters for their votes and allegiance—in almost perfect detail. The animated and erstwhile candidate leans out over a small circle of males, ranging in age from boyhood to old age, counting out his points with his hands as the sheaf of written speech lies ignored on

the rough-cut log lectern. Immediately beneath his hands, an old man rests his head on his cane and snoozes, while a young boy with bare feet sits on the ground counting coins in his right hand as the candidate counts points of rhetoric in his left hand directly above him. Opposing the candidate in his natty, white cutaway coat, a citizen in a dark hat and simple black coat stands up in the audience intently staring at the speaker while another younger man lies on the ground also fully absorbed in the speech. Bingham casts a strong light coming from behind the candidate, which streams over his shoulder and down into the close inner circle of the audience that looks up illuminated by its brightness (and the speaker's words). Behind the candidate, his opponent mutely watches the speaker's backside while another man next to him (perhaps a reporter) scribbles down notes on a tablet. The audience, or "the public," are arrayed around this small space with differing degrees of attention and concern. Some sleep. Some crane their necks to hear better. Some stare off into the distance. Some are totally absorbed in the speech. Some whisper to their neighbor. Some ignore it all and carry on their own conversations in the background. Some look well dressed and prosperous. Some appear coarse and near poverty. Parodying the electoral game, Bingham counterposes against the candidate's several interesting subplotted images, including two small dogs warily circling each other as they try to stare each other down and two small boys appearing to argue between themselves in the dirt before the podium.

The County Election (1851–1852), which was painted a second time in 1852 with brighter highlights and in sharp lines, moves from the debates of campaigning to the vote casting of election day itself. Here Bingham turns up the rhetorical flame, presenting all of the high jinks of local democracy—last minute promises, drinking at the polls, separate tallies of votes cast, pulling drunks up the steps to vote, inattentive officials daydreaming through the chaos, voters reading the newspaper at the last possible second to form their reasoned electoral choices, local opinion leaders buttonholing friends, dejected common men set adrift after casting their votes and left with only their hangovers and bad ballots to consider. Finally voters step up to the courthouse landing to cast their votes by voice as

they lay their hands on the Bible even as candidates or their partisans tug at them for their votes. Bingham clearly telegraphs his suspicions about these dealings. Two boys, like the two parties, play mumblety-peg in the dust, while an anxious dog sniffs around in the action as if it were a hunting pointer seeking out the raging corruption of this sad charade. In the original 1851–1852 version, a voter appears to flip a coin to decide his vote (which is excised in the second canvas); but, at the same time, a banner above and behind the voting reads "The Will of the People the Supreme Law." Still, despite all of its corruption and confusion, the people do exercise their sovereignty. And, fading into the disappearing point on the town's distant horizon, a riding crier still gallops down the main street of the town, like Paul Revere, perhaps raising the call to go out and vote.

The Verdict of the People works out its images in very harsh light and highly exaggerated poses to underscore its far more carnivalesque aura. At the center of the painting, two men examine "the verdict of the people" as they point out the final tally of the vote: 1406 to 1410. Simultaneously, a teller on the courthouse steps seems to announce the vote from another sheet to a largely inattentive crowd gathered into smaller clots of action, discussion, and celebration in the street around the courthouse. In the foreground, a black porter carts away a load of bottles, rags, and crockery, pushing toward a drunk or despondent man hanging his head to the street as two boys and a man slice up a watermelon behind him. Behind them, Bingham places a man dancing a jig in the style of his jolly boatmen and another man rides a white horse with three hats on his head—obviously, a winning bettor capitalizing on the day's events. And, behind him, a group of ladies stand in the background on a balcony, flying a flag with the words "Freedom for Virtue. Remember the Ladies." Centered in the picture, four men, perhaps from the losing party, count out their own running vote tally on a top hat as others read the news off a bulletin board on which an electoral official's head casts a garishly caricatured shadow like a warlock or scarecrow. And, in the middle of the image, a dog stands alertly on all fours, ironically the only truly attentive observer, listening and watching the entire scene.

As workers revel on election day, the local squires and bourgeoisie carefully tally "the people's verdict" to determine who from among their numbers will assume office. Beneath, behind, between them, young boys, blacks, and women are left to watch, listen, and wait for the propertied white male adult to voice "the will of the people." Bingham's work, then, seemingly portends the end of an era even as he apparently fetes its advantages. In celebrating the practices of Jeffersonian/Jacksonian democracy, his eye definitely frames these activities in the brackets of Whig suspicion. The exaggerated pose, aggressive stance, and overblown energy of the focal figures in the political paintings all are open admissions of Bingham's distaste for many rituals of popular democracy and political participation by the vulgar.

The West of Bingham's imagination was often no more than his idealized memories of antebellum Missouri. Neither "Far West" or "Back East," Missouri's early settlement by French- and English-speaking Europeans gave it an intense Eurocentric flavor that large waves of later German, Italian, and East European immigrants only helped to accentuate. The master codes of westward expansion, which were originally formulated in New England and along the Eastern seaboard, simply were extended beyond the Mississippi with the exploits of Daniel Boone and other similar white Anglo-Saxon frontiersmen. As the heroic pioneer who tamed the savage frontiers of Tennessee, Kentucky, and Missouri, Daniel Boone served as a perfect archetype of WASP America fulfilling its Manifest Destiny. In Missouri, there were no large populations of Hispanic settlers or Oriental laborers to integrate into the mythology of domination. Hence, they are vanished and silenced as a nonpresence. Indians, which did exist, were the cunning subhumans who laid ambushes from the rocks and thickets to kill white men and kidnap white women as Bingham's *The Concealed Enemy* and *Captured by the Indians* suggest. Women, of course, came into Missouri, but, like Rebecca Boone in *The Emigration of Daniel Boone*, they were expected and required to be led, riding sidesaddle in demure submission, by real frontiersmen. And, once in the West, like the woman washing clothes and watching her children play in the river of *Landscape: Rural Scenery*, the women suckling children, making

dinner, and setting the family table in *Family Life on the Frontier*, or even the tough squatter wife tending to her chores in *The Squatters*, women were trapped in the silent backgrounds of domesticity. Finally, the considerable numbers of blacks in Bingham's Missouri appear infrequently and at the margins of his paintings, as whites wished to see them, doing hard subservient service or shucking-and-jiving to entertain their white masters.

Here, then, in Bingham's canvases, the ideological codes of frontier America's meaning are closed, setting the stage for their further future elaboration in the plains, deserts, and mountains beyond Joplin, Kansas City, and St. Joseph. From the 1850s through the early 1900s the same nationalistic tropes and ideological closures will continue to play out the stunted logic of images encoded into Bingham's Daniel Boone. The clothes, weapons, equipment, and terrain will change, but even six or seven decades later this heroic white male conqueror will continue to dominate the Old West in Remington's and Russell's work. What is more, these iconic signs and cultural traces will become even more entrenched globally as Hollywood puts the implicit understandings of Bingham's painting into motion in thousands of picture palaces around the world. The deep structure of Hollywood's West can be excavated almost in toto from Bingham's depictions of the American frontier prior to the Civil War. Here are many of the ultimate archetypes of Kirk Douglas, John Wayne, Randolph Scott, Charlton Heston, and Burt Lancaster, dressed in buckskins and armed with muskets, fanning out across the Great Plains and Rocky Mountains in the movies to transform primitive territories into modern America. Only recently, as part of the New West movement in American historical debates of the 1980s, have these implicitly accepted visions of the West begun to be questioned seriously. By reaching back into the aporias of such images, contemporary historians are giving women, Indians, blacks, and Hispanics a voice and look other than those so densely encoded over them by the art, history, and literature of the old school. While the West is again becoming a hotly contested terrain, it is, at the same time, becoming a much more real place as the important contributions of all of its inhabitants are finally given due credit.

Most of Bingham's best works, therefore, always were much more than genre paintings with merely artistic merit. From their beginnings, they were produced to be mechanically reproduced for exhibition in mass markets as paper prints. Not surprisingly, they became national icons, distilling confused and contradictory times into simple, elegant images for communicating to new generations their peculiar sense of national memories and collective desires. Unable to see ourselves as we really are (or perhaps were), subtle aesthetic discourses can envision our past in terms of idealized scenes, like those in *The Emigration of Daniel Boone, Fur Traders Descending the Missouri, The Jolly Flatboatmen,* or *The Verdict of the People.* These unchanging images recast the past in visions of resolute and industrious common men, building a great society and new democracy by their own labor out of nothing but raw nature. From these images, the iconography of Manifest Destiny perpetually is rediscovered and renewed. Such frozen glimpses of everyday life from the wild margins of civilization, along the arteries of commerce, or in the town square also are ironically how we usually choose to remember the realities of the Native American genocide, a racist slave-labor economy, or rough-and-tumble white male democracy. The absences, the gaps, the silences of dominated and/ or destroyed otherness vanish in the bright grins or aching grimaces drawn across the faces of Bingham's irresistibly advancing Anglo-Saxon settlers. These discursive tendencies in America's past as well as its present also make the generous financial support from Boatmens Bancshares, the May Company, and Monsanto to stage the exhibition seem simultaneously more inappropriate and just right. While many things have changed, the old mythologies of expansionistic Anglo-Saxon power, so cherished during much of the Reagan-Bush era, can easily be recharged from ideological batteries like these Bingham paintings. Clearly, it is in aesthetic vehicles like these that ordinary Americans can still be taken for a ride back to the future as they and their leaders blindly speed forward, while looking out of the windows or into the rearview mirrors so artfully painted over with the Western visions of George Caleb Bingham.

2. FREDERIC REMINGTON

Riding into the Sunset

The myths of the Old West capture how intense political conflicts, naturalized as essentially incomplete but still easily circulated images, frame much of America's self-understanding. As Roland Barthes explains about myth, one must remember how "the meaning will be for the form like an instantaneous reserve of history, a tamed richness, which it is possible to call and dismiss in a sort of rapid alternation: the form must constantly be able to be rooted again in the meaning and to get there what nature it needs for its nutriment; above all, it must be able to hide there. It is this constant game of hide-and-seek between the meaning and the form which defines myth."[1] As a storehouse of instant historical meaning, brimming with tamed richness, few artists' works can surpass those of Frederic Remington. Indeed, his mythic visions of the American West provide limitless opportunities to play hide-and-seek with the meaning and form of America today.

The 1980s and 1990s in America plainly has been a very conservative era. In such times, the search for perennial meanings and enduring national values naturally seems to move realist, representational, and regional artists, like Frederic Remington, into the spotlight. Even a century after the closing of the frontier in the American West, Remington's artworks continue to fascinate with their vivid power and careful depiction of a way of life that already was becoming, to a significant extent, mythological even as he was painting or sculpting it. Working from tall tales, eyewitness accounts, soldiers' stories, and cowboy yarns, Remington pictured the Indians, mountain men, cowboys, cavalry troopers, and wildlife of the West so realistically that his images now are among the master prints of our collective memories of the Old West. Yet,

somewhat strangely, an exhibition of Remington's romanticization of the Western frontier opened in the late 1980s at a snarled juncture in American cultural politics just as the conservative Reagan regime anticipated its end, recounted its successes, and assessed its failings.[2]

As Doreen Bolger Burke observes in the exhibition catalog, the first important scholarly monograph on Remington was published immediately after World War II, "when patriotic sentiments were strong."[3] Remington's works long ago acquired iconic status in the collective cultural consciousness of most Americans, and the mania for these icons rises in times of patriotic enthusiasm. Today the "authenticity" of Western movies, Western landscapes, or Western personalities very often is judged against Remington's essentially fictional images of the Old West. Rightly or wrongly, his paintings and sculptures provide some of the most definitive benchmarks of accuracy that Hollywood, Nashville, and Madison Avenue have been exploiting for decades in their perpetual redefinition of the Western experience for new generations of Americans. In the arenas of national politics, a Western mythos and cowboy ethos have surrounded Ronald Reagan in the popular imagination here and abroad since his election in 1980. At that moment, many Americans felt engulfed in a troubling sense of economic, political, and social decline. After adopting a leadership style that many associate with the laconic no-nonsense approach of "a plainsman," Reagan's "playing" of the presidency allayed these doubts, recouping some of America's sense of its own identity and purpose. As *Newsweek's* review of President Bush's election in 1988 claimed, using its own bizarrely twisted movie metaphors, "In the end, Reagan was Mr. Smith come to Washington—a Jimmy Stewart figure who projected a purity of purpose but who could be tough as Gary Cooper at high noon when provoked. His gunslinger image gave him the maneuvering room to face down the enemy even when he didn't always deliver on the threats."[4] Playing out his role before a mass public desperately seeking reassuring images of America's greatness, Reagan's cowboy persona temporarily patched over the real crises of the age with uplifting illusions. Yet, President Reagan has moved on to greener pastures.[5] For many, his passage, like Rem-

ington's artistic portrayal of the disappearing Old West, represents the end of an era, leaving no one with equal authority, charisma, or stature to fill his boots.

In such a setting, this exhibition's particular resurrection and redefinition of Frederic Remington seems all too necessary in a way that was improbable in the forlorn 1970s. Remington's unabashed romanticization of the Old West as an industrializing America moved into the twentieth century parallels and prefigures today's nostalgia for the 1945–1973 era, which Reagan so artfully exploited, as the declining United States faces the unknown challenges of the twenty-first century. To evoke Remington's project, particularly in its entirety, one can tap directly into the deep currents of patriotism, nationalism, and Yankee exceptionalism that lie latent in many Americans. It often can be conjured up simply by citing images of a Remington cowboy out on the open plains. Consciously or unconsciously, then, a serious retrospective of Remington's project carries a powerful political charge. As one of the ultimate iconic sources of such symbolic forces, this exhibit might be expected to provide its viewers with renewed energy and some new inkling of where to go from here. And, inasmuch as the Bush-Quayle ticket took the reins of state over from President Reagan, it also seems clear that these fortifying insights are still very much in demand.

Given this context, why stage the opening of a major exhibition of Frederic Remington's illustrations, paintings, and sculpture during 1988 in St. Louis, Missouri? On the level of some proper historical "fit," the St. Louis Art Museum is a magnificent beaux-arts structure created by architect Cass Gilbert (a close friend of Remington), which was designed and built for the Louisiana Purchase Exhibition of 1904. Much of the territory that Remington's art addresses came into America with the Louisiana Purchase. For these reasons alone, it perhaps made sense. Still, on a second level defined by the urban site itself, St. Louis as a city is one of the most socially uncertain and culturally undefined of America's urban areas, placed more or less midway between the clearly "Eastern" industrial metropolis of Chicago and the obviously "Western" cow-town of Kansas City. A back door to the East, the front door to the West, side door to the North, last stop before the South, it exists as a

decentered historical ambiguity, which is capable of assuming virtually any regional identity. In the year of transition from the Reagan era to the post-Reagan years, the city aptly serves as a neutral zone or a place of waiting. Yet, on a third level of ordinary popular perceptions, to the populations in the urban centers along the Eastern seaboard and on the Pacific Coast, St. Louis is what its Saarinen Arc denotes: the symbolic gateway to the West. And, for the works of a New York born and based artist, Frederic Remington, it was the most appropriate place to begin an exhibition that would over two years retrace the tracks left by America's colonization of its own internal empire in the Old West: beginning in St. Louis in the museum left by the Louisiana Purchase Exposition, traveling to the Cowboy State of the Wild West and Buffalo Bill Historical Center in Cody, Wyoming, then turning south to the Museum of Fine Arts in Houston before returning triumphant to the Metropolitan Museum in New York City in the spring of 1989.

All of these sites pulse with meaning on several levels of significance. As the largest and most prestigious city located on the cultural and political seams joining East and West at the Mississippi, St. Louis bestows for many the authoritative legitimacy of a "big-time Eastern art museum" on the ultimate "cowboy painter" from the Old West. At the same time, the show's travels to St. Louis, Cody, and Houston allow irascible Westerners, who have adopted Remington as their own, to believe that the aesthetic mythology of their own region will appear first and foremost "at home" before heading east to amaze the New York City dudes. And, on the parallel plane of national politics, the Remington show opened in St. Louis during March, just as the Republican and Democratic presidential contenders of 1988 began to sort themselves out after Super Tuesday. It ran in Wyoming during the summer party nominating conventions and closed just after the traditional Labor Day presidential campaign kick-off. Opening in Texas during October, where the 1988 election was hard-fought between Vice-President Bush and Senator Bentsen, it again closed right before the 1989 inaugural to open finally "back east" under the regime of George Bush, the first post-Reagan president. Clinging to the romantic illusions of the Reagan era, the electorate chose Bush to continue "the mission"

loosely defined by Reaganism. And, ironically, Bush received the news of his national electoral victory in Houston as the Remington retrospective was in full swing at the city's Museum of Fine Arts. Like Remington, Bush is a bona fide Easterner, who adopted Texas, one of the ultimate signs of the West, as his new home and the source of his political identity. Looking east, but facing west, Bush has pledged to maintain the mythos of Reaganism, which in turn has been sustained by America's ideal images of the West so artfully preserved in the work of Frederic Remington. During "Decision 88," then, one of the strongest artistic traces of America's Western mythos migrated with the campaign, marking the closing of one frontier and foreboding what might perhaps follow.

Finally, at the level of the show's sponsorship, the major funding for its national tour came from Merrill Lynch, the financial services giant. Tapping into the Western mythos, this corporation fashions itself in its media representations as a powerful bull, which is "a breed apart" from the competition. In the swirl of electronic images and historical memory, Frederic Remington's art is powerfully charged with signs of power and independence. Like Remington's inescapable framing of the present era with mythic signs of its past, Merrill Lynch seeks to project a sense of a new world "that knows no boundaries" other than those defined and legitimated by corporate capital. Always "on the frontiers" of financial service, Merrill Lynch's symbolic show of itself presents its operations as being as free, independent, and bullish on America as the ebullient frontier society celebrated and perpetuated by Remington's art. Hence, as an opportunity to use art, America's frontier past, and the patrons of a few major cultural centers all across America as billboards for its message of professionally planned economic expansion, Remington's masterworks served as a perfect screen for Merrill Lynch's public relations departments. Riding on the backs of Remington's bronze broncos and oil paint cowpunchers, this big Wall Street player projected only the most positive corporate images to the firm's appropriate public of new middle class clients among the nation's devotees of Western art.

Remington was basically a self-taught artist. Although he did train for a while at the Yale School of Fine Arts, it was his career as an

illustrator that plainly dominated his painting, particularly through the early 1900s before he shifted toward the representational codes of Impressionism. He was not much of an innovator technically or stylistically. Even so, in his relatively short career he effectively mastered wood engraving, pencil, pen and ink drawing, water colors, oil painting, as well as large and small sculpture techniques. His work began in the realistic frame of literal illustration and slowly evolved into more impressionist compositions, brushwork, and color usage. Only with his later nature and nocturnal paintings does a symbolist side and a new, different romanticism appear. Yet, he died suddenly at age forty-eight just as these styles began to mature. While his night paintings immediately received strong critical acclaim, Remington is still remembered (and strongly typed) for his realistic works on the everyday characters of the Old West. Given that fact, this entire show was an exercise in repackaging, trying to make what has been devalued and disdained, correctly or incorrectly, as regional "Western art" into a major aesthetic project fully in stride with many of the complex currents in European Impressionism and Symbolism at work during the turn of the century. This show, then, attempted to revalorize what the traditions of Eurocentric art criticism always have treated as a curious, minor footnote by casting Remington as a major figure in American aesthetic development as well as the iconic seedbed of the nation's most potent mythologies. As a painter, illustrator, sculptor, and writer, Remington is reclaimed here from his regional peculiarities and historical obscurity to be recast and transformed, once more, into an "important artist." Nonetheless, for the most part, the exhibit stayed close to the iconic roads carved out by Remington's realist paintings of Western scenes and events. His earliest paintings bear all of the marks of his artistic origins in working up quick illustrations for the popular press, like *Harper's Weekly* and *Century Illustrated Magazine. A Dash for the Timber* (1889), for example, depicts eight cowboys galloping headlong across the plains to a wooded thicket, while a band of hostile Indians follows in hot pursuit. Exacting detail in the horses' movements and cowboys' figures dominates a painting that is done in strong colors, direct light, and careful draftsmanship. *A Frontier Trooper's Thanatopsis* (1889), *The Scout: Friends or Enemies?* (c. 1890), *A Cavalryman's*

Breakfast on the Plains (1890), *Aiding a Comrade* (c. 1890), *An Indian Trapper* (1889), *Conjuring Back the Buffalo* (1892), *The Fall of the Cowboy* (1895), *The Blanket Signal* (c. 1896), *Mier Expedition: The Drawing of the Black Bean* (1896), *Through the Smoke Sprang a Daring Soldier* (1897), and *Gentleman Rider on the Paseo de La Reforma* (1890) all are works painted in the same careful style, which essentially scales up and colors out the pictorial techniques used in his wood engraving, water colors, or pen and ink wash work for illustration. This is the kind of work usually associated with Remington: direct, dynamic, and didactic in tone.

Signs of this tight style survive in later works such as *Charge of the Rough Riders at San Juan Hill* (1898), *Scream of Shrapnel at San Juan Hill, Cuba* (1898), *Missing* (1899), *The Pursuit* (1898), *The Intruders* (1900), *His First Lesson* (1903), *The Quest (The Advance)* (1901), *Fight for the Water Hole* (1901), and *Trooper* (1902). Remington's evolving composition, however, clearly shifted more toward the Impressionists after returning from his stint in Cuba as a Hearst correspondent in the Spanish-American War. Even though he sticks with Western themes, he moves into more evocative brushwork in a series of night paintings after 1900. These works are startlingly good, because of their representational simplicity and symbolic power. *The Old Stagecoach of the Plains* (1901), *Fired On* (1907), *Apache Scouts Listening* (1908), *Night Halt of the Cavalry* (1908), and *Wolf in the Moonlight* (c. 1909) use just a handful of colors—dark blue, green, brown and hints of intense yellow—to create moonlit nocturnal scenes with incredible suggestion and symbolic force.

Pleased with the critical response to these works, Remington extended his less literal design and more impressionist presentation into a new series of historical and landscape paintings. *Coming to the Call* (1905), *Downing the Nigh Leader* (c. 1907), *Cavalry Charge on the Southern Plains in 1860* (1907–1908), *The Snow Trail* (1908), *With the Eye of the Mind* (1908), *The Gossips* (1909), and *The Outlier* (1909) employ a much more fluid, loose, and suggestive style of painting. In his landscapes, *Shoshone* (1908), *Untitled (Impressionist Winter Scene)* (n.d.), *Pontiac Club, Canada* (1909), *Untitled (Prairie and Rimrocks)* (n.d.) and *Pete's Shanty, Ingleneuk* (1908), Remington verges upon a completely Impressionist conversion.

As Clement Greenberg frequently claimed, a painting is nothing

but a flat, bounded object that must make a convincing three-dimensional impression out of the emptiness of a two-dimensional plane. Remington's work is so remarkable in many ways because so many of his paintings can seem, if only for an instant, like three-dimensionally perfect portals back through a frozen fourth dimension of time. His image of the West has become *our* image of the West, recycled and recast today through innumerable movies, videos, and books about this past. His work, therefore, often has the effect of effacing boundaries. Seeing his paintings, "we are there" aesthetically, historically, and emotionally. Or, at least, we often feel like it. And, caught in these feelings, one sees that we also still are trapped in many of the same ideological tropes of power, meaning, and identity a century after nightfall on the frontier.

Since the closing of the Western frontier in the 1890s, America has been grappling for decades with its own purpose and meaning on "the frontier of closings" brought on by the rapid changes in modern industrial life. How can we cope with "the end" of what was to have been endless—limitless and forever? Finding new frontiers has been our major response. Once discovered, in turn, we play over and over again our narratives of conquest and power. First in imperialism, then anticommunism, and antifascism, and counterrevolution, then the new high-tech industrial revolution and space exploration, the struggle on the Western frontier is replayed as frontier struggles in so many other places. Indeed, we slowly have refashioned the whole world as being tied to these fresh frontiers and front lines. In Europe, Asia, and Latin America, we have drawn new boundaries against Soviet communism and Third World dictators so strongly that our basic identity and national meaning as a capitalist democracy depends on their defense. Thus, as each closing of a struggle limits the frontierlike chances and choices of Remington's day, his nostalgic images become even more important. Indeed, after Reagan's Star Wars gambit and Gorbachev's program of *glasnost*, it clearly appears today that the whole frontier structure underlying the struggle between Western corporate capitalism versus Eastern Soviet communism has entered its final closing days.

Death, for instance, is one of Remington's most common preoc-

cupations: the death of frontier warriors, the death of a way of life, and perhaps the slow death of a civilization no longer sustained by the challenge of open frontiers. Partly out of fascination with death itself or partly out of a mission to keep a sense of this challenge alive through images of the existential demands that violent death placed on ordinary frontier Americans, Remington's artwork conjures up images of death conflicts in the West to renew every succeeding generation's interests in the mythology of the Old West. Few themes have as much mythic endurance or still spark as much permanent attention as duels with death, especially when the death motif strikes home the classic struggles of man against himself, man against man, and man against nature. And, in times marked by premonitions of "ending" or "death," his imagery is a perfect zone for playing semiurgic games of hide-and-seek to reaffirm or revitalize mythologically a way of life held in doubt about its own time of dying.

Consequently, Remington's vision is even more important right now. The "contestedness" of the Western frontier, and by extension the multiple confused meanings of America, disappear in the clarity of his mythic representations of everyday life on the frontier. Everything valued in progressive/expansionist/imperialist America takes shape in Remington's canvases and castings, regardless of their connections to the reality of the West. Like most modern Americans, Remington did not live or grow up in the West. He never was anything more than a perpetual tourist recording images for America's present and future in the subjects of its past. A native Easterner, he preferred to live and work in New England. Most of his works were studio pieces carefully reworked from notes and rough sketches after one- or two-month jaunts out west for inspiration. Although Remington had little use for modern urban-industrial society, particularly as its "civilizing" influences spread into the West and destroyed what was left of its old frontier ways, his career—like that of Owen Wister, author of *The Virginian*, who romanticized the West in print—grew out of the same popular press used to engineer consent among mass populations in America's growing industrial cities.

Having returned from traveling in the West, Remington in his

paintings in a sense exclaimed: "I have seen the past, and it works!" This claim simply accented and echoed important symbolic beliefs already held by the new corporate and government elites behind the rise of early twentieth-century American power. For a century, these myths have provided images needed by America to construct an identity for its collective self and project this mythos/ethos in its actions on a global stage. Remington's troopers in *The Quest (The Advance), Through the Smoke Sprang a Daring Soldier,* or *Cavalry Charge on the Southern Plains in 1860,* which gained greater mythic powers later in film and T V images, have been there to provide backbone for America's troopers on many frontiers in many battles against many mysterious foes from the Spanish-American War to the interventions in Grenada, Beirut, Lebanon, Libya, Panama, and Kuwait during the Reagan-Bush era.

Quite a few of these mysterious foes, like Remington's mythic "red man," have been "Third Worlders" or "people of color." And their inscrutability often has been wrapped in the same signs that Remington dramatically draped across his American Indians. The figures of Indians in most of his work are made to appear "noble." Such tones make them seem more powerful as Remington shows them living fully out in the past their now lost freedoms. Of course, this romantic view of the American Indians' former glories also occludes the actual details of how their "civilization" by Anglo-Saxon American society has left many of them much worse off than before. Similarly, nature and the struggle against it are critical themes in Remington's work. These symbolic themes carry more mythic importance today as nature's apparent power and independence virtually have disappeared under the pressure of human settlement, relentless economic development, and industrial pollution. Nature too is continuously celebrated in fear as if all America is precariously perched on a bronco, fighting its bucking as nature strikes back suddenly and unexpectedly, as in Remington's cowboy bronzes. The tie connecting all of these images to reality is nationalistic desire: the wish of the audience to see conquest as glory, genocide as contest, nature's destruction as struggle. It continues today with the same game of mythological hide-and-seek, seeking cultural self-definition and social redirection. Very much like the vision provided in Remington's painting of Indians, American so-

ciety today produces new complex images of its mysterious foes in the blurred outlooks of academic "area studies," popular literature, university curricula on "international business," and political propaganda. These interpretive products, just like Remington's paintings, also survive in contemporary consciousness as unstable amalgams of fear and respect, knowing and ignorance, glorification and debasement.

The mobilization of mythic meaning in America, then, continually returns in new forms at fresh sites against new adversaries. Resistance against expansionistic Soviet communism can, if perhaps only for a while, be supplanted by new battles against the militant Islamic Mideast. In the 1990s, for example, as President Bush claimed in his 1991 State of the Union address during the opening days of the war for Kuwait, "we know there are times when we must step forward and accept our responsibility to lead the world away from the dark chaos of dictators, toward the brighter promise of a better day. Almost fifty years ago we began a long struggle against aggressive totalitarianism. Now we face another defining hour for America and the world."[6] Thus, like Remington's pony soldiers on the plains or rough riders on San Juan Hill five generations ago, American soldiers today must spring through the smoke in the screaming shrapnel to free the world of dark chaos, brutal dictators, and moral outrages.

For Remington, combat on the frontiers of our always changing new world order "makes" Americans in "defining moments" of armed struggle, a belief carried on after him by many others, ranging from Teddy Roosevelt to George Bush. Ultimately, as Remington's troopers suggest in their swaggering stance, Bush reaffirms that:

> We are Americans: we have a unique responsibility to do the hard work of freedom. And when we do, freedom works.
>
> The conviction and courage we see in the Persian Gulf today is simply the American character in action. The indomitable spirit that is contributing to this victory for world peace and justice is the same spirit that gives us the power and the potential to meet our toughest challenges at home.
>
> We are resolute and resourceful. If we can selflessly confront evil for the sake of good in a land so far away, then surely we can make this land all that it should be.[7]

Fighting on wild frontiers is "simply the American character in action." The United States must help the world seize any opportunity "to fulfill the long-held promise of a new world order where brutality will go unrewarded and aggression will meet collective resistance," because "only the United States of America has had both the moral standing and the means to back it up."[8] These may be the demands of building the New World Order, but their origins can be tracked directly back to Remington's aesthetic vision of the responsibilities that arose from opening the Old West.

Paintings or sculptures such as Remington's, then, still are integral components of America's most basic mythologies of power, domination and control. In *The Pursuit, The Intruders, Fight for the Waterhole,* or *Coming to the Call,* we find modern America, bringing its civilization to Indians or Mexicans (the other) at gunpoint and to the West (nature) through industrialized ecological domination with the plow, cattle herds, and the railroad. The Old West emerges from Remington's imagination as not much more than many different sites of human struggle in its trackless waste: man versus man, man versus nature, man versus himself. The stakes of this struggle are the rewards of domination: the imperializing of territory, resources, and peoples for the power and glory of America as it is romanticized, glorified, and exaggerated in the gaze of an ardent nationalist. Nature and the other are vanquished in the actions Remington depicts, and then romanticized after their conquest through careful symbolist representations of their former power, dignity, and independence, "before the white man," even after American civilization had closed the frontier atop their destruction. American power myths and nationalist ideologies of manifest destiny ooze out of virtually every one of Remington's frontier images. Remington's art has provided, in part, one of the symbolic armatures for the self-understanding of an expansionist, industrial, urban power rising to the pinnacle of its global political importance. Myths of origin and purpose are fabricated from his stark impressionistic scenes of direct struggle with nature, primitives, and foreigners by can-do pioneers drawn from America's unconscious ideal images of itself.

In the end, President Reagan artfully played upon these leit-

motifs throughout the 1980s in the national consciousness. Just like the "good old days before Vietnam," his administration revitalized the frontier ethic, associating itself with cowboy diplomacy, rough and ready military aggression, and standing tall against all odds. And, as he left office, Reagan reminded the nation of its frontiersman's soul, bidding it to fulfill its "manifest destiny" in the colonization of space.[9] In Houston on September 22, 1988, Reagan—echoing Remington's imagery—remembered that he too has seen the past and that it works when he declared: "Let every child dream that he or she . . . may one day plant the stars and stripes on a distant planet." Since it is "mankind's manifest destiny" to "colonize this galaxy," Reagan asked all America to believe that "this is our mission, this is our destiny."[10] Ultimately, for Frederic Remington, the Old West was nothing but an immense screen for his imagination, now reflected in these claims made by President Reagan. Consequently, until our starship troopers land their spacecraft to plant the stars and stripes on some faraway planet, we also must be content to stop off periodically in Kuwait, Panama, Grenada, or Lebanon to keep these dreams alive. Indeed, as the strong public support for America's "liberation" of Kuwait under President Bush apparently indicates, Reagan's successful hide-and-seek with the meanings and forms of the Old West in the 1980s "worked" inasmuch as the body politic, once again, is steeled to fight any foe anywhere and at any time to defend a Remington vision of American freedom. Indeed, "this is the burden of leadership and the strength," as President Bush reemphasized in this 1991 State of the Union Address, "that has made America the beacon of freedom in a searching world" as Americans "do what must be done—the hard work of freedom."[11] Remington's crucial role in America's recurring shows of force, therefore, must not be ignored. In many ways, Remington specialized in producing artwork about "the hard work of freedom." From blank canvas and raw bronze, then, Remington fabricated the nutriment for vivid mythic visions collectively shared by many Americans, both then as well as now, to continuously reenvision what their future might become by presenting vital images of how grand the past perhaps had been.

Earth First?

A radical new vision of nature and society emerged in the 1970s and 1980s under the banner of "deep ecology." Deep ecologists would have modern society push far beyond the piecemeal environmentalist solutions embraced by many voters and government bureaucrats, in search of more comprehensive approaches for overcoming the current environmental crisis. By attacking the "dominant worldview" of technocratic-industrial societies, deep ecologists tout the virtues of replacing anthropocentric visions of humanity's dealings with nature with the values of self-realization for all forms of life and biocentric equality.[1] For deep ecology, all life has intrinsic value, the diversity of life contributes to all life forms realizing their intrinsic values, and humans have no right to lessen this rich diversity of life forms with their technologies or economies. Nature is seen as having a spiritual subjectivity by deep ecology, and it is humanity's mission to gain a full understanding of this spirituality in its dealings with the natural world.[2] In many respects, Frederic Edwin Church might be seen as the American painter whose works provide a superb aesthetic expression of such philosophical thinking. Many of his best landscapes represent the wonders of the natural world both prior to and apart from the ascendance of the dominant worldview of technocratic-industrial society.[3]

Few artists of any era in any culture have been as successful as Frederic Edwin Church at realistically capturing the spiritual aura of nature on a painted two-dimensional plane.[4] Church was born during the 1820s into one of the last generations, at least in the United States, to be still largely at the mercy of nature, because of society's limited technological capabilities. Yet, at the same time, Church also lived a very long and productive life, dying just at the turn of the

nineteenth century. Thus, in his lifetime he also witnessed the rapid development of humanity's tremendous new technical ability to alter or even destroy nature. The tenor of his paintings, however, and their obvious celebration of nature's transcendent forces clearly derive from his early experiences with the raw powers of nature in the diverse environments of North and South America.

Like Church, Alexander von Humboldt was fascinated by the diversity of lifeforms and the ruggedness of their terrain in South America. In 1799 he began a five-year exploration of the mountains and jungles of that region, which became the center of his subsequent scientific and cartographic work until his death in 1859. During the late 1820s, he began his multivolume study of the existing world, entitled *Kosmos*, to popularize the many findings of the sciences of his day. Church knew von Humboldt's writings very well, and even retraced some of the famous scientist's tracks during his travels in the tropical regions of South America during 1853 and 1857.[5] The intention of von Humboldt's intellectual project was to unify an objective scientific understanding of natural phenomena with a cultivated aesthetic appreciation of the feelings sparked by the natural world into a single sensitive and enlightened vision of the universe. In his view, landscape painting was the ultimate mode of articulating this unity of objective reason and emotive appreciation, science and art, observation and imagination. It must not aspire to photographic verisimilitude, but it should instead reimagine the ecological essence of the terrain being depicted, giving an accurate view of its features plus the feeling of its overall aesthetic effects. Even a quick glance at Church's work shows how closely he lived by von Humboldt's call to synthesize these contradictory forces in his vision of the landscape. While Church selects aspects of specific places in his representations of nature, none of his paintings are exact representations of particular places in precisely every aspect. *Heart of the Andes*, which was finished and displayed in 1859, the same year that von Humboldt died, is a complete summation of all these ideas. It begins in a foreground of lush tropical flora, and then the image ascends through several ecological zones on the surrounding hills and cliffs to the snow-capped mountain peaks, combining various aspects of the terrain and vegetation of an entire

continent in one complex but powerful image. The only human signs are a small village on the riverbank in the distant background, and, more prominently, two Indians paying homage before a small crucifix on the trail.

Art-viewing publics during much of the nineteenth century accepted such landscape painting as material icons of metaphysical unities, ethical teachings, and collective identities. Church is one of the most powerful American landscape painters to accept wholeheartedly these cultural assumptions in the production of his artistic project. His canvases are mostly all large, and many of them are gigantic. Church worked on such a grand scale, in part, to do justice to the grandeur of his subjects as well as in response to the mass marketing of his paintings in "Great Picture" viewings. That is, with *Niagara*, and most of his other major paintings in the 1860s, these works were shown in one-picture commercial exhibitions, in which special publicity created mass market appeal among large urban populations. Viewers then would be charged a quarter for admission into the show, but Church's careful concern for scientific precision and documentary verisimilitude made his paintings cultural events of the first magnitude when they were unveiled in this fashion during the 1850s and 1860s. In part, these arrangements made it possible for Church and the exhibiting gallery to profit more fully from his work, but they also made each show something much more than a conventional art exhibition inasmuch as the presentations urged the viewers to carefully contemplate the specific natural philosophy and nature aesthetic that Church was striving to communicate in his paintings. He almost always painted scenes from the Americas, both North and South, as enchanted regions of a new Eden, casting members of humanity in this vision of nature in very tiny roles. As small, insignificant beings living in the foreground but at the margins of nature, humans are represented on his landscapes as awe-struck spectators or reverent travelers in astounding natural spectacles of unusual scale, unknown mystery, or unprecedented color. Given his intellectual inspiration by von Humboldt and his own grand style, Church is able to expertly embed fragments from several discourses about science, art, progress, humanity, and nature in his canvases. In the ecological

climate of the 1980s and 1990s, these tendencies in Church's oeuvre resonate with even more significance as his audiences today perhaps consider his work against the backdrop of today's ecophilosophical debates.

Born in 1826 to the family of a Hartford, Connecticut business-man, Frederic Edwin Church was the only son of three to survive childhood. By 1843 he left Hartford and began studying art with Alexander Hamilton Emmons and Benjamin Hutchins Coe. Church then moved to Catskill, New York in 1844 to work with Thomas Cole, who proved to be his most important teacher with the greatest influence on his style, until 1846. From sketching in Connecticut, the Catskills, and on Long Island during these years came his earliest successes, including *The Catskill Creek* (1845), *View of Hartford* (1844–1845), and *Rapids of the Susquehanna* (1846). He made his first recorded sale in 1846, and then moved the follow-ing year to New York City where he resided off and on until 1860, when he married. Traveling and painting all over the eastern sea-board of Canada and the United States in the 1850s, he was elected to the National Academy of Design in 1849 and began to take on his own students in painting. During 1853, Church made his first trip to South America, and he later returned in 1857. Immediately after these trips, he completed several important works, such as *The Cordilleras Sunrise* (1854), *La Magdalena* (1854), *The Andes of Ecuador* (1855), *Cotopaxi* (1855), *In the Tropics* (1856), *View of Cotopaxi* (1857), *Cayambe* (1862), *Heart of the Andes* (1859), *Cotopaxi* (1862), and *Scene in the Andes* (1863–1867). However, it was his *Niagara* (1857) that firmly fixed Church's reputation after special exhibi-tions of it in New York and London brought him to the notice of John Ruskin. In 1860, he married Isabel Garnes and purchased property in Hudson, New York, known as "The Farm." After the Civil War, his approach to landscape painting increasingly fell out of fashion as art trends shifted. Nonetheless, from the 1860s through the 1880s, Church returned to Mexico and Jamaica many times in addition to making visits to Europe and the Middle East in search of new subjects for his work. After these travels, he painted several important works of locations from around the Mediterranean and the Holy Land, including *Damascus* (1869), *Jerusalem From the Mount*

of Olives (1870), *The Arch of Titus* (1869–1871), *The Parthenon* (1871), *El Khasné, Petra* (1874), *Sunrise in Syria* (1874), and *The Aegean Sea* (1877).

Influenced by his experiences in the Middle East, and given the waning interest in his painting, Church also during these years designed and decorated his new house, Olana. Started in 1870, it was built in a Persian style near "The Farm" on Long Hill, outside of Hudson, New York with help from the architect Calvert Vaux. By the 1880s and 1890s, he spent more and more of his time in Mexico with family members because of his deteriorating health. His wife died in May 1899, and he died less than a year later in April 1900 in the home of his patron and friend William H. Osborn in New York.[6]

Church's paintings evoke an almost metaphysical awe for nature that can overwhelm even today's viewers with its reverence for light, shadow, and color. Very few photographers even can capture on film the real richness and bursting brilliance of a colorful sunset on the masses of clouds and crowds of mountains Church repeatedly conjures up with oils on canvas. His paintings are not in any way simulations of photographic images, but they are almost "photorealistic" as they capture how the sun transforms the appearances of the earth every day into transcendental moments of metaphysical purity with nothing more than slight variations of light. These powers were evident early in his career in such works as *Morning* (1848), *Above the Clouds at Sunrise* (1849), *Twilight, "Short arbiter, 'twixt day and night"* (1850), *The Wreck* (1852), and *Beacon, Off Mount Desert Island* (1851). Later works depicting vivid dusks of orange, crimson, and purple only display his improving skills and growing ambitions to powerfully represent twilight in much more metaphysical lights, including *Twilight (Sunset)* (1856), *Sunset* (1856), *Twilight (Catskill Mountain)* (1856–1858), *Twilight in the Wilderness* (1860), *Cotopaxi* (1862), *Sunset Jamaica* (1865), and *The After Glow* (1867). His abilities at recording the moods of diffuse tropical light, filtered heavily by mists or clouds, as opposed to the crisp colors of twilight in the mountains also are remarkable. Paintings like *The Corderillas: Sunrise* (1854), *La Magdalena* (1854), *The Andes of Ecuador* (1855), *The Vale of St. Thomas, Jamaica* (1867), *Morning in the Tropics*

(1877), and *The Valley of Santa Ysabel* (1875), in particular, reveal this exceptional talent for evoking the heavy stillness of the tropical atmosphere simply by playing with light.

Except for its scale and technical sharpness, most of Church's early work often looks like fairly conventional pastoral painting. For example, one only needs to reexamine his *Hooker and Company Journeying through the Wilderness from Plymouth to Hartford, in 1636* (1846), *New England Landscape (Evening after a Storm)* (1849), *West Rock, New Haven* (1849), *New England Scenery* (1851), *The Natural Bridge, Virginia* (1852), *Home by the Lake* (1852), or even *Mount Ktaadn (Katahdin)* (1853), and *Tamaca Palms* (1854) to see Church painting essentially the same picture—peaceful country scenery framed by large, detailed trees and big open skies set around humble human abodes and grazing livestock. While his 1855 *Cotopaxi* clearly anticipates the powerful exaltation of nature in the 1862 *Cotopaxi*, its dormant cone, bright hard light, and peaceful hacienda-dotted valley are almost totally rendered in the same pastoral assumptions that he expresses in his New England paintings. This attitude continues in the placid boating scene in the lush tropical jungle of *View of Cotopaxi* (1857) and the exotic ruins of an Indian cenotaph in *Cayambe* (1858). The erupting volcano and ash-stained light of his 1862 *Cotopaxi*, on the other hand, is an almost otherworldly glimpse back at the origins of time. Except for a tiny llama led by an Indian on a faint trail in the bottom left foreground, the painting depicts an immense rocky canyon into which a tremendous waterfall tumbles from a huge lake on the plains. Looming above all of this is Cotopaxi's explosive eruption, which blankets the skies for hundreds of miles with a rusty red dust. Going far beyond his early pastoral statements, it is a vivid evocation of nature's metaphysical properties revealed in the various surging energies found on a distant physical terrain in South America.

Church's later landscapes with Middle Eastern themes, including *Damascus* (1869), *The Arch of Titus* (1869–1871), *Jerusalem from the Mount of Olives* (1870), *The Parthenon* (1871), *Syria by the Sea* (1873), *Watch Tower in Italy* (1873), and *El Khasné, Petra* (1874), are works of distinguished craftsmanship and considerable aesthetic power. Yet they also are unsettling, because of their more ordinary,

pedestrian qualities. Church's subjects here are the ruins of classical civilizations or the architectural heritage of ancient cultures rather than the grandeur of nature. While Church obviously does them justice, especially in his representations of Jerusalem as a city and the Parthenon as a cultural icon, not one of these paintings really reaches the same expressive perfection as virtually any of his nature paintings. In his visions of nature, individual persons and their social artifacts are minor counterpoints or tiny accents set into the broader sweep of nature. In the paintings of human cities, ancient ruins, or cultural shrines, nature must take a smaller role in the composition, leaving Church to concentrate upon architectural features at the picture's center that he would otherwise relegate to insignificance. The reversal is unsettling in these less striking efforts to give primacy to human artifacts over natural features.

Much of Church's enduring reputation as an innovator draws from the public reception of a handful of his paintings at "Great Pictures" exhibitions. During the height of his fame in the 1850s and 1860s, he produced a few masterpieces that pushed far beyond the conventional tropes of his earlier, more pastoral style of regional painting. They are virtual epiphanies, embodying Alexander von Humboldt's call to elicit powerful feelings of harmonious oneness with the universe in aesthetic representation of nature. These works include *The Andes of Ecuador*, *Niagara*, *Heart of the Andes*, *The Icebergs*, *Twilight in the Wilderness*, *Cotopaxi*, and his last real masterpiece, *Morning in the Tropics*. They are still totally astounding images of nature's many forces, especially today when we wonder if they are merely a remembrance of things past or perhaps utopian images for the reinhabitation of nature by humanity in the future. We see nature as humanity's partner at best and its uncaring master at worst. Nature in these images still overwhelms, awes, and intimidates with its scale and power. Beautiful and awesome, it can tower over any human creation as well as capture, contain, or crush the best of human technology. This is nature seen in ecophilosophical or deep ecological terms as a sentient and responsive being inviting partnership, if not submission to its powers.

Church's work is well known, but it also has gone in and out of fashion both during and after his lifetime. He enjoyed his greatest

successes in the 1850s and 1860s, although his later paintings of Middle Eastern subjects in the 1870s also were well received by the art-viewing publics of the day. By the time of his death in 1900, the new trends of Impressionist and Expressionist work had almost totally eclipsed his careful, detailed style of representational painting. In recognition of his earlier importance as an American painter, the Metropolitan Museum of Art memorialized him in 1900 with a special exhibition of ten paintings, but his work fell into obscurity until the 1945 Art Institute of Chicago exhibition, *The Hudson River School and the Early American Landscape Tradition*. Major exhibitions of American painters of the Hudson River School in 1966, 1978, 1980, and 1983–1984 also concentrated upon or prominently featured his work in presentations to new contemporary audiences. In the aftermath of this recent acclaim, the rediscovery and sale at auction in 1979 of his *The Icebergs* (1861) set a record price for that time of $2.75 million. Yet, this latest show of his paintings, sketches, and architectural designs is the most comprehensive review of Church's work ever staged anywhere. Why, and why now? In his own time Church was lionized as the ideal embodiment of explorer and artist bringing new visions of nature to American civilization. While he is becoming recognized again as one of the most outstanding American landscape painters of the nineteenth century, one also must ask what needs his images fulfill or which ideals his artistic project voices in the events of the 1990s unfolding beyond the walls of this exhibition.

The year 1989 saw the inauguration of George Herbert Walker Bush, "the environmentalist president," and the nation's worst-ever oil tanker accident off Valdez, Alaska. In this political context, ironically, the National Gallery of Art staged this major exhibition, one year after the inauguration, to revitalize and reexamine the work of Frederic Edwin Church, one of the nineteenth century's preeminent landscape painters. It is fitting that this exhibition of Church's almost overpowering paintings of nature should open in the National Gallery of Art and run through the initial weeks of 1990—the twentieth anniversary year of Earth Day 1970. Indeed, obvious conflicts and contradictions swirling through this show sum up the real environmental confusion reigning in contemporary

American civilization: not enough money is available for building safe supertankers or bankrolling exhaustive oil spill clean-ups, but plenty of funds are to be had for nostalgic journeys back to those olden days when nature was regarded as having a transcendental Oversoul rather than being treated as a dead dumping ground for depleted industrial wastes.

George Bush, of course, systematically campaigned for the White House as an authentic "true believer" in conservation and environmentalism. He often asserts that in this respect he is a " 'Teddy Roosevelt-kind' of Republican." Although he frequently stages his photo opportunities and videotaped sound bites for the evening news against impressive natural backdrops from the Maine coast to Wyoming's Grand Tetons to the Florida Keys, his actual performance on environmental protection consistently has taken much less ambitious, corporate-backed lines of march. Bush did appoint William Reilly, the former president of the World Wildlife Fund, to head the Environmental Protection Agency, and he also has backed initiatives to transform the EPA into a cabinet-level operation. Yet, in terms of substantive policy changes, Bush continues to drag his feet. Little or no progress has been made on vital ecology issues, ranging from reducing automobile tailpipe emissions to global warming to protecting old growth forests. Despite his infamous Boston Harbor attack video against Governor Dukakis, Bush also has not supported new spending to clean up such messes in the nation's marine environments, which even has meant accepting a slow, inadequate response to the Exxon Valdez oil spill. Still, Bush is effectively managing public impressions by letting William Reilly into his upper-level policy circles, while allowing John Sununu, his White House chief-of-staff, to obstruct any serious environmental policy changes, and by posing for the news media in pretty natural places to project a warm fuzzy image of ecological concern. Displaying the works of Frederic Edwin Church in the East Building on Pennsylvania Avenue, however, might give the impression to citizens and taxpayers, when visiting the nation's capital, that the president and Congress in 1990 both have the environment at the forefront of their political consciousness, although little of their apparent concern actually makes it into really decisive public policies.

Images like *La Magdalena, The Andes of Ecuador, View of Coto-paxi, Rainy Season in the Tropics,* and *Scene in the Andes* are all aesthetic amalgams of virtually prehistoric natural splendor with basically very insignificant signs of any human presence. In these renditions of Nature, the wonder of life's diversity and the awesome scale of the raw terrain make a mockery of anthropocentrism in any shape or form. Indeed, the scale and sweep of Church's work completely contradicts the lame premises of environmental protection advanced by media spectaculars, like Earth Day/Earth Week 1990, or mass market pulp pamphleteers, like Jeremy Rifkin, editor of *The Green Lifestyle Handbook*, or Ruth Kaplan, author of *Our Earth, Ourselves*, which claim that modern consumers can shop their way to ecological transformation. Church's nature is so vast and powerful that its crises cannot be solved on a global level by individuals using fewer Pampers, burning less Exxon Hi-Test, or buying Coke in returnable bottles. The ecological crisis is instead the product of those systematically flawed ways that we mine the earth, fish the seas, farm the land, cut the trees, and build the factories. It is a producer's supply-side, not a consumer's demand-side crisis. And its impact shows up as pollution in the sky, clear-cutting in the forest, soil silt in the rivers, dead zones in the sea, and toxic sites on the land. It takes major technological powers to kill nature on the scale that Church paints it, and only modern industrial producers—not modern suburban consumers even taken in the aggregate—have the capabilities of wreaking this sort of destruction.

Nature, as Church represents it, is transcendental even in its temporal manifestations. The features of nature are mute, but Church's paintings of them render each aspect and attribute totally articulate with conscious moral significance. Man's absolute arrogance in technological attempts to dominate nature are reframed in the proper perspective of humanity's puniness and pitiful insignificance. Church rightly presents human beings as one more small filigree in an immense tapestry of geologic, meteorological, and biological time all working beyond humanity's complete control or comprehension. At best, men and women should coexist in total harmony and on the proper scale within nature, but as the splintered ship's mast in *The Icebergs* or the crumbled ancient ruins of

Syria by the Sea show, human efforts to dominate nature can only end in disaster if humanity pushes its arrogant projects too far against nature's essential indifference.

Unconsciously voicing a call for living lives that are "technologically appropriate," Church's images show human society coexisting with nature on the right scale in the correct tempo at the perfect pitch of simple technical production. Nature does not dominate humans in cruel struggles which are red in tooth and claw. Rather nature is the lifeworld of humanity, ready to teach and nurture if it is fully understood. Yet, it also can be grandly indifferent or absolutely uncaring, if it is foolishly ignored. The astounding panorama of Andean Mountain vistas and the comforting fecundity of tropical river bottoms both suggest that nature is alive, sentient, and purposeful. Humans only have to listen, watch, and learn from its many signs. By exaggerating perspective or toying with scale, then, Church shows humans how they might rightly live in and with nature, treading lightly on soft paths, using appropriate technology directly in various bioregional environs, and thrive in the aesthetic grandeur of nature's spectacles. His paintings could be mandalas for the deep ecology movement or icons of ecophilosophical thinking. *Morning in the Tropics*, for example, is a flashback to the primeval origins of the world. The lushness of the vegetation and stillness of the scene persuasively argue for the necessity of having worlds beyond the reach of human intervention. It is a perfect image of utopian nature free to just be as it is. Today, however, one immediately must wonder when looking at it: is this the earth during a prepleistocene century or our planet bathed in the haze of some post-petroleum era after greenhouse gases have melted the polar ice caps?

The deep ecologists' intense desire to protect every living animal and plant species, as their strategy for safeguarding the diversity and complexity of nature, finds aesthetic expression in Church's work. His great tropical paintings often include in one canvas the diverse vegetation of many different life zones as they stretch from the jungle floor to snow-capped Andean peaks. Similarly, he never gives any sense of anthropocentrism in his vision of nature. Like John Muir, Church frequently asks us in his images of nature to

"think like mountains," or icebergs, volcanoes, glaciers, waterfalls, river cataracts, or rain forests. There is no place for dams, canals, powerlines, waste dumps, or pipe lines in his vision of nature. It shows a nature respected and revered by human beings, whose artifacts and works either lie lightly on the land or stand in ruins as the sea, the jungle, or the weather reclaim them. Church's work, in a sense, can be seen as quietly glorifying a biocentric aesthetic of life, which would accord dignity, equality, and autonomy to other forms of life and the natural terrain as well. The wonder of seeing the world in this way and the joy of living this way in the world are some of strongest feelings that wash over any who see themselves on the footpath in *Heart of the Andes*, in the small canoe of *View of Cotopaxi*, or on the streambank in *Morning in the Tropics*.

How the West Was Won, or Why Is

the Winning Westernized?

Artistic images always carry many meanings. A focused collection of artistic works usually acquires a thematic purpose or expresses some deeper unities in privileging one set of meanings as being definitive, or, at least, emblematic of the entire group's central significance. The Gerald Peters Collection of Western Art is no exception in this regard.[1] Its catalog and display both suggest that its collector intentionally accumulated specific images which have been meant to express the deepest wellsprings of American identity and meaning. Much of this art is openly symbolist, even didactic in tone. There is very little sophisticated intellectual subtlety or avant-garde polythematic coding in such presentations of the West. Indeed, as the collection openly illustrates, "Western art" is one of the few realms of aesthetic production in modern America where the art itself is expected to "imitate" life in directly realist, representational terms. Yet this is its greatest irony inasmuch as these realistic images are continuously subjected to an unending process of symbolic manipulation to extrude their latent idealist, mythological potentialities.

Art exhibitions also are assembled, cataloged, and displayed for many different purposes—both intended and unintended. This exhibit, which was presented at the Roanoke Museum of Fine Arts in 1990, demonstrates this principle on several different planes of inference. On one level, the exhibit is a respectable collection of many unusual images from a diverse set of places and a variety of times that all are defined as being related to "the West." Yet, as we look at them, one soon asks, "What is the West?" A region drawn on a map of North America beyond the Appalachian Mountains, beyond the Mississippi River, or beyond the Rockies? A region

indefinitely comprehended as anywhere that European civilization had not yet penetrated in the conquest of the Americas? A region of the imagination made more real by eliciting its archetypical signs— Indian braves, mountain men, wagon trains, cowpokes, gunfighters, buffalo herds, wide open spaces—in the minds of any modern mass audience? All of these identities have been and will be tied to the West merely by mentioning its name. The West and its meanings, therefore, become significant to the extent that these definitions are essential for understanding many Americans' psychosocial identifications with their fellow citizens as a collective national group. Traditionally, exhibitions such as this are seen as "answers" to questions of "how the West was won." In fact, they also are vital evidence about how "winning," or exercising domination over native peoples and nature, on the nation's early frontiers was "Westernized" in the conventional coding of history, cinema, and literature fabricated around frontier themes.

As a result, caution and care are needed in approaching "the West" in this and other art exhibitions about the American frontier.[2] These conventionally accepted representational codes and their realist messages need to be reread and decoded very critically to reexplore the exploration of the West in such artistic images. This art collection's narratives claim that to discover the real values shared by many Americans and find their ultimate sources of self-understanding, we must look to its images of the West. Their presentations of nature, community, individuality, society, and everyday life allegedly provide the basic guidelines for understanding everything that we do and have done. So, then, what pictures are shown, and what do their images present as archetypes of action and for faith? There is, as we would expect, something here of the post–Civil War "Old West" tied to our movie myths of John Wayne in *Red River* and *Rio Bravo* or Jimmy Stewart in *The Naked Spur* and *The Far Country*. But as we perhaps would not ordinarily anticipate there is much more here that is strangely tied to pre-Revolutionary War images of Spencer Tracy in *Northwest Passage* or Henry Fonda in *Drums Along the Mohawk*. Assembled by the Gerald C. Peters Gallery, a private art dealer in Santa Fe, New Mexico, this carefully accumulated collection of Western art includes an incredible number of works that are *not* about

the post-Civil War, trans-Mississippian "West" of the "cowboy and Indian" legends manufactured by Hollywood. Ironically, many of the works instead depict incidents and places from a time when any place beyond the Catskills, the Alleghenies, or the Smokies was "the West." In other words, they represent sites and situations that are actually from—in terms of today's cultural grids—"the South," "the East," or "the Midwest," whose frontier days were largely forgotten long ago.

This angle of course made the show particularly interesting for Roanoke and southwestern Virginia audiences, who still try to remember "the frontier days" of their region, when roving bands of Shawnee Indians incessantly raided settlers' cabins and small frontier hamlets, as something separate and apart from the English colonial culture of the Tidewater and Piedmont. Every summer, for example, in nearby Radford, Virginia, there is an "outdoor historical drama" entitled "The Long Way Home," staged by local residents. It commemorates the Indian massacre of European settlers at Drapers Meadow in 1755, focusing on Mary Draper Ingles's violent abduction afterward by hostile Indians. The drama recounts how she later escaped from their camp and returned home through the wilderness after many personal travails. Even more ironically, one must consider this show's audience. Roanoke as a city did not exist prior to the Civil War, except as a tiny crossroads hamlet known as "Big Lick." Its development, like that of "the West," was tied to the national expansion of railroads after 1865. Indeed, Roanoke was founded as a recognizable municipality only in 1882, and it still has today a somewhat Midwestern and non-Southern image of itself. Thus, on this level of urban self-imaging, the show provided a very attractive opportunity to reinterpret the West in very Eastern images within the confines of a Southern-state city, which itself grew up as a wide-open boomtown during the same years as the trans-Mississippian Western frontier.

On another level, this exhibition also was first conceived and displayed as the inaugural show of the Gene Autry Western Heritage Museum in Los Angeles, California during November 1988. As the museum's curator suggests, "public expectations" from the time that this museum was first planned anticipated that it would

take an orientation like those "museums" dedicated to celebrating Nashville's country music stars, dealing solely with Gene Autry's life story or the history of the B-grade Hollywood Western. (In fact, this mission is unnecessary, because Mr. Autry already has a syndicated television show that repackages his old serials and films for broadcast on The Nashville Network for this purpose.) Consequently, this serious show of real Western art serves to illustrate the Gene Autry museum's curatorial design for serving higher purposes, namely, "preserving the history of the real West and providing a better understanding of those forces which have molded our perceptions of the frontier experience."[3] Rather than serving as tinsel town's memorial to the singing cowboy and his hokum history in the unreal West, the curator assures us that the collection is guided by "an abiding interest in the history of the American West and a devotion to preserving its divergent real and imaginary elements."[4]

On yet another level, these manifold meanings become even more complicated in the context of the Roanoke Valley in 1990. As the owner of a small, rag-tag accumulation of this and that gleaned from cultural leftovers in Europe and the United States, the Roanoke Museum of Fine Arts moved in the 1980s from its former headquarters at an old mansion in south Roanoke to the new Center in the Square cultural center. Since that time it has survived a severe flood during 1985 and numerous community disputes over its focus and purpose, but it never has really caught on among the Valley's citizens as successfully as the other tenants of the Center— Mill Mountain Theater, the Science Museum of Western Virginia, and the Roanoke Valley History Museum. Occasionally serving as the venue of minor art, crafts, and photography shows that wander to and from similar small city "arts centers," the museum basically has been undistinguished. In 1988 the institution's trustees decided that the former director was not taking the museum in the right direction and eased him out during the summer. Anxious to be known as a more dynamic center for the arts, the trustees hired Ruth Appelhof, who was then working as curator of the Museum of Art in Birmingham, Alabama. After her arrival, the museum's staff and annual budget nearly doubled, and she has

overseen an extensive remodeling and expansion of the museum's space.

The new director's agenda, in marked contrast to her predecessor's, has been pegged to organizing a first-rate collection of regional art, staging big blockbuster shows, and opening the museum to more intensive use by the community. In many respects, then, *The West Explored*, which Appelhof successfully brought to Roanoke through her contacts with Peters, was to be a prefiguration of things to come. Although the show is a minor collection of a genre that many do not even consider "art" and from a new, small Los Angeles institution, it was, for many local people, a big-time "L.A. Show." Consequently, its display did hint at a fresh agenda brimming with much more energy. It also was a signal that the museum would be the preeminent art institution in the region as well as a new cultural player in the larger arts scene in the Commonwealth. One sign of this change, for example, is that—under Appelhof's guidance and during the run of this show—the Roanoke museum received its first, albeit small, infusion of public appropriations from the General Assembly in Richmond. Of course these monies dried almost immediately in the state's financial crisis of 1990–1991, and the museum faced draconian cuts in its overall support from Richmond after the inauguration of Governor Doug Wilder. The governor, who sees the arts as a "nicety" rather than a "necessity," reduced arts funding from $5.3 million in 1990–1991 to $1.5 million in 1991–1992. So with the state government spending only 5 cents per capita for all art programs, all cultural activities in the Roanoke Valley face a very bleak future.[5]

On a final level, *The West Explored* might be seen as a kind of cultural stalking horse, running roughshod through the ranks of Roanoke's culture-consuming elites with an urgent message about the infamous Explore Project, the "living history museum" which will be built in the area. Like many American cities in the 1970s and 1980s, Roanoke has been experiencing a painful industrial and financial restructuring. The once dominant railroad industry has declined as the Norfolk and Southern Corporation closes down railway offices and relocates jobs elsewhere in the South. While many new manufacturing concerns and service companies moved

into the Roanoke Valley during the 1980s, its population levels and regional markets have more or less remained steady. Fearing that the region will be by-passed in coming years by corporate investors looking for more growth-oriented and progressively minded localities eager for outside investment, the area's leadership has endorsed and supported Center in the Square, a new regional airport, the construction of several new shopping malls, and the Explore Project to give the Roanoke area that right "rising fast," "hungry for growth" image to outsiders as well as to maintain employment in the region's localities.

Thus it is perhaps impossible to separate *The West Explored* exhibition from the designs for Explore. The Peters collection "serendipitously" is focused, as the catalog claims, on "the early exploratory material" of American art.[6] Interestingly, this era and its ethnographic/historical materials are also the major substantive focus of the Explore Project being planned for construction just outside of Roanoke. Although an ecological dimension recently has been added to the plan, the ultimate design of the Explore Project is to construct a "living history museum" around the concept of the early exploration of the American West. Given President Jefferson's negotiation of the Louisiana Purchase, the origins of the Lewis and Clark expedition in Virginia, and the transit through southwest Virginia prior to the Civil War of thousands of settlers headed out west, business leaders and civic planners in Roanoke City and County have dug up a fairly legitimate excuse for the Old Dominion to subsidize such a costly public works project. At the same time, the Explore Project promises to employ many of the Roanoke Valley's workers as its older manufacturing and railroad industries are scaled down in the 1990s. The scope of the Explore Project, as it originally was planned, aimed at reproducing images of life on the early frontier in simulated frontier towns, different types of Indian villages, and an immense habitat-style zoo full of North American fauna and flora. By reproducing the total physical, cultural, economic, and social environment of those lands opened by the early westward expansion, the Explore Project hoped to elicit the same aura of "living history" for the West that is produced by Williamsburg's re-creation of early English settlement in Tidewater Vir-

ginia. *The West Explored* is a perfect prefiguration in painted images of much of what the Explore Project promises to do in live simulations, making it an ideal artistic legitimation of local public policies. In the Explore Project, one can observe how the real world of pork barrel politics can mobilize culture as a means of promoting commerce and economic growth in any locality, including even southwest Virginia. Yet, at the same time, *The West Explored* also shows how the commerce of the art world usefully serves culture by making possible new economic growth tied to a permanent cultural exhibition, which becomes, in turn, a mechanism to promote pork barrel politics.

Therefore, it was possible to see in museum-bound art the historical era and cultural imagination to be evoked at the new theme park on the Roanoke River downstream from town. In fact, the owner's introduction to the exhibition's catalog strangely sums up the same boosteristic ethos of the Explore Project as it has been packaged publicly thus far:

> These images represent the importance of the West to the creation of the American myth. The spirit of discovery, which inspired such motivation for entrepreneurship, is a powerful part of American culture. It seems most of the sources of American entrepreneurial faith come out of the Western myth—the freedom to not be held in by barriers of any kind, the freedom to conquer insurmountable odds, the sense of "can do" reliance that is so important to American self-confidence, and the honest belief that every situation presents a new opportunity. These beliefs—honesty, effort, freedom—seem to be the foundation of American enterprise. To me, these moments of discovery and these images have much more meaning than what they say about their own time, because they represent the sources of so much of our underlying psyche.[7]

In other words, the collection allegedly holds essential aesthetic images that are, in a very real way, the ultimate Rosetta Stone for reading the most vital cultural truths shared by all Americans in Roanoke, the Commonwealth of Virginia, and the entire United States of America.

The show filled the entire first floor of the museum, which essentially is arranged as one large continuous space, with four thematic subsections. The first section combined images organized

around the themes of "Scenes from Indian Life" and "Portraits" (all of Indians), and the second section grouped together works on the themes of "The Wilderness: The Land, the Wildlife, the Hunter" and "Settlement and the Passing of the West."

The images presented as "Portraits" all were painted from 1824 to 1860 to document what purportedly is the inner character of American Indians. Not too surprisingly, then, each of these likenesses reverberates with notions drawn from Rousseau's "noble savage," living in the pleasant environs of benevolent nature. These conventions of anthropological interpretation also frame Indians in terms of enduring cultural types, which had immense pedagogical value in a society seeking to justify their violent conquest. While these images may have little or no correspondence to reality, by representing the West as populated by such ethnological curiosities they make this region worthy of "exploration." Thus we see paintings that immediately suggest subtexts beneath the brush strokes, like "Humanity in the State of Nature," "The Noble Savage," "Humanity in Harmony with the Environment," or "The End of the Era." Charles Bird King's *Powasheek* (1837) and *Wanata* (1826) as well as Henry Inman's *Moanahonga* (1824) portray Indian chiefs in ceremonial dress as powerful sovereigns of native peoples. King's subjects usually were "diplomatic representatives" sent by their tribes to the American republic's capital, and King painted them in formal sittings in his Washington studio. Holding their tomahawks, sacred pipes, muskets, or bows with regal authority, these subjects rarely move out of the shopworn aesthetic codes of courtly presentation used to envision European nobility. On the other hand, the German-born Charles Wimar and the Swiss Karl Bodmer traveled around the West intent upon providing ethnographically "accurate" representations of Indian cultures. Wimar's *Portrait of Bear Rib* (1860) and Bodmer's *The Word of Life, An Old Piegan in Mourning* (1833) both try to show Indians as they really were rather than as the aesthetic conventions of power, status, and authority might concoct their images.

These tensions between realistic representation and formalized stylization also are evident in the "Scenes of Indian Life." James David Smillie's *Indian Camp* (1877), Alfred Jacob Miller's *Elk Swim-*

ming the Platte (no date), Seth Eastman's *Winnebago Encampment* (no date), Charles Deas's *Winnebagoes* (1843), Rudolph Friedrich Kurz's *Indian Village* (1852), Paul Kane's *Medicine Mask Dance* (no date), and George Winter's *Scene along the Wabash River Near Logansport, Indiana* (1848) all depict simple romantic images of Indians living idyllic existences in the safe embrace of nature. Winter's vision of carefree Indian families along the Wabash, enjoying its beauty and bounty, show fragments from a way of life that vanished with the advent of white settlement. Alfred Jacob Miller's *Mirage on the Prairie* (1840) also presents two Indian braves on horseback passively watching the passing of an immense wagon train of European settlers out into a shimmering mirage of immense cities rising on the Western prairie. Of course, as the presence of horses, metal pots and firearms in the paintings' views of these Indians' everyday life tacitly suggests, such societies already were changing irreversibly even as they appear to be graced by the state of nature. These transformations are blatantly apparent in the two works by an unknown Canadian artist, *The Bear Hunt* (no date) and *Micmac Indians* (1850). Here Indians are seen in a very different optic as no more than Anglicized copies of white colonists. In one image, they are hunting bears with dogs and a musket, much like any white mountain man; in the other image, they are indiscriminately slaughtering wild game birds on a lake with guns from ashore and from canoes. This second image of Micmac Indians shows them all wearing uniform-looking cloth clothing, using metal implements, firing modern muskets, and using their canoes as if they were punting on some lake in the English Midlands. Unencumbered by academic preconceptions from romantic philosophers, this unknown folk artist gives a candid assessment of the Indians' unfortunate ugly acculturation by white civilization.

The section of the show devoted to "The Wilderness: The Land, the Wildlife, the Hunter" presented images displaying some of the iconic powers assigned to the Western landscape. Thomas Moran's *Green River, Wyoming* (1907) and Sanford R. Gifford's *Mount Rainier, Washington Territory* (1875), for example, depict mysteriously eroded volcanic buttes and immense snow-swathed Sierra peaks glowing luminously in a crystalline light. Both are almost idyllic

commentaries on humanity's small and insignificant role as brief walk-on players in the immensity of nature's enduring sweep. Here "the West" is virtually another planet—exotic, unusual, and novel, beyond the normal experience of ordinary Americans bred on flatter, greener, and more familiar territory back east. Carl Rungius's *In the Bighorn Country* (no date) continues these themes in showing a crowd of bighorn sheep, existing before, outside, or beyond human time, against an immense mountain range rising skyward and stretching forever behind them.

Still, it is the mythology of men dominating nature that forms the essence of Western expansion and exploration, themes which are celebrated in John Mix Stanley's *The Buffalo Hunt* (1855) and in *The Finishing Touch* (1850) by John Archibald Woodside. Both depict gravely wounded buffalo. Turning on the mounted Indian hunters who first attacked them, the buffalo thrash in their death throes against these tormentors as other Indians ride to the rescue of their imperiled companions. Stanley's image shows a downed Indian rifleman with his horse being gored by the buffalo as fellow Indian hunters spear and shoot arrows into the dying buffalo. Behind them, more buffalo are under attack from mounted horsemen, who are firing arrows into their stampeding prey. Woodside's picture also repeats these tropes of man as the great hunter versus the ruthless wild beast, projecting such classical myths onto Native American subjects.

The actual messy realities of buffalo hunting as an entire village's mode of economic survival, which usually was conducted by scores or hundreds of humans in a mass slaughter, are mystified in these transpositions of aristocratic hunt metaphors into American aboriginal society. Actually white hunters doomed to oblivion the immense herds as well as the Indian societies that were dependent upon them for survival. Stanley's image of "the Noble Savage" struggling against a wild beast of nature compounds the values of white Anglo culture with the forms of Plains Indian life to evince the red man's primitive strength over civilization. As one warrior with a rifle is unhorsed and helpless on the ground, his traditionally armed comrades dispatch the wounded buffalo with lance and arrow; thus, the contradictions between primitive weapons versus

modern technology, master hunters versus industrial killers, and noble savages versus Anglo culture all are put into play thematically in this one image.

This aesthetic confusion of Indians with white men continues in many artists' depiction of white men as Indians, as in William T. Ranney's *The Trappers* (1856) and William Holbrook Beard's *The Trapper* (1857). Here ambiguous images set the European/American trappers, or mountain men, in dark natural settings against dawn or dusk skies suggesting their critical but ambiguous roles. As trailblazers of Western exploration and/or final markers of the native cultures' demise, these solitary marginal characters always were pushing away from European settlements to seek new wilderness territories to explore. As cross-cultural adaptations to a hostile environment, their services become superfluous once "civilization" arrives, making them as endangered as the game they once hunted. With the demise of the wild, the end of the mountain men follows. This nostalgia for their paradise lost in the West also is apparent in William Jacob Hays's *Deer at Dawn* (1865) and Newbold Hughes Trotter's *Remnant of the Herd* (1889). Hays's painting shows four deer cautiously coming down to water at sunrise, while Trotter's moody, dark image shows ten buffalo enveloped in a mist at dusk as if they already were fading away completely like a memory into history, much like the mountain men.

The largest and most complex section of the exhibition unfolded in the images grouped together around the theme of "Settlement and the Passing of the West." Even as the West was being "explored," it was being, more importantly, settled and exploited by the expanding American economy intent upon realizing its "manifest destiny." Many of the works included in this section are easily forgettable—depictions of cowpunchers riding the range with their herds, like Charles Russell's *Worked Over* (1925), Edward Borein's *Making Good Time (The Cattle Drive)* (no date), or James Walker's *Roping Wild Horses* (1875); wagon trains on the prairie, like Charles Deas's *Dragoons Crossing River* (no date); or, an iron horse sliding down the rails, like Peter Peterson Tofft's *The Great Crossing* (no date). This stuff survives in the output of today's cowboy artists, painting pony soldiers, cowpunchers, and iron horses in millions of

pictures, to fill the walls of millions of households from San Diego to St. Louis.

The art of the West, as it is shown here, is again largely art "representing" Indians, only now in discourses of conquest and settlement as they are shown as the antagonistic "other," opposing the advance of European Anglo and Hispanic civilization. The attitudes displayed in these images of Indians, then, span a broad spectrum from fear and suspicion to nostalgia and patronizing sentimentality. Indeed, Weir's *Landing of Henry Hudson*, Brush's *The Shield Maker*, Shingler's *Midnight Attack on Settlers*, Remington's *The Signal*, and Farny's *Through the Pass* iconically sum up the entire course of the Indians' interactions on the frontier with white European civilization. Robert W. Weir's huge painting *The Landing of Henry Hudson* (1838) bizarrely foretells the entire history of Europe's colonization of America in one painting. Floating on the placid Hudson River as if it were a UFO from another planet, Hudson's ship, *The Half Moon*, towers over the tiny Indian canoes paddling out to meet it. On the bank, a small group of Indians stands amidst a tangle of twisted, lightning-struck trees, awaiting some sign from the ship. And, like a thunderbolt, the power of European civilization strikes the American mainland bringing death and destruction to its native peoples.

The Shield Maker (1890), painted by George DeForest Brush as he traveled in the West during the 1880s, renders an Indian brave in closely defined classical styles as a sitting contemplative nude isolated in time intently working on his craft. Trained in Paris, Brush gives the Indian a full-tilt beaux-arts treatment, reducing him to a master craftsman totally absorbed by the construction of a ceremonial shield from flamingo feathers. Aloof and apart from the collapse of his culture under pressure from Anglo invaders, he sticks to his quaint traditional customs to maintain purpose and identity. A. Zeno Shingler's *Midnight Attack on Settlers* (no date) is a dark account of every American pioneer's worst nightmare—a band of bloodthirsty, cutthroat Indian hostiles posed to attack a settler's isolated log cabin. Lurking in the shadows of the treeline, they are preparing to cross the colonist's farm fields, violate his home, and destroy this tiny outpost of "civilization" in the wilderness.

Frederic Remington's *The Signal (If Skulls Could Speak)* (1900) continues the tenor of painting of Hudson's landing with even greater insistence and urgency. In it, a Plains Indian brave rears his horse, waving a buffalo hide frantically in the air to signal his comrades. Before him and his mount, a buffalo skull lies bleaching in the sun as another sign of doom. Again, Remington's fascination with death surfaces in this painting as all the ominous signs of impending danger are ignored or heeded too late to make a difference. *Through the Pass* (1903) by Henry F. Farny echoes this foreboding of the Indian's demise. It shows two Indians—perhaps a brave and his squaw—traversing a mountain pass. Behind them an immense peak is bathed in very bright light, almost disappearing into its brilliance, while before them the pass obviously is getting narrow and dark. The brave is mounted, his rifle cocked, and he is warily searching for an unknown threat. The woman is afoot, standing next to a heavily laden pack horse, and she also is scanning the cliffs for danger. The whole image suggests a retreat from faded glories into an uncertain and insecure future by a defeated but not unbowed people.

The obvious importance of the American military in these conquests is shown in Remington's *The Scouting Party* (1889) and Charles Schreyvogel's *The Lost Dispatches* (1909) in images of U.S. cavalry troopers searching for and then battling it out with "the hostiles." Of course the troopers are shown as idealized WASP warriors, rather than as the newly immigrant, freed black slave or lower class lumpen that they usually were, largely because of such military images' enduring propaganda value in these artists' vision of the Old West. These glorified visions of the U.S. Cavalry ironically gain fresh life with each passing generation as new viewers choose to see themselves as contemporary equivalents of such troopers, scouting the terrain of the latest frontiers or facing the onslaught of the most recent enemies of the nation. Newer generations of soldiers always can put themselves into these uniforms, on these mounts, behind these weapons in the imaginary terrain of frontiers in their young minds as they actually face real enemies in today's uniforms armed with real weapons. Even after Vietnam, as the recent Panama invasion and Kuwaiti campaigns have affirmed,

these kinds of artistic icons still can serve as anchors of meaning and harbors of significance, guiding young soldiers to discover America's national traditions of military might through art.

The Hollywood images of the West, which also are, of course, the same vision expressed in many of Gene Autry's Melody Ranch Westerns, predominate in almost all of these works of art. The important roles played by blacks, women, new European immigrants, Asians, clergymen, miners, farmers, and merchants are completely ignored in the larger collection's overall view of the West's exploration. James Walker's *Roping Wild Horses* (1875) is one of only two pictures in the exhibition showing non-Anglo participants in the exploration and settlement of the West. It simply presents four *vaqueros* rounding up a herd of mustangs as their *patron* rides up to the herd. Edward Borein's *Headin' up the Range* (no date) also continues this carnivalized, exoticized, or marginalized construction of the outsider, showing a *vaquero* on a Mexican saddle, wearing a sombrero and colorful sash, heading out to the range. The Mexicans put in an appearance, but basically they—like the Indians, or the buffalo, or the purple mountains—are shown as decorative counterpoints to the broader big motifs of the Anglo-Saxons' exploitation of North America.

To quibble over the versimilitude of the artistic works in this display would not lead to very productive lines of discourse. Clearly, the paintings often were painted with the presumption of recording reality; yet the deeper motives embedded in such presumptions by each artist are diverse and contradictory. Reality is always a contested range of conventions or collected set of convictions that never proves wholly accurate or totally complete. The question is not whether it is truly "realistic." Rather, it is why one view of reality is privileged enough to appear hegemonic and to be held as definitive in spite of strong resistance in the responding hail of "yes, buts" and "yet, it is also true thats."

The privileging here of course accords with two larger forces. On the one hand, in the larger society these images do resonate with the cinemagraphically inscribed visions of the West fabricated by the auteurs of Western movies and videos, including Gene Autry's Melody Ranch oeuvre. These tropes and tones are widely recog-

nized and immediately affirmed as being somehow "true" or in some way "realistic" by anyone who has seen *Stagecoach, How the West Was Won,* or *Cheyenne Autumn.* Merely living in contemporary informational society, and tuning in to the flow of videoscapes and audio atmospheres which it constantly generates, moves gallery goers to give credence to "the reality" of *The West Explored*'s vision of opening and exploiting the western United States. On the other hand, in the context of southwest Virginia, many corporate, governmental, and not-for-profit agencies across the Roanoke Valley are relentlessly touting the controversial Explore Project. It too would present many of the same lessons about the westward expansion of the United States in a broad array of permanent, three-dimensional, historical re-creations of European settlements, Indian villages, period-specific transportation rides, and wildlife habitats to demonstrate the critical significance of Virginia in the opening of the West.

The final purpose and ultimate price of the Explore Project are still unknown, but many believe that the cost will run into the tens of millions once all of the associated infrastructure, roads, and land acquisition costs are added to funding the "living history museum" itself. Nonetheless, the frozen fragments of eras now past but "preserved" in paint eventually will be thawed out and resurrected in the simulations of a highly engineered leisure industry to draw tourists off of I-64, I-81, and I-95 as they flow north and south, east and west near the Roanoke Valley. Like many regions of the now played-out trans-Mississippian West, Roanoke too is staking a big part of its future on the tourism-based "attractive industries," as its ties to older, industrial "extractive industries" wane in commercial importance.

Defining myth and certifying reality. Preserving real and propagating imaginary elements. At the bottom line, serving these mythological ends too is part of this show's actual agenda. And, given the centrality of the real West that we still are called to "feel inside of ourselves" by political pundits, fashion designers, presidential candidates, or perfume manufacturers even in the 1990s, this show is a significant ideological operation that gathers and concentrates images with powerful collective meanings for all who view them. The

West remains mythological, because it is highly marketable. As myth, it can be yet another "roadside attraction" or "terminal destination" for the industrial planners of the leisure business. In formatting history as "The West Explored" rather than as "The West Exploited," the development of virgin territories, the despoiling of unsullied nature, and the destruction of native peoples perennially remains a heroic contest of western man against nature (and non-western man), whose chronicles continue to merit permanent memorials paid for with public funds in art exhibits, learned discourse, and "living history" theme parks.

5 . GEORGIA O'KEEFFE

Ideology and Utopia in the American Southwest

Few artists ever come to symbolize by themselves an entire region and era in their works and persons. Yet Georgia O'Keeffe clearly is such an artist. The mass audience's appreciation of her work has unfolded with America's postwar economic transformation. Much of this rapid expansion has occurred in the American West by rampantly pillaging the land, water, and mineral resources of the region to build huge new air-conditioned urban sprawls from Los Angeles to Dallas to Phoenix to Denver. Entire new corporate empires have grown with this boom, mobilizing millions of work-ers—male and female—to labor in this remaking of the American Southwest. And, ironically, during much of this economic revolu-tion, Georgia O'Keeffe produced an incredibly diverse and rich set of images that have served simultaneously as the important new signs of this new American utopia while providing an ideology of untouched natural simplicity to mask the realities behind its un-checked exploitation of nature. Once more, then, one faces the bizarre tendency of transcendentally charged aesthetic images to be reconstructed through mechanical reproduction and constant ex-hibition as convenient logos for public relations. That is, imagery of the absolute, such as O'Keeffe's painted visions of nature, "which was once a means of entering into communion with the divine, has now become an instrument used by those who profit from it, to distort, pervert, and conceal the meaning of the present."[1]

The recent O'Keeffe retrospective at the National Gallery of Art, the Art Institute of Chicago, the Dallas Museum of Art, and the Metropolitan Museum of Art was not a definitive display or grand restatement of her career.[2] It was more of a sampler, which already was in the advanced planning stages when she died in 1986. Hence it

was more suggestive, focusing on O'Keeffe's artistic evolution from her earliest abstract works done in charcoal on paper, like *Special No. 2* (1915), *Special No. 13* (1915), and *Special No. 9* (1915), to her later oils, like the immense *Sky above Clouds, II* (1963), *Sky above Clouds, III* (1963), and *Sky above Clouds, IV* (1965). Still, the major focus of the show fell on her most distinctive works, executed from the 1910s through the 1940s. The exhibition of this range of work reveals how good an artist O'Keeffe could be as well as how bad an artist she frequently was. The essentially photographic qualities make O'Keeffe's work both more accessible and banal. Although they are paintings, these images play through a viewer's feelings in the same direct decorative terms as outdoor photography. Hence there is little aesthetic advance in O'Keeffe's project as she ages. Rather she simply tends to repeat most of the same photocompositional assumptions in studies of different mesas, flowers, or adobe buildings.

Across the fifty years of her career documented in the exhibition, one can clearly see how O'Keeffe basically recasts and reuses essentially the same set of basic forms and shapes developed in her early charcoal images. Indeed, the show opened with her simple charcoal abstractions and closed with her abstract paintings of corners and doors of her Abiquiu house, like *My Last Door* (1954) or *White Patio with Red Door* (1960), as well as colorful swirl-and-line works, like *It Was Red and Pink* (1959) or *Blue, Black and Grey* (1960), that directly echo her early charcoals. One immediately senses, for example, that *Special No. 13* (1915) is the Rosetta Stone of her vision, combining the basic permutations of jagged lines, bulbous shapes, and wavelike bands of different tones which all make her work so distinctive. Seeing her art evolve from abstract images, like *Blue Lines X* (1916), *Special No. 16* (1916), and *Blue No. IV* (1916) to big colored oils, like *Series I, No. 8* (1919), *Red and Orange Streak* (1919), and *Music—Pink and Blue, II* (1919) to her nature paintings, like *Flower Abstraction* (1924), *Nature Forms, Gaspé* (1932), and *Jack-in-the-Pulpit, No. IV* (1930), one cannot avoid tracing the lineage of her designs back to *Special No. 13*. Even over four decades later, these elements recur in *Drawing V* (1959), *It Was Red and Pink* (1959), *Blue, Black and Grey* (1960), and *Winter Road I* (1963) in both charcoal and oil presenta-

tions. This show's grandiosity was planned to mark the centennial of her birth. Featuring 120 works, it carefully sought to include representative works from each period of her artistic development: her earliest works, her years in New York and with Stieglitz, her first works in New Mexico, at Taos and the Ghost Ranch, and then her mature innovative work when she settled in Abiquiu. While the selection is representative, it is at the same time not very remarkable or moving because, in the final analysis, O'Keeffe's aesthetic tracks along a trajectory first traced by modern photography. So many of her paintings, particularly the flower paintings, feel like intense photo blow-ups. Slightly distorted or highly exaggerated, the petals and pistils loom out of the painted plane as they might be seen in the optic viewer of a supertight close-up. Similarly, her juxtapositions of desert scenery with floating images of animal skulls or traceries of antlers subtly mimic surrealistic photocompositions or experimentalist photo-print montages. She felt that she could not paint the object her images appear to represent; instead, she only painted her experience of an object, place, or sounds by her use of color, light, and form. When it is all brought together, this decorative leaning in her work becomes far more pronounced. Except for the big cloud and door panels from later on in her life, most look like what they have become in the popular consciousness of her—valorizing images in New Mexico travel literature, Sante Fe chamber music festival posters, or suggestive images for an artistic celebration of deserts. They are utopian wishes more than they are paintings; ideological signs of Sunbelt self-understanding and part of contemporary America's overall vision of its natural heritage in the Southwest.

Clearly, no other contemporary artist's vision approaches O'Keeffe's in its blending of color, form, and spiritual involvement with the subject. Her work is one of the first links between the painting of the American modernist movement and the innovations made by the European avant-garde, even though she never visited Europe until very late in her life. Like the other artists in Stieglitz's circle—Marsden Hartley, Charles Demuth, John Marin—O'Keeffe found guidance in the modernist waves of Europe and America, but her own work in many ways was particularly regionalist in its

power and inspiration. In fact, as with many other regionalist artists, these very localistic groundings are the major source of both the high esteem and low respect that different critics have accorded to her painting. Although she began as a promising young avant-gardist in New York, the Southwestern twist in her work during the 1920s and 1930s makes it seem much less complex and sophisticated than that of painters who kept working exclusively in more cosmopolitan surroundings.

O'Keeffe's life history is, of course, inextricable from her art.[3] Born in 1887 in Wisconsin, she grew up in Virginia. After attending the Art Institute in Chicago and the Art Students League in New York, she worked as a commercial artist in Chicago during 1909. Beginning in 1912, she worked for two years as the supervisor of art in the Amarillo, Texas public schools. From 1913 through 1916, O'Keeffe taught art in the summer at the University of Virginia. In 1916, she took on an appointment for three years as the head of the art department at West Texas State Normal School in Canyon, Texas. Her first one-woman show at Stieglitz's 291 Gallery opened in 1917—the same year she first saw New Mexico. In 1917 she also first served as a photographic model for Stieglitz, and then began a love affair with him. Although he was married and twenty-three years older than O'Keeffe, Stieglitz set up house with her in 1918 and married her in 1924. From their romance, and Stieglitz's fascination with O'Keeffe as a model for his photography, the myth of O'Keeffe's public persona took shape in the 1920s and continued until her death in 1986. From 1917 to 1937, he produced over three hundred portraits of O'Keeffe that have fixed her mass-culture image as a uniquely mysterious, sensual, and independent woman, who also is, like Andy Warhol or Pablo Picasso, one of today's mass-culture icons of "the artist."

From 1918 to 1928, O'Keeffe lived and painted in New York City and Lake George, New York. During this period she produced some very powerful representational paintings of Manhattan and its buildings that employ the same vocabulary of form and line later used in her Southwestern works. *Street, New York No. 1* (1926), for example, presents a Manhattan street as if it were a dark deep arroyo rushing down into a "V" that dwarfs a single New York lamp post

at the street corner, like a solitary tree at a canyon junction in the West. Other paintings of buildings and cityscapes, like *The Shelton with Sunspots* (1926), *Radiator Building—Night, New York* (1927), *New York, Night* (1929), or *East River, New York, No.2* (1927) continue in this same direct style, while *East River from the Shelton* (1928) is an interior view of an apartment window ledge above the East River. A bowl with fruit leaves lapping over onto the ledge floats prominently in the foreground, prefiguring her later combinations of animal skulls set in the sky above the New Mexican desert.

During the summer of 1929, O'Keeffe first visited with Mabel Dodge Luhan in Taos. From that point on, she spent most of her summers in New Mexico. She first visited the Ghost Ranch region in 1934 and bought a house there in 1940. After Stieglitz died in 1946, she bought her new house in the tiny town of Abiquiu, west of Taos and south of the Ghost Ranch on the Chama River, where she began living permanently in 1949. Still, throughout her career, she traveled widely in North America and, then, much later in Europe and around the world. Yearly exhibitions of her work were featured in New York at Stieglitz's An American Place Gallery from 1930 to 1946 and the Downtown Gallery from 1952 to 1963. Major retrospective exhibitions of her work were held in 1946, 1960, 1966, and 1970 in New York, Massachusetts, Texas, Chicago, and San Francisco. After completing her monumental 8-foot-high and 24-foot-wide *Sky above Clouds* in 1965, O'Keeffe began to lose vision in one eye. She continued working in other media, but this ailment basically ended her painting career. Despite her failing eyesight, she continued to work quietly into the 1970s and 1980s as she lived in Abiquiu. She died in 1986 at the age of ninety-eight.

By the 1920s, as Stieglitz's model, she already was a legendary symbol of modern womanhood and modern American art. As part of Mabel Dodge Luhan's Taos circle and a key figure in the burgeoning New Mexican arts movement from the 1920s to 1940s, O'Keeffe played a major role in popular consciousness of art and the Southwest for nearly six decades. Her later semireclusive life-style and quiet personal tranquility only heightened public fascination with her and her life. She was, in many respects, the breakthrough

figure in art for contemporary American women. And, not surprisingly, many of her most ardent devotees are women, who see a role model in her career and admire her very personal vision of nature, the outdoors and the West. Her life itself *was* in many respects an ideal chronicle and vision of women's liberation and emancipation from World War I through the 1970s. She broke many of the prevailing rules in art and life, but still "succeeded" personally and artistically. Her life, in many respects, has drawn attention to her art as much as her art attracts interest in her life. This is reflected in the cultic fascination with her and her life, especially among younger women during and after the 1960s. Both O'Keeffe and her work, then, have become iconic forces for many women seeking to make their own way in the art, business, and professional worlds.

Yet the most striking dimension of Georgia O'Keeffe's work is its simultaneous potential for displaying complete originality and bizarre banality. Her work is plainly pathbreaking and unusual in its use of color, composition, and scale. Yet, in many ways, it does not change tremendously over time. Many of her flower paintings and Southwestern landscapes, particularly now, seem remarkably ordinary in having provided the ultimate inspiration of innumerable sofa paintings, bank officers' backdrops, and elevator lobby decorations all across the Sunbelt. Endless imitation has made familiar and unremarkable even this unique and remarkable corpus of work. Indeed, it often seems pitched to the plane of interior decoration, bringing the ineffable and irreducible complexities of Southwestern lifescapes down to standardized images that immediately trigger a positive and predictable response. Similarly, her show's sponsorship by Southwestern Bell and her growing adulation in the Southwest and nationwide reveal a curious double bind in her career. She has been so successful in reducing an entire area to a set of artistic insignia that even she and her works now can be sponsored by corporate capital as one of the most prepotent insignia of the same area and its recent transformations.

When O'Keeffe first worked in the Southwest, it was largely without modern amenities. Good roads, reliable services, electricity still were many years away; yet, in representing the simplicity and naturalness of life there, she ironically played a major role in

its modernization. Her summations of natural beauty and simplicity became emblems of attraction, endowing what once was seen as a wasteland with the new images of "the Great Southwest," "the Sunbelt," or "the Land of Leisure." Although this show did not include as many of these works as it could, paintings like *Ranchos Church* (1929), *Cow's Skull with Calico Roses* (1931), *Horse's Skull with White Rose* (1931), *Red Hills and Bones* (1941), *Hills-Lavender, Ghost Ranch, New Mexico II* (1935), *Red Hill and White Shell* (1938), *Grey Hills* (1942), *Black Place-III* (1944), *Pelvis III* (1944), and *Pedernal* (1945) all typify her ability to cast the Southwest with overwhelming utopian clarity in both powerful abstract and representational images.

Many of her early works from the mid-teens to early twenties are abstract images rendered in water color or charcoal. The compositions often have a hard close-up quality to them, like black-and-white art photography done with oil paints. Her architectural paintings of New York skyscrapers and New Mexico adobes clearly are marked with these qualities. However, her representational images of flowers most clearly reveal these approaches to composition. Diverse works over a long period of time, like *Open Clam Shell* (1926), *Pink Sweet Peas* (1927), *Red Poppy* (1927), *Two Calla Lilies on Pink* (1928), *Horse's Skull with White Rose* (1931), *Zinnias* (1920), *Pink Roses and Larkspur* (1931), *From the Old Garden No. 1* (1924), *Cactus and Indian Paintbrush* (1940), *An Orchid* (1941), *Pineapple Bud* (1939), or *Leaves of a Plant* (1943) are painted almost as if the artist's vision were a camera focal plane, framing the image for maximum impact and pushing the f-stop for fullest color intensity. There is more to her imagery than suggested by Clement Greenberg's complaint that it is no more than "tinted photography." It is inspired by photography and draws much of its impact from modern audiences already attuned to the symbolic codes of artistic photography. But it is both representational and abstract, like her many cross paintings, which combine realistic images of Southwestern settings with thick, dark, overpowering crosses as in *Black Cross, New Mexico* (1929). The powerful composition of her many flower paintings centers more on smaller details in their peculiar forms or shapes rather than the entire image of the plant as such. In these respects,

the parallels with the photography of Alfred Stieglitz, Imogen Cunningham, and Paul Strand are very clear. This approach also recurs in some architectural images, like *A Fragment of the Rancho de Taos Church* (1929) and other nature images, like *Deer Horns* (1938) and *Gerald's Tree II* (1937).

The symbolic/emblematic nature of her work is most clearly evident in her skull, bones, and landscape combinations in which horned skulls, pelvis bones, and flowers float against the Pedernal mesa or Abiquiu hills. *From the Faraway Nearby* (1937) imposes a huge multipronged elk's skull and rack on an image of the low hills around the Ghost Ranch. These themes continue in works like *Summer Days* (1936), *Ram's Head with Hollyhock* (1936), *Pelvis with Moon* (1943), *Pelvis with Shadows and the Moon* (1943). Each of these works plays with the popular image of the West already being cultivated from the 1920s to the 1950s with movie and literary images of wide-open Western spaces. The horned animal skulls and red hills of the Abiquiu area directly tap into the mass culture's utopian vision of the West—its emptiness, purity, dangers, openness, and colorfulness—with surreal compositions of bones, hills, and sky that instantly evoke carefully cultivated images. Like John Ford's equally illusory and recurring use of Monument Valley to set the scene of his many Westerns, O'Keeffe's use of the Abiquiu hills and the Pedernal mesa is part of modern America's iconic imagination of its archetypical Western self.

O'Keeffe, of course, was not given to intellectual assessments of her own artistic project. Other than declaring, "I paint what I see," she maintained an imperial silence about her work. In taking this quiet stance, O'Keeffe became a kind of logo of lonely genius and an alluring sign of open Southwestern spaces. This tendency, in turn, has been reinforced by her unending fascination with the same forms and shapes that the symbolic coding of the mass media uses to represent the West in film, print, and video. Animal skulls, deer horns, the Pedernal, adobe buildings, sandstone cliffs and buttes, gnarled juniper tree stumps, and exotic flowers all reappeared constantly as stock elements of her work. In the end, she now mainly is remembered most for her surreal kitschy projections of antelope skulls, elk antlers, and steer horns into the New Mexican sky,

because today they are indelible signs of the region and its allure. Her earlier city paintings and more abstract water colors in juxtaposition with this work are incongruous and almost shocking discoveries from her younger years that seem totally out of character with her later works. Ultimately, Georgia O'Keeffe's work *is* more than this exhibition suggests, but in the end, this show also tended simply to reproduce the mythology that its curators sought to eschew. From the opening room's panels with a big photo blow-up of O'Keeffe at Abiquiu to the closing room with her immense sky paintings, O'Keeffe was left entombed in her image as the Southwestern sphinx who "paints what she sees." But in having painted what she saw, she represented in the exhibition a valorizing icon of a growing region by all who want to profit from all who wish to be there.

Georgia O'Keeffe worked at the intersection of several remarkable trends in American culture and society. She provided one of the initial and most moving visions of the American Southwest just as it was being broadly subjected to outside penetration and economic development. In this regard, O'Keeffe's life and works reveal how aesthetic *Bildung* can be mobilized to help energize economic and cultural development. Lacking much obvious use-value, the empty vistas and desert lands of the American Southwest acquired incredible sign-value in the mysterious visions of O'Keeffe's very personal painting. In one sense, a utopia can be seen as wishful thinking projected into space.[4] O'Keeffe's sublime imagination wishfully reconstructed these desert sites as magic destinations, zones of enchantment, and charmed mysteries with apparently irresistible powers. In these guises, her art helped valorize what hitherto had been by-passed as barren nothingness. Many of the reasons for this area's development rest *in nuce* on her canvases. With her colors and lines, she is inscribing points of interest, lines of development, and places of note upon the entire Southwest region. By depicting tranquility, beauty, and transcendence in the settings themselves, she drew thousands upon thousands into the American West, seeking fulfillment of their own personal visions from its scenes. Ironically, from these aesthetic assets an entire mode of economic development has arisen, parlaying personal growth, geographical

setting, and cultural fantasy into the everyday routines of "Southwestern Living." She is, in a sense, one of this era's most successful pioneering symbol engineers.

Southwestern Bell, of course, implicitly acknowledged a debt of sorts in subsidizing the show. On its tour from Washington to Chicago to Dallas and back to New York, it mainly was viewed by urban art patrons, who are still eager to see the Southwest represented in these familiar utopian terms and perhaps even willing to be drawn there by the same old ideologies of Western expansion. Without O'Keeffe, the area might not have blossomed nearly as fast, nor would Southwestern Bell's profits have been as high. The utopian visions of Sunbelt living romanticized and popularized in her work helped tag this region ideologically for popular settlement and corporate expansion. And the local Baby Bell recognized the worth of bathing in the positive feelings that her art stimulates among all those phone service consumers, who so frequently daydream about summers in the same cool mountain towns that O'Keeffe loved so much in northern New Mexico.

Much of O'Keeffe's art now seems banal, because it is so decorative, reproducible, accessible to these mass audiences. Mass-produced prints and posters of her work provide the perfect piece for many a room in the suburban Sunbelt—the ultimate tasteful touch in sofa paintings, bathroom prints, or entry foyer posters to set moods in decoration for all those who hoot at the tasteless drek from "starving artists" roving weekend shows at a thousand Holiday Inns. Her art semiurgically alloys emblematic Western artifacts with evocative settings, resonating the dominant commercial aesthetic of the age. O'Keeffe's paintings, then, can be regarded as rugged billboards for a million dreams, summing up in the right colors strange and mysterious Southwestern places with simple images of "natural" things. The rugged realities of nature in the West are cleaned up, refined, and made clearly beautiful in hill lines, animal skulls, and the multicolored rock buttes. Within such forms, such signs are taken as really "being the West." Western landscapes, forms, and living all are blended into sign, signature, emblem—a perfect set of regionally grounded insignia for environmentally aware, socially conscious, and artistically inclined consumers.

As the traffic and urban sprawl of the Southwest's thirsty cities intrude farther and farther out into the deserts, Georgia O'Keeffe's paintings along with those of lesser Southwestern artists still provide reassuring images of how it used to be. After crawling through gridlock on the streets of Denver, Dallas, Los Angeles, or Phoenix, an O'Keeffe print or poster perhaps provides some solace on the average Southwestern suburbanite's living room wall, reminding him or her with artistic imagery of why they might have originally moved there. Each ideal image in her West is totally devoid of any urban distractions or industrial destruction—a study in pure form and color. The ideology of unspoiled nature that drives economic growth in the Southwest now finds itself belied with every new subdivision, freeway, and ski town that feed directly off of artists like O'Keeffe. "Ideologies," as Mannheim observes, "are the situationally transcendent ideas which never succeed *de facto* in the realization of their projected contents."[5] The projected content of living in beauty with the Southwest never can be realized in these primitive aesthetic terms. Instead, ironically, each of O'Keeffe's Abiquiu, Pedernal, or Black Place paintings projects utopian images of untrammeled spaces and pure places that sadly draw more and more people to the West, rendering this ideology of pristine nature even more false. Once drawn there, their growing numbers destroy the natural attributes that first enticed them out west. They are left looking at their O'Keeffe posters, hanging on to enthralling images to convince themselves that the congested miseries of their overdeveloped Sunbelt paradise still are somehow part of that "Great American West" out behind O'Keeffe's Ghost Ranch in the Abiquiu hills.

In the Realm of Ideas

Arizona has an image problem. As the home of Evan Mecham, one of America's small handful of impeached governors; the "Azscam" scandal, during which seven state legislators and four lobbyists were videotaped in an undercover sting operation taking bribes to support casino gambling; Rev. Tommy Barnett, the Phoenix First Assembly of God minister who wheels and deals in local real estate as well as flies on wires like Peter Pan during his sermons all as part of his calling to Christ; Charles Keating, the key figure in the rampant corruption behind the California and Arizona savings and loan scandals; and the average Arizona voter, who consistently returns to political office bizarre public servants like Evan Mecham while voting down referenda establishing a statewide holiday to celebrate civil rights and Dr. Martin Luther King, Jr.'s birthday, Arizona is not considered a bastion of cultural sophistication or artistic excellence, particularly by most Americans living outside of the state.

In this grim political context, then, it is not too surprising that image-conscious local groups would attempt to put a more positive spin on public life in the Grand Canyon state. After all, Mecham was the target of a recall campaign, Barnett is considered by some to be a new Jim Bakker in the making, the Azscam group is under indictment, Keating has gone to trial, and many city and county governments in Arizona have enacted their own King holidays. And, on the plane of high culture, the most important arts and cultural organizations in the state collectively mobilized their energies to celebrate the life and work of Frank Lloyd Wright with an elaborate retrospective festival, "Arizona Celebrates Frank Lloyd Wright: 1990–1991," with a series of small exhibitions, lecture series, seminars, and field trips.[1]

The Phoenix Art Museum, Taliesin West, Arizona State University, and the Tucson Art Museum all participated in this comprehensive series of statewide programs to illustrate the scope and scale of Wright's innovative architectural projects. Almost as if he should be regarded as the State of Arizona's key character witness against its indictment for Neanderthal cultural crimes, the initial slick brochures publicizing these many elaborate events strongly emphasized that "Frank Lloyd Wright loved Arizona. He could have lived anywhere in the world, but the man the *New York Times* called the 20th century's greatest architect chose to live in Arizona." While all of these presentations largely were pitched to resident and tourist audiences in Phoenix and Tucson, the larger and far more complex exhibition, "Frank Lloyd Wright: In the Realm of Ideas," largely was developed in Arizona for extended duty as a high-powered, national touring show. This particular exhibition opened in Dallas during January 1988. After a three-month stint in Washington, D.C. at the Smithsonian's National Museum of American History, it traveled to Miami, Chicago, and San Diego, and closed out this extensive run at the venue of its main sponsoring institution, the Scottsdale Center for the Arts.[2]

Like most treatments of Wright's work, and especially those connected closely with the Frank Lloyd Wright Foundation in Arizona, this most recent retrospective review of Wright continued the adulatory lionization of him as a visionary architect and building artist. The reasons for this particular presentation of his oeuvre in the current context are fairly transparent. Wright's world-renowned Taliesin West architecture school and personal residence is located on the fringes of Scottsdale, Arizona, and the primary organization, funding and direction of the exhibition was provided by the City of Scottsdale and the Scottsdale Arts Center Foundation. Such an exhibit culturally casts the State of Arizona in a very favorable light, puts Scottsdale on the national art map, accents Wright's important spiritual ties to Arizona, and points to the influences of the local desert with its unique terrain and flora on Wright's notions of an "organic architecture." Therefore, aided by the Kohler (kitchen and bathroom fixtures) and Whirlpool (home appliances) corporations, this sophisticated exhibition sought to repre-

sent how important Wright was to the transformation of twentieth-century American commercial, public, and residential building as well as how important the inspirations of the Arizona desert became in Wright's imagination.

The notions of "organic architecture" are Wright's architectural attempt to emulate and administrate an organic totality in building materials. Wright's means of embodying this ideology in matter by framing everyday life within the built form gave his architecture a strongly political twist.[3] Architecture in this regard is for Wright nothing but a materialized mode of communication. Not only a sense of utility and beauty but also ideological and cultural messages are emitted from the architectural product in each human's living use of buildings. From this perspective alone, Wright's project probably merits greater attention, because it is a perfect aesthetic expression of the twentieth century's impulse toward attaining a measure of benevolent, comprehensive control over everyday life as the mark of modern rational "progress." While Wright did not aspire to inject his peculiar teachings directly into everyone's inner being, he did wish to embody them in structures that could impart his messages indirectly through the spatial form of buildings. Merely by organizing the private interiors and public exteriors that we all live and work within, Wright pretended to attain a totalizing power through his floor plans, arrangements of walls, and use of spaces as they were rooted in his visions of organic balance.

For many reasons, then, Wright and his work are difficult to explain, categorize, and interpret. His life spanned much of the entire modern era.[4] He began his own architectural practice in 1893 and remained active until his death in 1959. For nearly seven decades he designed many of the most significant and interesting buildings in modern American architecture, ranging across the spectrum from the ideal suburban house to the perfect civic megastructure. Yet much of his project is wrapped in riotous confusions. An advocate of democracy and freedom, Wright also sought to empower persons like himself—the master architect—as the ultimate authority in the administration of modern cities. A devotee of greater liberty for all, he was in favor of comprehensive mass planning and strict social regimentation to produce the proper or-

ganic effects. A strongly modernist artist and architect, he nonetheless established and ran two small, craft-based architectural studios—one in Wisconsin and one in Arizona—to advance his ideas, and managed them like feudal guilds with himself as the high master. A romantic individualist in the modern age, an organic regionalist working against industrial internationalism, a site-specific artist in an era of transnational Bauhaus conformity, and an almost postmodernist stylist of space, light, and form in a time of uniform modernism, he was, in many respects, a living tangle of contradictions.

Architecture is difficult, if not impossible, to put on display in museums. Since architecture as engineering embodies the human ability and desire to exert power over the natural environment and its material resources by building new artificial environments, one simply cannot reproduce its full effects without experiencing full-scale representations of the buildings as such. Yet, because museums are themselves buildings, bringing full-blown displays of architecturally distinctive structures into ordinary museum structures virtually is impossible. Remarkably, this exhibition exploded many ordinary representational constraints by presenting an entire building—a Usonian Automatic House—as the keystone of the show. Inside the museum building itself, Frank Lloyd Wright in the realm of ideas was put on display. And, outside on the plaza, a whole house in the realm of practice put Wright's ideas to a three-dimensional material test as the climax of the museum's theoretical presentation. On the whole, it worked very well—both showing how and revealing why Wright's organic architecture is both a success and failure as an aesthetic/architectural undertaking.

The exhibit opened with a multimedia, audiovisual presentation of Wright's work and architectural philosophies. The continuously running, six-projector slide show, set against an obtrusive score of pseudomeditative/pseudodramatic synthesizer music, depicted many of Wright's works in the conceptual frames adopted by the exposition. Interlaced with recordings of Wright in his own voice making a brief for his architectural experiments, the narrative cued the visitor to focus on the four themes drawn from Wright's teachings in "the realm of ideas"—the destruction of the box, the nature

of the site, the choice of materials and methods, and building for democracy—that frame the exhibition. Wright's career as an architect began in the early 1890s in Louis Sullivan's architectural firm in Chicago. Hence visitors passed by an elaborate wrought and cast iron elevator enclosure grill designed by Sullivan for the Chicago Stock Exchange Building in 1893–1894, symbolically marking the exhibit's and Wright's beginnings. Like Wright's architecture, the exhibit's layout used interesting combinations of sweeping arcs, jutting angles, and open expanses to define its informative spaces as they developed the four conceptual motifs. Visual continuity between the four themes in the presentation was provided by color, a gridwork background design, and a running graphic stripe inspired by one of Wright's geometric laceworks of interlocked squares and rectangles. Using shades of peach, sand, mauve, and tan, each thematic space focused on one major concept, fading in and fading out of its antecedent and successor with shifts in color.

The arrangement of the exhibit, therefore, unfolded outward in a didactic maze, beginning inside the museum. By entering the small darkened audiovisual theater, one passed into "the realm of ideas," seeking enlightenment from the masterworks of Wright's organic architecture. Opening with the multimedia slide show to orient and inform visitors, the display snaked around through a series of coves and crannies in which each of four larger spaces elucidated one of the organizing key themes. Finally, after passing through each of these spaces with their additive lessons, one exited the museum building to enter the full-scale Usonian Automatic House built in front of the museum amid the fountains and green spaces of the Scottsdale Mall. This structure represents the synthesis of all Wright's architectural goals in "the realm of action." On the way, a final display showed a few of Wright's furniture designs, examples of his china service for the Tokyo Imperial Hotel, and some stained-glass panels that reveal his talent for interior design.

The first space in the exhibit stressed Wright's fascination with "The Destruction of the Box" in architectural design. In this area, drawings and photographs of the Unity Temple, Fallingwater, Jacobs House, Coonley House, Hanna House, the Johnson Administration Building, and the Guggenheim Museum were provided to

represent this notion. In addition, models of the Jester House and the Guggenheim illustrated in three-dimensional terms how Wright sought to blow apart simple boxlike structures with more open and irregular arrangements of space or volume to open building interiors to air, sunlight, and the environment. Of course "the box" often simply is "destroyed" by using variants of other more complex boxes in more unconventional ways. Still, Wright makes his claim stick more or less convincingly in the openness and light of works like the Guggenheim's spiral interior, the Johnson building's forestlike spaces, or the Jacobs House's solar hemicycle.

To destroy the box, Wright also intuitively worked to exploit "The Nature of the Site," which was depicted in the next section of the exhibition's mazelike progression. Here, of course, again Fallingwater is the ultimate example of this design goal. Set over a small waterfall in the middle of dense woods, this house blends almost perfectly into its organic environment. And, on a larger scale, Wright takes advantage of sites in the Arizona desert and Bay Area hills in his Taliesin West and Marin County Civic Center structures. Both are organically matched in tone, scale, and color to the sweep of their natural settings. In each work Wright's idea is to fuse the building into the site, melding the building's purpose, place, and processes with its organic environment as if it evolved there along with the plants and animals.

Ultimately, as the next area on "Materials and Methods" illustrated, Wright's first two organically directed design goals could be realized only by utilizing the new technological wherewithal provided by advanced industrial technology. The basic material stuff of Wright's work is still composed of brick, glass, wood, plastic, stone, plaster, concrete, and block. Yet he produced completely new effects by combining their traditional effects with steel for strength and durability. Likewise, he skillfully exploited the new technologies of mechanical heating and cooling in his buildings to deconstruct the box and admit the natural site into the structure. Taking advantage of cheap, mass-production techniques, he also used new kinds of brick, concrete block, and glass to build solid-structural frames that freely admitted air and light into every room of his structures. By utilizing old materials in new combinations,

like the natural stone and cast concrete walls at Taliesin West, and new materials in unexpected applications, like the plexiglass pipe "ceiling" or steel-concrete "tree" columns in the diffuse natural lighting of the Johnson Administration Building, Wright could destroy the box as well as blend his buildings into their natural settings.

Wright's larger goal of "Building for Democracy," as the exhibition's displays suggested with their drawings and models of mostly *unbuilt* projects, was not fully realized. His vision of democratic freedom implied natural, free, accessible buildings as the motive force behind democracy as well as the primary space for its realization. Actually, Wright's own architectural designs for attaining these ends seem ironically to deny their professed intentions in vast totalitarian designs for immense urban sprawls, like his Broadacre City Project, or huge integrated megastructures, like his Crystal Heights Project, Arizona State Capitol Project, and Pittsburgh Point Civic Center Project. These incredibly complex proposals present mammoth schemes for monumental undertakings to empower the master architects rather than the ordinary citizen. Of course smaller individual projects, like the Baird House, Zimmerman House, or Bazett House, do express his desire to provide simple, beautiful housing for all Americans.[5] But, even here, Wright's emphasis on individual differentiation is balanced with a resolute commitment to collective integration as demanded by the utopian gridworks for his visions of a sixteen-square-mile urban complex which he named Broadacre City. Blending urban and rural living with light industry and services, this project put the architect in charge of designing virtually everything—from the city, its buildings, road network, and basic economy down to its churches, schools, houses, and each space's intimate interiors—in a forced reconciliation of man and nature. Tied together by superhighways and personal helicopters, this new transformative urban experiment placed skyscrapers in the middle of forests and brought fields and orchards directly into densely populated zones.[6] While it might be a very rational vision of an emancipatory future, its very scope belies the irrational and irregular nature of democracy and freedom that the design supposedly seeks to realize.

Nevertheless, the exhibition did close with a complete experience of Wright's overall intent with its full-scale Usonian Automatic House, which Wright designed to be built in 1955 for $25,000—of fireproof concrete block with 1,800 square feet of living space. While it provided the exhibition's main corporate sponsors—the Kohler Company and Whirlpool Corporation—with an incredible opportunity to showcase their latest wares (like Buck Rogers sinks, Star Wars cooktops, and Flash Gordon commodes in zippy designer colors) in the kitchens and bathrooms, the Usonian Automatic House also suggests how Wright could use new methods and materials to destroy the "boxiness" of traditional houses and blend structures into their sites. The three-bedroom house does offer an abundance of useful and beautiful space, but at an affordable price by employing standardized, mass-produced components. Wright's desire for total control in "building for democracy" also shows up in the built-in furniture and heavy decorative details on the house, but, on the whole, it provides an attractive, interesting, and affordable space for living.

With steel, concrete block, and glass, as the Usonian Automatic House indicates, the old box at the heart of historical forms of architecture could be exploded open, allowing the site and nature into the interior. Here Wright's four ideas intersect into one expressive intention. The use of new materials and methods as well as working with the site are simply his means for building structures for popular mass democracy. Not all of what he actually intended has been fully put into practice in post-World War II American suburbia; however, echoes of his visions linger as traces in many contemporary single-family residential dwellings with their great rooms, cathedral ceilings, open floor plans, picture windows, and use of natural landscaping. Unlike the high-density brick row-houses of nineteenth-century city blocks or the boxy uniformity of central hall colonial farmhouses, Wright blows apart small, tightly enclosed spaces and invites nature into the building itself.

Wright's architectural project remains so powerful because it evolves within a rationalistic discourse of total power and an absolutist vision of construction that is dedicated to leaving no stone unturned in creating the perfect aesthetic effect. Yet, ironically, his

project also is rooted metaphorically in a discourse of organicism, turning the alleged teachings of nature to the rational fabrication of new human spaces. Wright's intuition, however, is that nature too is nothing but a machine; hence, by finding analogs to its inner mechanistic logic, the architect can fuse beauty and efficiency, organicism and mechanism, simplicity and complexity in every built environment. As Wright's own writings and the exhibition's introductory slide show constantly reiterated, it is "natural" form—flowers, trees, plants, the earth's hills—that Wright takes as the foundational power of his vision. Extending this mechanistic logic of design and organization over the natural world, Wright reconstructs these conceptual projections as a professionally empowering discourse that teaches how to build organically. From these premises, Wright mounts his assault against existing architectural practice: the destruction of the box, adapting to the nature of the site, experimenting with new materials and methods, and building structures appropriate to democratic practices.

In the final analysis, however, geometric simplicity and modular models of proportion, rather than nature, underpin each of Wright's designs. It is the organizational logic of the grid and its power of generative construction that drive Wright's work, despite its apparent organicism. A grid for everything, and everything in its grid motivates his efforts to destroy the box. He deconstructs the traditional box by elevating a new rational system of box-formation to serve as the successor to its obsolete historical form. Evading full authorship, he credits all of these innovations not to himself but to his observations of natural form and organic balance. Unlike many other architects before him, Wright is, first and foremost, an ideological builder who follows his own individual building philosophy drawn from "the realm of ideas" rather than the dictates of national style or imitating classical forms. And, like many of those who follow him in many architectural schools from the twentieth century, he consciously casts his work as a materialized discourse, transmitting through brick and mortar his idiosyncratic messages about cultural engineering, political theory, and social programming. Consequently, his architecture is more than artfully enclosing and furnishing space; it also is explicitly a cultural experiment

and political manifesto for transforming life in urban-industrial society in accord with an almost dictatorial design imposed by the architect as a heroic legislator.

This radical quality in Wright's ideas, of course, nicely parallels the ongoing deconstruction of society and individuals, which obviates the family's traditional, owner-built boxes which were once needed to define identity and purpose during the twentieth century. Wright's explosion of classic bourgeois interiors out of the confinements of their complicated little, traditional boxes broadly matches corporate capital's and the state's intrusive expansion into the family sphere, opening it up as a new fluid space for the endless consumption of new methods and materials shipped into it from without. The mass-consumption society of the present era clearly is anticipated and partially planned out in Wright's designs for Broadacre City and the Usonian Automatic House. Today, however, most of Wright's vision lingers only in traces, surviving at best as parodies of what he desired. Few American cities, for example, have a more inorganic housing stock or unnatural style of building than the Phoenix metropolitan region. From the first postwar boom after V-J Day to the latest bust during the great savings and loan debacles of the 1980s, acre after acre, square mile after square mile in the Phoenix area has been transformed by new construction. Using millions of tons of glass, steel, brick, lumber, and concrete, most of which is produced outside of the state and then imported into its desert environments, builders have outdone themselves at creating a tawdry style of cheap, lumber-frame, stucco-covered, nondescript housing that is the virtual antithesis of everything Wright ever advocated. Built by the thousands, these single- and multi-family structures are almost always ugly, poorly suited to the desert, usually expensive, basically energy wasting, culturally confused, and essentially inorganic expressions of very unnatural architectural designs.

The social contract of the post-World War II era has given the common man little more than an on-time mortaged interest in these unsatisfying houses. Yet this almost insignificant material stake in the existing system is touted as the linchpin of today's economic democracy. Caught in the design grids of corporate master plan-

ners, which actually work on much smaller and more anarchic scales than Wright envisioned, contemporary suburbanites in Phoenix, Los Angeles, Chicago, New York, and Washington do not own even the single acre of land apiece that Wright's notions of modern democracy would have granted to them. Only a weak parody of his thinking holds true today. In the artificial green belts and open areas of yet to be exploited real estate, average consumers do live partly "in nature" and partly "in cities." But their communities are knitted together by congested interstate freeways and mass-media networks. The liberating possibilities of accessible public spaces and moving about by freely flitting personal helicopters, as Wright prophesied, never have been realized. Instead, new materials and methods have brought weak, artificial simulations of nature into the Portmanesque atriums of bland urban high-rises, while confused postmodernist styling often deludes many into believing that their downsized personal spaces are somehow beyond the box once assaulted by Wright. At the same time, in every new suburban development, the real nature of the site usually is scraped off and redesigned with enough transplanted trees and shrubs to guarantee that it has all of the tasteful signs of being a pleasing "natural site."

Wright once argued that if Phoenix were to develop its own authentic urban civilization, then its architects would have to fuse its various human structures with the textures, light, and forms of the desert. Its cacti, boulder-studded hills, and clear air alone were ingredients enough for Wright to construct truly unique architectural experiments. Urging Arizonans to eschew the bogus Spanish-inspired, red-tile-roof, white-stucco-wall, quarry-tile-floor, imitation "Southwestern motif" structures of Los Angeles or San Diego, Wright urged Arizonans to embrace organic architecture as their salvation for the state's special environment. However, virtually no one listened, and Phoenix today is largely a Spanish-style parody of Wright's Broadacre City choking on the poisonous gases of its own smog. The nature of the site around Phoenix and much of its surrounding desert has been practically ignored, instead of artfully exploited, in developing the city's architecture. Somewhat cynically, then, most Phoenicians have denied the merits of Wright's

work in the realm of practice, while they remain quite willing to idolize it in the realm of ideas, especially if it puts their city in a brighter cultural light or draws in the nation's cognoscenti for an expensive getaway visit at a local resort. The opportunity to realize Wright's project, then, still stands unfulfilled as a serious challenge for Phoenix or any other American city, even in today's allegedly more postmodern conditions. Despite the flaws in his overall project, this exhibition nicely affirmed why Frank Lloyd Wright's organic architecture will remain at the cutting edge of architectural design well into the twenty-first century.

"California Dreamin' "?

The contradictory role of art in contemporary society has long been the center of intense controversy and extended commentary. T. W. Adorno, for example, suggests that "art is and is not being-for-itself,"[1] because artworks have elements of unreality, pure figure, nonexistence, and momentary autonomy as well as aspects of reality, historical ground, existence, and enduring contextuality. After the cultural upheavals of modernism, however, art increasingly is seen as being no longer truly auratic or spiritually transformative, making its meaning extremely problematic. Consequently, as its spiritual dimensions are stripped away, the much more volatile commodity-status of art as "not being-for-itself" comes to the fore. Acquiring great exchange value in contemporary art exchanges and auction houses, art turns into an important medium of speculation as well as promising a new area for investment; meanwhile art criticism increasingly decays into discourses about style futures, bids for this or that piece, and patron buying patterns. The attention of a rich collector, the patronage of a new museum, the discovery of hitherto undervalued works all can transform minor players on the art market overnight from relative obscurity to major celebrity. An excellent example of all these dynamics coming into focus at a single expressive point is the Morton H. Fleischer Collection of California Impressionism.[2]

Hovering like a mirage in a vast stretch of undeveloped desert acreage on the far outskirts of Scottsdale, Arizona, the brand-new headquarters building of Franchise Federated Financial Corporation of America (FFCA) rests at the center of an elaborate but still empty 261 acre real estate development, housing the new Fleischer Museum of California Impressionism. FFCA at The Perimeter Center

is, in the final analysis, a venture capital operation. The ventures that it capitalizes, however, are thousands of fast food operations on the highways and byways of the United States. In meeting the demands of America's mobile society, entrepreneurs in the fast food business apparently found it difficult in the 1970s and 1980s to raise the requisite capital in traditional credit markets as investors sank their funds into more attractive propositions, like Texas S&Ls, Florida condo projects, Mexico's foreign debt, or Tokyo real estate. Seeing this pressing social need, Mr. Fleischer provided a significant public service by pooling new investor monies and packaging owner loans for the American fast food industry. Plainly, the opulence of the new building, the grand design of The Perimeter Center, and the scope of the art collection all are testimonies to the profitability of this very specialized market in contemporary corporate capitalism. Constructed of native Arizona materials, the FFCA's new stone and glass building is a solid statement of refined corporate postmodernism. Full of allusions to Frank Lloyd Wright's organic architecture, which was in turn hammered out as a practical building philosophy close by at Wright's Taliesin West complex, the overhanging roof, dark glass, rough-cut reddish stone walls, and desert landscaping of the building also hint at something else— a gigantic, two-story, new-wave fast food restaurant. Perhaps it is the half-berm walls, the low roof line, the large expanses of glass, or the complicated access ramps, but the FFCA building strongly echoes its origins in the interest payments made by hundreds of fast food operators from around the nation.

On many levels, the entire complex is a perfect study in the contemporary corporate use of art, architecture, and high culture as articulations of corporate image and mediations of executive ideology. To gain access to the Fleischer Museum, for example, patrons must pass by an immense bronze sculpture of six powerful mustangs energetically galloping all-out across the Arizona desert. The sculpture, entitled *Spirit* by sculptor Buck McCain of Tucson, is positioned on its own tiny hill of dirt, stone and desert grasses at the entrance to the museum. Along with the wild mustangs cavorting in the highly exaggerated lunges and kicks usually associated with the worst of "Western art" or "cowboy art," the piece's cast cap-

tioning plaque also provides a uniquely expressive dedication to "the strength and creativity of the New American Southwest." Indeed, these wild desert ponies are cited (and sited) as iconic representations of a "tremendous energy" that also stands for "what we believe America and Franchise Finance Corporation of America are all about—democratic capitalism at its best, and the deep connection between individual freedom and the indomitable spirit of the American entrepreneur."

The stone-cased museum entrance behind the sculpture is quite foreboding and mysterious, because the precise location of the museum itself in the complex is left so vague. Above the doors are four giant letters "FFCA" with Franchise Finance Corporation of American spelled out underneath in much smaller lettering. The Fleischer Museum signs are relatively insignificant affairs in the parking lots, directing pedestrian traffic toward the small plaza holding the McCain sculpture and a broad bank of stairs leading to this ominous FFCA doorway. Passing through a set of tall, richly stained, glass-and-wood doors, one enters a vast marble foyer with two grand counterpoised staircases, which are almost *Gone with the Wind* in scale and scope, off either side of the marble floor. The museum and company receptionist's booth sits beneath Hanson Duvall Puthuff's immense painting *Grand Canyon* (1926–1927), originally executed for a major corporate patron, namely, the Santa Fe Railroad, as part of an elaborate promotion and advertising campaign. Showing three blanket-wrapped Indians on the canyon's rim, it tries to capture the ineffable enigma of sun and clouds sweeping over the cliffs and mesas of the Canyon's interior. This entire south side of the building arcs around, enclosing a large two-story, semicircular space containing the two main floors of the museum display area. Beyond it, a large, glass-enclosed atrium holds more works of sculpture and then leads off into FFCA's corporate offices on three sides.

It is an art space, but with a decidedly grandiose aura and assured corporate feel of flat-out self-importance—fine marble, shiny brass, thick carpets, glossy woods, chic furniture, sassy design. Viewing the show is all free, because the museum itself is always open as "a public service." Yet, unlike the art philanthropy of the Gilded Age

or Roaring Twenties, when the truly rich turned their homes into museums, or the modernist museums of the New Deal/New Frontier era, when nonprofit foundations built and maintained new museums for new art, this operation is a seamless blend of art and corporation, museum and firm, display and business. This new corporate headquarters building strongly states a completely conscious fusion of art space and financial space in its overall design. While the large south lobe of the structure houses art, the even larger north, east, and west lobes of the Perimeter Center are dedicated to commerce.

What is California Impressionism? As one might expect, the term itself fuses place with style, keeping close to the art history logic used for describing and interpreting Impressionism in France, Spain, or Latin America. Yet, the heyday of California Impressionism, as one also might anticipate from a smaller, regional movement, comes decades after the dominance of Impressionism in France. Indeed, according to this show, the California Impressionists really take off only in the 1920s and 1930s when Expressionism and Modernism are beginning to take hold elsewhere in the United States and Europe. The California school, in turn, disappears only when these later movements begin dominating the state's art galleries and art markets.

The discourses of definition and interpretation used to describe the California school of Impressionism by the Fleischer Museum and the collection's curator are exclusively geographic, naturalistic, and historical. Basically, as Jean Stern argues in the original 1987 catalog for this collection, "the California Impressionists were, for the most part, artists who came from throughout the United States to settle and work in California. Only a few were born in California and another few came from Europe. That they all ended up in California is significant. They sought a haven which offered ample natural light, as they invariably painted out-of-doors. In addition, they needed stimulating and fresh subject matter which California, with its hills, ocean, desert and mountains, provided in close proximity. Many of these artists were seeking to escape the rigorous disciplinary bonds of the New York establishment, with its pressures and hierarchy. California was a new milieu with opportunities

for all newcomers."[3] Defined as those artists who came and worked in California from the 1880s to the 1930s, attracted by the state's diverse outdoor scenery which suited some of their understandings of European Impressionist statements, and discontent with the fads and fashions of the Eastern art scene, a disparate group of different artists turns into a school of painting. Through this analytical optic, the school also becomes an entire aesthetic project, or "California Impressionism," which acquires a significant discursive outline, purpose, and place in the art chronicles of America from this presentation of its best examples by the Fleischer Museum.

Although a handful of the California Impressionists were working before the turn of the century, most came to maturity or moved into the area only in the early 1900s. What little organization the movement developed was provided by the California Art Club (formed in 1909) and the Laguna Beach Art Association (organized in 1918). Their essentially representational style of work, in turn, remained in fashion until the late 1940s, when California and national art patrons turned to newer abstract modernist movements to diversify their collections. Yet, in the late 1970s and early 1980s, as Donna H. Fleischer explains in the 1989 catalog for these paintings, "interest in this period was renewed. Art historians, museums and galleries began researching this fascinating period and its personalities."[4] The pull of a new big-time collector, namely, Morton H. Fleischer, who was willing to start with one painting in December 1983 and expand it into a large collection of over 125 pieces by 1986, of course made a big difference. As Donna H. Fleischer so archly puts it, "The Fleischer Collection was a directive force that helped to bring about this awareness," and, now in the 1990s, "the Fleischer Museum is dedicated to preserving these masterworks of art by giving these artists and this period of American Impressionism the recognition that it so richly deserves."[5]

While the works of California Impressionists have of course been around for decades, the redefinition of such artists as a special school of painting or a fresh focus for collecting took on its special new meaning only in 1983. At that time Morton H. Fleischer and his business associate, Paul Bagley of E. F. Hutton's Phoenix office, apparently were cruising through art galleries in Beverly Hills,

looking for undiscovered art collecting possibilities. Cued into this field of painting by Bagley, who apparently is a long-standing devotee, Fleischer spotted and purchased in December 1983 a large painting by Franz A. Bischoff, namely, his *Mt. Alice at Sunset* (c. 1920), which depicts Temple Crag in California's Sierra Nevadas in the rosy-pinks of the sunset as its rocky cliffs tower over an alpine lake and foothills swathed in snow.

Most of Bischoff's oeuvre is to be found on china and ceramics, since he spent a major part of his career working in ceramics studios or glass factories in Pennsylvania, Ohio, and Michigan. Many of his paintings, therefore, especially the still lifes, look like they belong on a china plate rather than a canvas. Still, his Western landscapes, like *Mt. Alice at Sunset* or works from a later series, including *Pinnacle Rock, Utah* (1928), *Scattered Farms on the River Bank* (1928), and *Cathedral Points, Utah* (1928), painted during a trip to Zion National Park, are totally arresting studies in desert light, color, and form. Likewise, his studies of scenes from the Southern California coast, like *Capistrano Mission* or *Monterey Cypress*, are very satisfying Impressionist considerations of two excessively studied regional subjects. In this instance, then, as the old television ads told us, E. F. Hutton spoke, and Fleischer listened. Hence, we witness the beginning of the Morton H. Fleischer Collection of American Impressionism, California School on that December 1983 day.[6]

California Impressionism, however, is tough to nail down. Many of these painters are essentially self-taught or highly idiosyncratic artists, who really have only tenuous ties with any sort of strongly partisan or extremely self-conscious aesthetic movements. Jessie Arms Botke, as her *Two Peacocks on a Grapevine* and *White Peacock, Cockatoos, and Flowers* suggest, was mainly a decorative artist who did mural work and tapestry designs. Christian von Schneidau painted portraits of movie stars (while on staff with Twentieth Century Fox) as well as many murals in Los Angeles and Chicago. George Brandriff was a practicing dentist with little formal art education. Victor Clyde Forsythe did a great deal of magazine cartoon and advertising poster work for popular magazines, and then turned to "Western art," or paintings of desert mountains, mining prospectors, and ghost towns, later in life. Edgar Alwin

Payne was totally self-taught in art, beginning his artistic career as a house and sign painter; Charles Reiffel learned most of his style on the job as a lithographer and advertising artist. Yet, painters like Abraham G. (Abel) Warshawsky, Donna Norine Schuster, Elmer Wachtel, Marion K. Wachtel, Arthur Grover Rider, Percy Gray, Maurice Braun, William Clapp, Guy Rose, and Alson Skinner Clark do have very strong Impressionist traits. Braun, Gray, the Wachtels, and Clark were strongly affected by James Whistler. Clapp studied in France and came under the sway of Renoir, Seurat, and Signac. Rider worked in Spain, becoming closely tied to the Spanish Impressionist Joaquin Sorolla. Rose was an art student in Paris with Jean-Joseph Benjamin-Constant, Henri Lucien Doucet, and Jules-Joseph Lefebvre as well as lived in Giverny as one of Monet's neighbors. Rose, in fact, is regarded as the most outstanding California Impressionist, because of his close connections with Monet and his conscious emulation of the great French Impressionist's style. These influences—in terms of light, color, repeated paintings of the same scene at different times—are clearly apparent in Rose's *Mist over Point Lobos* (1918), *Laguna Rocks, Low Tide* (1916), and *San Gabriel Mission* (1914). While not as close to the core of French Impressionism as Rose was at Giverny, Warshawsky also maintained a studio in Paris from 1908 to 1938 as he worked on his craft.

At one level, these California Impressionists' landscape and seascape scenes are interesting, occasionally outstanding, examples of Impressionist composition done by Americans and Europeans for the small but growing urban art markets of the Pacific Coast region from 1900 to 1940. While there are few real masterpieces or expressions of true genius in this lot of painters, one does get a sense of how technically sophisticated some of them were. In their sense of the West and the Pacific's sharp light, subtle color, and stark terrain, there is a unique understanding of the region and its definite differences from the East and the Atlantic. Thus, at another level, it is not too surprising that many of these images either were painted intentionally or soon acquired unintendedly extra-aesthetic sign value, as utopian images of exotic, faraway places worthy of being visited on extended vacations.

Indeed, an entire branch of California Impressionism, as the Fleischer Museum represents it, began as special commissions granted to California artists by the Atchison, Topeka, and Santa Fe Railroad to paint grandiose representations of Southwestern or California scenery for its travel posters. Seeking to sustain a mythic vision of "the New West" after 1912–1914, which already had been developed so well by Russell, Bierstadt, Remington, Moran, and others before World War I, many of these scenes continue Russell's and Remington's tropes of sky, mountains, and clouds but efface "the Old West" icons of cowboys, cavalry, and Comanches. Those Indians that do remain are cigar store or trading post Indians, fully domesticated for the enjoyment of tourists, rather than great buffalo hunters or fierce war parties. In this vein, the Fleischer collection includes several different Santa Fe Railroad commissions to paint the Grand Canyon, including series of works by John Bond Francisco from 1906, George Gardner Symons from 1914, and Hanson Duvall Puthuff from 1926. Other works by these artists as well as paintings by George Kennedy Brandriff, Sam Hyde Harris, Paul Lauritz, and Edgar Alwin Payne express these same impulses to romanticize and glorify the West and its native peoples. Payne's *Headin' for the High Country, Navajos*, and *Canyon de Chelly Desert Skies, Navajos*, for example, as well as Brandriff's *Into the Sunset, New Mexico* present rugged cowboys or noble redmen in all of their familiar places against high Sierra Nevada peaks or red sandstone cliffs.

This implicit marketing dynamic is fairly transparent in the images of the Grand Canyon, Zion, Navajo country, or New Mexico, but it also ripples just underneath the surface of many paintings of California as well. In addition to drawing tourists to the Southwest by train, California Impressionist painting produced an idyllic vision of California itself drawn in terms of sun-washed old Spanish missions, idyllic coastal meadows brimming with poppies, quaint little villages in eucalyptus groves, and surf-torn rugged shoreline. John Gable's studies of poppy-filled meadows, Alfred Mitchell's views of country inns, Rider's or Rose's representations of Capistrano and San Gabriel Mission, or F. Grayson Sayre's *caballero* playing his guitar astride a donkey in the desert outside of Palm

Springs all provide solid examples of this sort of high-status sofa painting.

Actually, at the Fleischer Museum we can see the original aesthetic ancestors of thousands of canvases that now are up as inventory in hundreds of little shops along the California coast from La Jolla to Bodega Bay, depicting old Spanish missions, surf-splashed rocks, and tawny hills spotted with scrub oak or eucalyptus thickets. Eager to take something back home to Riverside, Las Vegas, or Yuma, tourists buy up the output of California's many weekend painters or starving artists, whose works ironically continue much of the style of California Impressionism. The realism of a John Steinbeck or Walker Evans, depicting migrant camps, cannery work, polluted skies, or industrial wastelands, does not catch the eye of California Impressionists. Although Joseph Kleitsch realistically depicted parts of Laguna Beach, John Christopher Smith painted scenes of villages like Cambria, Carmel, and Monterey, and William Clapp executed pointillist cityscapes, only Sam Hyde Harris really directs some of his best energies to more gritty urban subjects, like old wharfs, broken-down buildings, and city street scenes. Consequently, we get a painted archive at the Fleischer Museum of long-gone small-town simplicities, natural beauty, and astounding interplays of sea, sky, and shore. These works are old-time glimpses at an American paradise, but with the radical transformation in California's economy and society after 1941, it now is a paradise that has been largely lost, especially north of the Mexican border all the way to I-80 between San Francisco and Sacramento. Ironically, as today's tourists drive through California's urban sprawl and killer smog, they can dream of how it all was once so beautiful—calling up reveries based upon these painted images—as they stop for rest and refreshment at one of the FFCA's cleverly financed fast food operations out on the freeway interchange.

When all is said and done, the whole show here, including the Perimeter Center development complex, the FFCA headquarters building, the Fleischer Museum, and the much-vaunted "discovery" of the California school in American Impressionism, smells of big money. Money to accumulate art, money to redefine art history, money to generate new buying patterns in the art markets, money

to rediscover (or revalorize) an obscure regional collection of various assorted painters as now having unappreciated major significance. Art, then, exists here not for art's sake, but for money's sake or, even worse, for the sake of corporate business strategy or company public relations.

Much of this art has little transcendent meaning or tremendous symbolic power. It began, at best, as marketable representations of California scenery for the region's haute bourgeoisie or as advertising images for corporate capital eager to package and sell attractive visions of California and the West in their big Eastern markets. The Fleischer Museum's discovery of this genre of art simply extends the larger trends toward turning art into high-status signs of corporate self-affirmation. Mobilized for high-profile use in company image-building campaigns, the California Impressionists become decorative adornments for a young-and-hungry venture capital firm with investments all over the region so nicely illustrated by this school of painting. Rather than art, these works are reconstructed as not much more than publicity, but publicity that has assumed the rarified discursive forms of a high art genre, a new school of painting, and a fine new art gallery. In this operation, therefore, one sees in actual contemporary practice the bizarre theories of managerial merit and corporate legitimacy—so deftly bracketed and criticized by Hans Haacke in works like *On Social Grease* or *MetroMobiltan*—that developed in the United States during and after JFK's thousand days of Camelot. Arguing that American society should be judged as much by its art as its technology, economy, and democracy, President Kennedy's words were soon taken to heart by many of the same corporations that do dominate America's democracy, economy, and technology. Therefore, beginning in the 1960s, one does see much more art interwoven into the matrix of corporate assets, employee relations, company image, and product publicity.

FFCA is so extremely interesting because here (on the Sunbelt's frontiers outside Scottsdale, Arizona) its corporate use of art is so raw. As Morton Fleischer argues in his 1987 catalog, "Art and ideas are the two most enduring phenomenons [*sic*] of enduring value in man's [*sic*] life. . . . Both add immeasurably to the quality of life."[7]

Art is, of course, California Impressionism, while ideas are, quite simply, corporate capital. Fleischer continues, "FFCA, like a good painting, began with an idea. But ideas can only become successful when they are effectively executed. . . . FFCA has been my canvas . . . and much like an artist with a sound idea for a painting, my associates at FFCA have executed my ideas through concentrated effort and discipline on their part."[8] Ironically and unconsciously, Fleischer sees how his capitalist idea is, in a distorted market form, a highly socialized enterprise as he nobly goes on to thank all of his employees, managers, corporate counsel, and 100,000 investors in addition to his office supplies vendor, printer, advertising agency, title company, and banker for so efficiently helping to amass the great wealth that allowed him to buy these paintings.

While Fleischer also claims that the FFCA art collection embodies his "personal taste in art" as well as "lifts his spirits," this art always had a dead-serious purpose. Money may not be able to buy happiness, but it can buy respect. What better way to acquire an aura of sophisticated professionalism that has so often been lacking in the cowboy capitalism of Arizona's booms and busts since its statehood in 1912 than buying an impressive art collection? As Fleischer openly admits, this *is* why the FFCA art collection exists: "From the start, the idea of forming an art collection has always been with the benefit of the Company in mind. The art collection has functioned in that respect by adding credibility to our Company. I often refer to it as 'instant institutionalization.' Many of our associates come to Phoenix with the view that we are somehow less professional or sophisticated than our counterparts in the major business centers. When they enter our offices and see the art collection, their view of the Company begins to dramatically change."[9] Moreover, through the fusion of art gallery with financial service work in the white-collar factory of contemporary informational capitalism, in which firms produce and sell ideas, information, and images rather than material objects, art also becomes part of the employee benefit package. That is, as Fleischer continues, "It is my opinion that our art collection substantially increases employee morale. It creates an environment with an ambiance [*sic*] second-to-none. . . . We believe it has improved our employees' attitudes, which has increased indi-

vidual 'Espirit de Corps'; and this adds an important ingredient to business creativity and improved work productivity."[10]

Apparently, the art is very much an integral part of FFCA's corporate operations, because it does not go out much on loan for other art shows. Since it is such a key factor in employee morale and an essential aspect of the firm's marketing stance, management would, of course, be reluctant to let it travel elsewhere on exhibition. From its beginning as a formal collection in 1983, the FFCA art has had only two other public showings, at minor Western venues. After being first shown in Tulsa at the Gilcrease Museum from February 20 to May 24, 1988, the collection opened a second time at the Scottsdale Center for the Arts from January 26, 1990 to March 18, 1990, allowing time for the move to the permanent display at The Perimeter Center. Thus, as FFCA promotional literature for the Fleischer Museum suggests, this collection of California Impressionist art "serves as the cultural focal point for The Perimeter Center." And, in turn, according to the Fleischer Museum, "as a corporate environment without equal, the 261-acre Perimeter Center development has been designed with every thought to the changing demands and complex needs of modern corporate society. Embodying the ideals of a *corposphere*: an integrated work and lifestyle habitat designed to promote a positive work environment and high quality of life. The Perimeter Center is recognized as a top corporate address in the Southwest."

This almost seamless fusion of art with capital, museum with firm, school of painting with market for investment, or aesthetics with publicity still does appear to be a largely progressive addition to the Valley of the Sun's gallery scene. Nonetheless, the price of this progress can be counted in each of these artfully enforced equivalences. Once such reductions are accepted by art collectors, museum patrons, and art producers, then can any reflexive, autonomous, or critical role be discovered in any art? Or, in the corporate world, does disruptive art become potentially nothing more than an offensive adornment, bad decor, or tasteless appointments whose unsettling dimensions only rankle some mythological public hunch about propriety rather than ripping into collective mystifications with moral outrage? There are no challenging pieces, for example,

in this entire collection. Indeed, the only possible upset, which might not pass review in Cincinnati or from Senator Helms, are two paintings by Christian von Schneidau and Abel Warshawsky. The very corny von Schneidau work, *Preening*, shows a young nude woman by an open window arching her back and throwing out "her chest" to mimic a white dove preening its feathers on her windowsill. Warshawsky's *Girl in Green* is a very powerfully done Impressionist portrait of a little French girl under the shade of a tree, but her not quite closed knees show a nearly indecent stretch of white slip or petticoat under her skirt. Even in relatively unsophisticated Maricopa County, Arizona, such dangerous images will not raise any dust, because these tame aberrations are about as radical as a corporate art collection can get if it aims at attaining "instant institutionalization" or hopes to create a "lifestyle habitat designed to promote a positive work environment."

To conclude, this exhibition is an astoundingly rich collection of over two hundred works by the better-known representatives of the California school of American Impressionism. Often derided as "the eucalyptus school of outdoor painting," many members from this group of artists actually do display considerable imagination and skill at applying Impressionist principles to Western landscapes. Still, on another much more interesting level, this whole operation stands out as an astonishing display of sui generis corporate self-promotion. Using strategic capitalist agendas that ironically are at the same time so raw and so cooked, Fleischer and FFCA have reassembled discrete components of high finance, aesthetic discourse, and museum development in such an artful and artless manner that all these elements melt into a strange brassy amalgam at The Perimeter Center. This compound, in turn, virtually turns corporate public relations into its own new aesthetic genre, an experience which should not be missed by anyone interested in the late twentieth century corporation's fusion of art, capital, and power into mysterious new ideological alloys.

DEVELOPING THE PRESENT,
DEFINING A WORLD

II

8 . JAPAN—THE SHAPING OF
DAIMYO CULTURE, 1185–1868

The Ironies of Imperialism in the Empire of Signs

After a visit in the 1960s, Roland Barthes aptly named Japan an "empire of signs."[1] On the slightest cultural traces spinning through everyday life, he saw written tremendously rich and important cultural messages. His insight in turn provides here a trail into the thicket of traces in another important show of force. From October 30, 1988 through January 23, 1989, a very curious exhibition occupied a major part of the East Building in the National Gallery of Art. Entitled "Japan: The Shaping of Daimyo Culture, 1185–1868," this exhibition was organized by the National Gallery in close collaboration with Japan's Agency for Cultural Affairs and the Japan Foundation with the financial backing of the R. J. Reynolds Tobacco Company, the Yomiuri Shimbun, and the Nomura Securities Company. Its curiosity draws from many sources—the site, its timing, the presentation, its substance, the exclusivity, its visibility. As the Sunday "Show" section celebration of the exhibition in the *Washington Post* admitted, "This is cultural diplomacy at a high level: Because of the importance attached to the relationship between their country and ours, the holders of the great public and private collections throughout Japan were persuaded to relinquish many of their most valued icons for the exhibition . . . which will be seen only in Washington."[2]

Opening a week prior to the 1988 presidential election, and closing on the inaugural weekend following the swearing-in of America's forty-first president, who once flew a torpedo bomber against the Imperial Japanese Navy, the exhibition succeeded in erecting yet another cenotaph for what once was Pax Americana. For many reasons, the inescapable mystery and exotic quality of Daimyo Japanese culture evokes a strong sense of almost extrater-

restrial complexity and interpretive uncertainty. In a society whose silent majorities long ago forgot who fought whom in World War II or why, on what continents or in what oceans major foreign powers lie, and which even now cannot locate the Persian Gulf or understand why Iraq fights, an intricately layered and infinitely sophisticated history of medieval Japan was presented coldly *de novo* and in great detail. While the presentation's immense sweep was almost overpowering, and its impact often left audiences with a strong sense of feudal Japan's style and decor, it did not provide many deep insights into Daimyo Japan's actual political, economic, and social dynamics. Still, the coincidences swirling around a show like this can compound themselves in strange serendipities. And, simultaneously, other deeper meanings can emerge with a special clarity out of such chance collisions. In the late 1980s, as the mystifying veils of Reaganism fell away from the stark realities of global change, several new dynamic forces—rising in the 1980s and continuing into the 1990s—colluded and combined in an exhibition of art. Taken alone they may mean nothing. Read in one way, however, they might reveal something very suggestive about some significant shifts in the contemporary political economy of the advanced capitalist "West."

In 1980, Japan still was running a distant second or third in global rankings against the United States in most measures of economic and technological power. Yet, after a decade of Reaganism, the contradictory and ill-considered fiscal, monetary, and trade policies of the Reagan and Bush administrations are rapidly rearranging the relative rankings and absolute positions of Japan and the United States as global powers.[3] No longer a net capital or technology exporter, the United States in the 1980s saw Japan surpass it in one area after another—automobile output, high-tech innovation, consumer electronics, manufacturing efficiency, and robotized production. Throughout the 1980s, the Tokyo stock market gradually came to rival New York's Wall Street in its size and importance. The yen is challenging the dollar as the major global currency. Japanese investors are buying billions worth of American firms, land, and securities. Gradually but not imperceptibly, the world's financial, technological, and economic center of gravity is shifting out of the

Atlantic, into the Pacific basin, and toward Japan. What once was a colorful and relatively backward corner of the globe now is emerging as the new core of the world capitalist system.

On the plane of global finance, Washington now entreats Tokyo to play a greater role in the World Bank and International Monetary Fund because of its greater resources. After the shift in world capital flows and accumulation in the 1980s, nine of the ten largest banks in the world now are Japanese.[4] In the ongoing Third World debt crisis, the bottom line in the new Brady Plan is increased Japanese lending to hard-pressed debtor nations. Thousands of Japanese nationals now live and work abroad, each one a living sign that extends the reach and scope of Japan's technoeconomic empire. Japanese foreign aid and trade already exceeds that of the United States in many nations, and these trends are pushing the tides of financial power rapidly toward Japan. In the dimension of geopolitical maneuvering, the United States willingly has accepted the reassertion of Japanese military power in the Pacific, signing off on former Prime Minister Nakasone's promise to turn Japan into "an unsinkable aircraft carrier" for the Western democracies.

At the same time, Tokyo no longer is willing to buy only American weapons—employing Americans in American factories using American technology—to fulfill its defense obligations. Bowing to Japanese pressure, for example, the Reagan and Bush administrations have pledged to collaborate with the Japanese in the production of a new F-16 fighter derivative, the FSX, to supply Nakasone's unsinkable carrier. After conceding defeat in industry after industry at the hands of Japan, America's chief executives are voluntarily turning over the latest defense technology in one of the United States' last industrial strengths to its greatest competitors. Fearing that the Japanese might actually develop a better fighter plane on their own without U.S. assistance, Washington is agreeing to accept a plane deal involving 60 percent Japanese and 40 percent American content.[5] Such a deal, notwithstanding its lopsided qualities, will provide some Americans with jobs. But, more importantly and even more ironically, it also will provide the Pentagon access to advanced Japanese technology, technology that it cannot obtain elsewhere at home or abroad.

Five years, ten years, or fifteen years ago, this exhibition would not have been presented in this manner. If it had been staged at all, such a show undoubtedly would have been shown in a less prestigious space and on a much smaller scale. Like the art of a South Korea, Thailand, the Philippines, or Mexico today, it would have had a tinge of faraway places that still were not yet fully modernized—much like Japan was when Hirohito first ascended to the throne in 1927. However, it made its appearance during 1988–1989 in the premier art space of the nation as Japan's extensive economic powers translated themselves into a highly visible cultural presence to flex their political clout.

Only recently the magnificent new Arthur M. Sackler Gallery of Oriental Art opened in Washington. Yet this facility is stuck off on the less grandiose Independence Avenue side of the Mall hidden behind the old original Smithsonian Institution "Castle." It also, like the West's deep consciousness of its Asian roots, is placed mainly deep underground. While such an inauspicious architectural space may be suitable for generic displays of tribalistic "Asian" and primitive "African" art, it clearly does not have the presence or prestige of the East Building of the National Gallery on Constitution Avenue at the base of Capitol Hill. Ordinarily, one might have expected this show to have been the Sackler Gallery's first big blockbuster exhibition. However, we no longer live in ordinary times with obscure professionals exercising mere curatorial discretion in deciding where a major Japanese exhibition might appear. Instead, the immense East Building of the National Gallery on Constitution Avenue near the base of the Capitol was chosen as the site of the exhibition. This space alone carried an appropriate weight for a show such as this on the art and culture of the Daimyo era. Actually, in a fascinating reversal of the logic demonstrated by the display of Daimyo Japan, the more recent exhibition of Yokohama wood block prints *was* given deep underground at the Sackler Gallery. During a time when the Japanese equivalents of Commodore Perry and the treaty port of Yokohama are operating out of every Toyota dealership, Toshiba franchise, and Nissan factory based in America's heartland, it perhaps made more sense to recall the opening of Japan and the end of the shogunate in the Sackler's subterranean caverns of Orientalist exoticism.[6]

On one hand, very little openly was said in this exhibition of feudal Japanese culture about contemporary Japan's rising power and growing prominence. On the other hand, however, the entire show spoke endlessly about it in its silences. By showing what Japan no longer is, and what it never will be again, Japan's power gains its greatest voice in stressing images of its past. The specter of America's uncertain future also was raised uncomfortably by this conjuring of another nation's almost indecipherable past. Having spent so much of its capital and energy in modernizing the nations of the Pacific Rim, America now confronts the insurrection of hitherto subjugated cultures imposing their demands for respect and attention in Washington with blockbuster aesthetic offensives somewhere on the Mall. The art treasures of the Daimyo era perhaps are only the first probe of sappers and shock troops soon to be followed by fresh waves of future displays from South Korea, Thailand, Singapore, Taiwan, or China as they either become important economic powers in their own right or continue to be invaluable vassals in Japan's empire of signs.

Given the climate of Japanese-American relations, the urgency and significance of this tremendous cultural offensive is quite clear. Public opinion polls in February 1989 showed that over 60 percent of all Americans believed that Japanese imports into the United States should be restricted, 45 percent said that Japanese nationals must not be permitted to buy property in the United States, 80 percent wanted limits on Japanese corporate takeovers, and over 60 percent thought that Japanese firms outcompete American business by using unfair trade practices.[7] Since these attitudes have only hardened and deepened in the 1990s, the time period emphasized by the show also was not an insignificant sign. Its multilayered representation of feudal Japan highlighted basically quaint and nonthreatening images of a preindustrial, premodern, and pre-Westernized society that once had chosen consciously not to be "up to snuff" by global economic, military, or technological standards. Rather than portraying the contemporary arts of a society that has equaled and/or surpassed virtually all of the once hegemonic Western powers in the world capitalist system in a little over one century, in this show one simply gets a longer peek at the larger cultural context behind the superficial glimpses of feudal Japan hitherto provided

only in Akira Kurosawa's, Masaki Kobayashi's, or Kenji Mizo-
guchi's samurai swordplay movies.

The exhibition itself was unfolded carefully as a comprehensive
cross-section of Daimyo Japan, encompassing its entire material
and symbolic culture. Tracing the emergence of the Daimyo feudal
lords back to the Kamakura period (1185–1333), when the first of
the shogunates that would rule Japan until 1868 was established, the
presentation unfolds historically through many of the stylistic shifts
and cultural changes of the Muromachi (1333–1573), Momoyama
(1573–1615), and Edo (1615–1868) periods of Daimyo Japan. In
keeping with the ideals of the era, the show's curators took special
pains to balance equally the ways of *bu* (arts of the sword) and *bun*
(arts of peace) in the display. To present *bu*, many artistic examples
of samurai swords, sword guards, battle armor, ceremonial armor,
and warrior imagery were scattered throughout the display rooms.
And, to illustrate *bun*, very elaborate examples of calligraphy, ink
painting, poetry, and court rituals were shown in their many varia-
tions from the Kamakura to the Tokugawa shogunates. The re-
ligious dimension, in particular, was given close consideration.
Numerous images of Buddhas, Shinto divinities, and Zen priests
were marshaled to display the ambiguous but powerful spirituality
of Daimyo Japan.

Augmenting these artifacts of war and peace, the exhibition also
gave detailed attention to the decorative arts, architecture, screen
painting, and costumes of the Daimyo era. The mastery of medieval
Japanese ceramics, lacquer ware, silk weaving, and screen art all
received their appropriate recognition. Most importantly in this
regard, the Japanese government included three of the nation's most
valued national treasures to round out the showing of Daimyo art.
The paintings of Minamoto Yoritomo (1147–1199), Kanesawa Sa-
damasa (1302–1333), and Hojo Sanetoki (1224–1266), which hung
prominently in the first rooms of the exhibition, never had left
Japan before. Their inclusion, of course, was the critical sign of
Japan's own perceived closeness to the United States as well as its
ultimate aesthetic entreaty for greater respect in Washington as an
ally and vital cultural force.

Nonetheless, the extent of Japan's new economic and techno-

logical dominance in the 1980s and 1990s seeped out of every crack and crevice of this exhibition right down to its material modes of aesthetic production. Basically, like any colonized Third World country, the United States provided only the physical site, cheap labor, and mass audience to stage the exhibition. Virtually everything else, save, of course, a few raw materials, came "Made in Japan." Beyond the art treasures and cultural artifacts themselves, the documentary films, air transportation, printed guides, financial backing, and elaborate catalog were essentially all Japanese, leaving American gallery-goers to silently bob through the displays, nodding in bemusement and listening to the guest curator's, Yoshiaki Shimizu's, acoustiguide tour on Japanese minicassette players.

Finally, the exhibition also included brief treatments of No theater, the Zen aesthetic of Japanese gardens, and the art of the tea ceremony. Full-scale replicas of a No stage and the Ennan teahouse with a fragment of its grounds and garden brought these aspects of Daimyo culture into three-dimensional verisimilitude. During the exhibition's run, live tea ceremonies were staged daily, and No theater performances were held every other day, as vivid testimonies of performance art/anthropology to lend even greater lived reality to the vital significance of this household rite and such dramatic traditions in aesthetic, spiritual, psychological, and social terms. The subtexts were crystal clear: a complex medieval aesthetic was reduced and recast into a positive modern ethnography only to be sold as a brightly wrapped bit of bridge-building cultural insurance. The arcane ritual and obscure symbology of tea ceremonies or No dramas, it suggests, are the "real" core of Japanese life and values, not buying real estate, movie studio takeovers, or transplanting automobile factories in the United States. Thus Japan the economic superpower is shown as merely a thin veneer, which has been laid over the solid core of traditional Nippon only recently, hiding "the real Japan" that still can be (or must be) ritualistic, underdeveloped, and mystical in the eyes of Western audiences.

The time period captured by the Daimyo exhibition, or 1185–1868, reveals an essentially continuous civilization unfolding under the tight control of landed military lords. During the same centuries that Europe was experiencing the Renaissance, the Reformation,

the discovery of the Americas, the Enlightenment, and, then, the Industrial Revolution, Japan's military dictators successfully contained virtually all foreign influences from either Asia or Europe while maintaining the indigenous culture, economy, and society of their feudal society. Yet, ironically, as the show suggests, it was this same cultural foundation that has provided much of the basic strength behind Japan's rapid industrial modernization since Commodore Perry "opened" it up to the global capitalist economy in 1853. Despite the institutional reforms brought on by the Meiji Restoration in 1868, the inner spirit and essential substance of Japanese life during the last century remains deeply embedded in many Daimyo traditions. Although he died with his postwar image as a secular leader gathered tightly around him, Emperor Hirohito spent the first decades of his reign on the Chrysanthemum Throne in the Shinto holiness and militaristic trappings of feudatory imperial power. Reflecting the influence of America's post-1945 reconstruction of Japanese political practices, Emperor Akihito has been schooled completely in the modern mediagenic styles of personal power. Nevertheless, the unique spirit of national unity, devoted service, and disciplined hard work that still anchor Japan's newfound power are all traditions rooted in the practices of Daimyo culture.

Living in a world where everyday life increasingly is colonized by the corporate products of Toyota, Sony, Nissan, Mitsui, Honda, Toshiba, and Mitsubishi, it is comforting to most Americans to see the authentic signs of this "other Japan," replete with the tokens of No theater, samurai armor, Shinto priests, bamboo teahouses, and Buddhist temples. The Japanese recognize this reality, and they plainly seek to manage it as artfully as possible as one more province of their empire of signs. As a result, alongside the news hole in the pages of the *Washington Post*, which usually was filled daily in 1989 with the latest scoop on the FSX fighter deal, the Liberal Democratic party's Recruit stock trading scandal, the worsening trade imbalance with Japan, Hirohito's slow death from cancer, and the threat of Japanese supercomputers, the entire run of the Daimyo show was touted weekly with a full-page, front-section photo ad anchored by a painting of a fourteenth-century samurai warrior. This comfort-

able image continued to broadcast the "safe" mental picture of Japan that most Americans actually want to keep forever—colorful, exotic, anachronistic, backward, quaint, feudalistic.[8]

This art exhibition, its setting, the sponsors, and its particular context, then, are vital carriers of complex meanings above and beyond the simple exhibition of feudal Japanese art and culture depicted in the show's catalog or publicity. Over the past few years, an entirely new transnational economic and political order has emerged in the Pacific Basin. Based upon the weak fusion of Japanese industrial productivity and American military power, some see a new (but still divided and conflicted) state and civil society in the workings of this strange partnership between Tokyo and Washington. With the growth of Japan's new financial hegemony, however, Tokyo now has the resources to begin translating some of its economic power into cultural display and hegemony. The one last remaining redoubt of American power during the last two decades has been its unstoppable cultural vitality. By the same token, the major flaw in Japan's technological and economic prominence in the 1980s has been its cultural limits: shows like this one provide fresh opportunities to make up for these deficiencies and push toward becoming a global cultural force as well. This exhibition, then, comes at an auspicious turning point in American and Japanese history. As the mass electorate chose what will undoubtedly be its last World War II era president (former U.S. Navy pilot George Herbert Walker Bush) and its first baby boom era vice-president (Senator Dan Quayle), the old imperialistic enmities that once divided Japan and America are fading. Nonetheless, fresh transnational antagonisms—based on trade, finance, and technology disputes in the 1980s and 1990s—threaten to split the two nations' close forty-five-year-old alliance.

Public opinion polls conducted in the United States during February 1989 on the eve of Emperor Hirohito's funeral showed that 54 percent of Americans named Japan as the "strongest economic power in the world today."[9] Similarly, 40 percent felt Tokyo was a much greater threat to the United States than Moscow. Even so, 70 percent were still positively impressed by Japan, and 60 percent continued to see it as a very reliable American ally.[10] This, then, is

the question. Do these aesthetic displays of Daimyo civilization represent the further solidification of a trans-Pacific zone of Japanese-American coprosperity or do they mark the last gasp of a dying alliance now trying to postpone its final collapse through grandiose shows like this? Here art consciously is mobilized as an ideological tool to communicate many messages on many levels to many audiences. On one level, this exhibit clearly is one of the first, biggest, and strongest signs of some coming Japanese cultural imperialism that now is poised to follow on behind the tides of Japan's well-entrenched financial and technological imperialism. Fully funded by a consortium of major Japanese banks and industrial conglomerates, the exhibit had the weight of their clout to open the spaces of the ever conservative and uninnovative National Gallery of Art to an essentially historical, if not anthropological, display of medieval "national treasures and art objects" from Daimyo Japanese culture.

On another level, contrary to his rhetoric about bringing America back from its dark days of military defeat and failed diplomacy in the 1970s, President Reagan watched over and largely approved of this unprecedented expansion of Japanese power in the 1980s. As a California politician ever mindful of the growing importance of Pacific commerce in the West Coast economy, Reagan cultivated close ties with Prime Minister Nakasone. Alternately cajoling and wooing the Japanese, the Reagan administration saw Tokyo as a critical variable in the changing equations of American world power. Without Japanese investment, American macroeconomic policies would collapse. Without Japanese consumer goods, many American consumers would go wanting. Without Japanese industrial expansion in the United States, America's employment and productivity would drop. Without high-technology Japanese components, even America's front-line, first-generation weapons systems would be useless. While Reagan's media managers cast Reagan's two terms as the revival of American economic autonomy and political authority in 1980 and 1984, it was readily apparent in the hollowing out of corporate America throughout the 1980s that this too was as much of a mirage as Reagan's willingness to seek peace in Central America, give real help to American cities, or balance the federal budget.

Despite the recalcitrance of these realities, Reagan also recognized that Japan and the United States must work in both directions on a two-way street. Without American markets, Japan's economy could go into a tailspin. Without American military power, Japan's access to global resources and markets could collapse completely. And, without American economic prosperity, Japan's producers and consumers would lose their main overseas market with its strong promise of continuing economic growth. Although many Japanese see their national economy as more innovative and competitive than America's, they also recognize that their individual enjoyment of its wealth falls far short of American standards of living.

Japan's power now is so immense that it even can bribe sitting American presidents to lend their aura or sell their dignity to dress up a home islands extravaganza. When Emperor Hirohito finally died on January 7, 1989, President-elect Bush agreed almost immediately to represent the United States in Hirohito's elaborate state Shinto funeral. After the animosity that marred the early years of Hirohito's *Showa*, or Enlightened Peace, era with war, the quite recently inaugurated President Bush gladly attended the February 1989 funeral rites to start off Emperor Akihito's *Heisei*, or Achievement of Universal Peace, era on a much more positive note as well as to provide a final seal of approval of Japan's full reintegration into the world community. Bush's visit was meant to be a key sign of Washington's regard for its Tokyo ties, and Tokyo enthusiastically touted these signs with exactly this spin on their significance.

Likewise, in October 1989, former President Reagan gladly delivered two speeches and served as master of ceremonies at the "Premium Imperiale of the Arts" in Japan for the Fujisankei Communications Group. Fronted by Charles Wick of the United States Information Agency during one of his last official junkets abroad in October 1988, the deal was signed, sealed and delivered in February 1989 for about $2 million. For a former big-business shill for General Electric, this well-paid gig was nothing new. Again, in this trace, one can read the shifting patterns of influence, prestige, and authority. Ronald Reagan does not "need" the money, even though this $2 million for one week's service exceeded his public pay for two terms as president. Apparently for one more time in the global

limelight, this bringer of "Morning Again in America" let himself be imported, like American lumber, copper ore, wheat, or crude oil, as yet another commodity for Japanese consumption from *Beikoku* (or America, "the rice country"). Such pilgrimages, then, by American presidents to pay respect to Japanese princes—both state and corporate—perhaps are some of today's best signs of the new dawn for a Pax Nipponica.

Exhibits like this one are freeze-dried helpings of cultural understanding packaged and presented by their sponsors to provide the "right" picture in art and culture, which, in turn, might further cement some crucially important transnational political bond. Everything Japan was, had become, and is today was on display and up for appraisal in the glass cases and display rooms holding the Daimyo artifacts. And, with Akihito's new era unfolding a new logic of Japanese power, the stage is set for a profound cultural transformation. The Daimyo exhibition staked out some of the new fault lines of shifting world hegemony in the signs of arcane medieval art and culture. Like many sea changes, it surfaces first in such a concatenation of coincidences, each trace pointing to some small aspect of significant change that might otherwise float by unnoticed or unremarked upon.

"The Pride Is Back"?

In an age in which "Made in Japan" (or Hong Kong, Taiwan, South Korea, or Mexico) often has come to outweigh "Made in U.S.A." in both quality and quantity, the organizing logic behind a show with this title once again proves the truth of Hegel's well-worn dictum that Minerva's owl flies only at dusk.[1] However, it is a night in which, unlike Schleiermacher's cows, all American art from the 1950s and 1960s is—explicitly or implicitly—red, white, and blue. The "Made in U.S.A." exhibit which in 1987 worked its way back east from the West essentially celebrated a now long-gone America before its "fall" in the 1970s—Vietnam, Watergate, and the oil crisis. Even so, the display had a remarkably dead, museumological quality to it inasmuch as the confident, globally hegemonic America it celebrated is, in most respects, dead.

According to the narrative presented by Sidra Stich in the exhibition's catalog, one must correct the severe false consciousness of this era that is shared by art historians and critics, who "have not yet set this body of work in a cultural context that elaborates upon the nature and significance of its iconography."[2] This exhibition about the 1950s and 1960s showed the artists who were working at that time as players in a vast historical theater that powerful, unseen social forces were scripting as part of the unfolding of "Americanization." In turn, the art works of the time were presented as emblems of this particular era, set into five different thematic lines, framing the display of the works—American Icons; Cities, Suburbs, and Highways; American Food and Marketing; American Mass Media; and the American Dream/The American Dilemma. Passing through the rooms one sensed an uncomfortable aura of presumption, because the exhibit largely decoupled the old "col-

lapse of modernism" era 1950–1970 from the new "postmodern" era in a manner that severed most ties and many continuities. From the ashes of that golden era of Eisenhower and Kennedy, the curators exhumed and exhibited tatters and smatters which summed up that ancient Atlantis known to them as "the U.S.A. in the '50s and '60s." From this inspiration, the show became an anthropological disquisition conducted in aesthetic terms with individual art works entered into evidence to make essentially ethnographic, moral, and political claims.

The opening section of the exhibition centered upon the theme of "American Icons" to examine how artists have portrayed American symbols in the postwar era. More specifically, American icons were defined as conventional images and symbols appropriated from America's civic traditions in the new critical and ironic art works of the 1950s and 1960s. The initial and most important example was Larry Rivers's *Washington Crossing the Delaware* (1953), which deconstructs Emanuel Leutze's famous 1851 work into an incohesive smattering of obscure figures around a non-Olympian, "humanized" Washington. In the context of McCarthyism and the Korean War, Rivers presented a painting with the proper "patriotic" subject, but he did it with subverted and doubtful tones. Rivers remained within the broader idioms of American civic culture, while recharging one of its central idealistic icons, the cultic image of George Washington, in new, downsized, accessible, secularized codes of presentation.

Reflecting perhaps the larger population's ambivalence about its imperial responsibilities, American artists in the postwar era consciously rejected the pious celebrations of "American Life" so carefully orchestrated in the "capitalist realism" of Norman Rockwell in the *Saturday Evening Post* or the literalist photojournalism of Henry Luce's *Time* and *Life* magazines. Instead, they created provocative but comprehensible works that secularized and deenergized the super patriotic potency of civic symbols. The American flag, George Washington, District of Columbia monuments and buildings, presidential portraits, and the Statue of Liberty were reduced in this art to soft, commercialized signatures for a new consumerist culture rather than retaining their traditional meaning as rigid, politicized totems of a capitalist republic.

Once Jasper Johns, Claes Oldenburg, and Tom Wesselman reduced the Stars and Stripes to post-red-white-and-blue art objects of sculpmetal, scrap wood assemblages, and backdrops for nude studies during the Eisenhower era, it was only a few short steps more in the Johnson years to Old Glory's being sewn across the backsides of hippies' dungarees, slapped over pick-up truck windows as a sunscreen decal for rednecks, and stuck onto safety helmets, like a tourist's bumper sticker, for hardhat steelworkers. In being given these mundane assignments, such civic symbols can be mobilized continuously by corporate or organizational interests to stand for whatever meanings these self-interested parties assign to them. Yet, at the same time, there is a cost involved for the community in such secularizations of its symbols. When these images are dislodged from their highly charged political settings, as with Andy Warhol's *Statue of Liberty* (1963) or Richard Artschwager's *The Washington Monument* (1964), they become standardized, replicable, neutral signs with little instrinsic symbolic content, which then float in obscure, gray hazes of ill-defined fuzz in the collective memory.

Above and beyond the flag, images of the American presidency also have been remanufactured as central icons in American life. Tom Wesselmann's *Still Life #31* (1963) combines a black and white TV set, Gilbert Stuart's portrait of George Washington, and a Middle American interior with a fruit basket, houseplant, and steam radiator looking onto rolling hills and farm fields. Even though Wesselmann's image hints at European still life motifs, everything in it still serves as a frame for the TV, which is the real core of the American experiment—the electronic mediation of material bounty. Robert Rauschenberg's 1962–1964 silkscreen painting series is one of the first, and still one of the best, attempts to articulate these forces in art. By the same token, the presentation of Presidents as primary markers of historical and cultural change also shows up in Robert Rauschenberg's *Retroactive I* (1964), one of the works which capped this entire series. It casts JFK as the primary sign of the new media-driven, space-bound, consumer-directed frenzy of modern American life in a collage of unrelated images—an astronaut, nudes, construction workers—that mimics an evening news broadcast in its discontinuities and graininess. James Rosenquist's

President Elect (1960–1961) fuses JFK's face with a cake mix promo and the Chevrolet fender, suggesting the president's place as a historical signifier and packaged commodity, whose presence is not much different from those commercial images pushed in the changing yearly parades of food or auto ads.

On a par with the president as an icon, Tom Wesselmann's *Great American Nude #8* (1961) colorfully illustrates the fusion of good, clean sex with wholesome American patriotism in the 1950s and 1960s. Wesselmann's nude openly imitates Varga's perfect airbrush nudes or Hugh Hefner's immaculate touched-up nudes, which gained great currency in the post-1945 era. Sprawled across a red couch on a blue pillow below a white curtain, she is blond, curvaceous, and faceless—the ideal, commodified sex object. Yet she also rests under a field of stars, the Great Seal of the United States, and Old Glory itself, suggesting the real centrality of intense sexual images in the trendy soft-sell of contemporary American commerce.

This preconception of America as a vast, polygot but loosely unified "consumption community" also pervaded the works assembled in the section structured around "American Food and American Marketing." The exhibition spotlighted American food and the corporate infrastructure for production and distribution, because, as Stich observes in the catalog, "hamburgers, hot dogs, french fries, corn on the cob, ice cream cones, popsicles, Coca-Cola, Campbell's soup, and corn flakes are decidedly American foods enjoyed by a great majority of the population regardless of age, class, sex, or geographical location. Such foods are signatures of America culture, evidence of popular taste as well as culinary customs, and skill in advertising and marketing."[3] Accepting this breezy generalization (which could have been lifted straight out of any typical food page celebration of American junk food) as fact, the exhibition set out the expected Thiebaud, Lichtenstein, Oldenburg, Wesselmann, Westermann, Rivers, and Warhol works for the visitor's enjoyment and edification. Their hot dog studies, hamburger portraits, diner fare still lifes, and dessert sculptures all were displayed, because allegedly these foods are the generic emblems of American culture.

More importantly, this section of the exhibit also examined the role of food products in America as useful media in the commercialization of everyday life. As slickly packaged commodities, food products are both material satisfactions for human hunger and symbolic gratifications of collective myths. In particular, works like Andy Warhol's *Soup Cans* (1962), *210 Coca-Cola Bottles* (1962), or *Brillo, Campbell's Tomato Juice,* and *Kellogg's Corn Flakes Boxes* (1964), H. C. Westermann's *Pillar of Truth* (1962), Larry Rivers's *The Friendship of America and France (Kennedy and De Gaulle)* (1961–1962), or Tom Wesselmann's *Still Life #24* (1962) and *Still Life #30* (1963) ironically re-emphasize how Coke bottles, Campbell's soup cans, and Kellogg's cereal boxes have become the central symbols of America itself. They are as recognizable and perhaps even more potent than the red, white, and blue or George Washington. Whereas most people today associate Lenin or the hammer and sickle with the Soviet Union, a Coke bottle or Marilyn Monroe or the Ford logo are accepted legitimately as *the* definitive signatures of America. These works express both the material promise and spiritual emptiness of America in the 1950s and 1960s. Although America could deliver a tremendous bounty of different goods to the market, the commodity-image had so penetrated the psychic spaces of the society that now, ironically, even refunctioned or parodied consumer packaging can be accepted as setting new standards of aesthetic beauty, national identity, and cultural meaning.

Richard Estes's *Food City* (1967) and *The Candy Store* (1969) document this conflation of commercial corporate marketing plans and the personal conduct of everyday life in his photorealist store displays. In these paintings it is clear that only by floating within the shiny surfaces and filmy promises of marketing's smoke and mirrors can the consumer find his or her real satisfaction, and at bargain prices in an endless array of specially marked items. The transparent and meaningless boundaries of self and society, ego and economy, being and buying attain complete clarity in Estes's images. Like Delacroix's revolutionary studies done in the afterglow of empire in France's Orleanist interregnum, Wesselmann's still lifes of Middle American kitchen interiors, like *Still Life #24* and *#30*, present corporate commodities as the real heroic figures of the postwar era.

Larger than life, perfect in form, marching in unison, 7-Up bottles, Dole pineapple cans, Tareyton packs, and Del Monte asparagus tins bear the true shapes (and false promises) of mass consumerism to America and the world. It can be a true utopia of complete material satisfaction in bright, attractive packaging at reasonable prices with brand quality in light, modern spaces, if only everyone accepts the packaged scripts of corporate capitalism into their most personal moments in the kitchen, living room, or bedroom.

The transformation in American urban life from highly concentrated industrial centers to a lower density, freeway-structured suburbia was documented fairly well by the thematic section of "Cities, Suburbs, and Highways—The New American Landscape." The chaotic frenzy of congested high-rise cities is presented by Romare Bearden's *Childhood Memories* (1965), Robert Rauschenberg's *Estate* (1963) and *Choke* (1964), and Red Grooms's *One Way* (1964). These collage, oil and silkscreen, and oil works present urban life—before or beyond suburbanization—as a dense mass of people, cars, signs, buildings, swarming with frantic energy. Yet such cities were doomed after 1945. As the nation expanded the interstate highway system, provided cheap gas and low prices for personal autos and private homes, and dismantled old city centers in urban renewal programs, American society itself headed out on the highway. And the highway, the automobile, gas stations, suburban streets, and single-family homes emerge as the new markers of modernity. In its search for major icons, the "Made in U.S.A." exhibition gathered together a cluster of works tracking this shift in perspective. Richard Artschwager's *High Rise Apartment* (1964) shows an old-wave urban ziggurat as it floats bizarrely in its frame, a gray ghostly semblance of a fading way of urban life with no grounding in the street. Similarly, Artschwager's *Untitled (Tract Home)* (1964) simply shows a postwar three-bedroom, two-bath love nest set in a new suburban neighborhood, filled out with landscaping and finishing details. It too is done in a sepia haze, but its image is growing in clarity as it becomes more dominant in everyday life. Likewise, Richard Estes's *Welcome to 42nd Street (Victory Theater)* (1968) and *Gordon's Gin* (1968) are stark, colorful photorealistic images, largely devoid of life but vividly perfect, like the momentary flashback to

one's old downtown neighborhoods. Joe Goode's *November 13, 1963* (1963) and *The Most of It* (1963) also envision the suburban tract dwelling centered in large monochrome panels, like the spot of light in a long dark tunnel, as one approaches it in the future. Yet, these panels suggest that the house might be the isolated cage or tiny trap of millions' dreams as they drive in and out of their bedroom ghettoes everyday on the suburban treadmill, although Robert Arneson presents the suburban dream in *1303 Alice Street, Viewed (As If It Were a Billboard) from the Corner of L and Alice* (1968) as a grandiose retreat, gloriously unto itself, stretching out in a parklike yard with a basketball backboard and family van.

The other sacred object of contemporary America—the private automobile—was shown best by Robert Bechtle's *'60 T-Bird* (1967–1968). There, in front of a typical suburban home, the idealized image of "a truly satisfying personal luxury car" (the Thunderbird by Ford) is displayed by its proud owner out on a beautiful day. Although the precise, flat literalist composition connotes the banalized myth behind this mass-produced dream, the painting perfectly mimics the millions of snapshots taken of such automotive totems to give some meaning or purpose to the shallow lives of those dim souls who display them.

In turn, it is the auto and its needs that increasingly structure the daily routines and visions of contemporary Americans. Rather than gathering collectively on town greens or city squares, Americans now stare out of their car windshields at life on the interstate. John Baldessari's *Looking East on 4th and C, Chula Vista* (1967) or Vija Celmins's *Freeway* (1966) illustrate very well how the automobile windshield is now a special screen, revealing unique new visions of the world. For the motorist, gas stations and their products provide oases on the road, offering a few minutes' rest, a fill-up, and automotive services to keep the entire system in motion. George Segal's *Gas Station* (1963), *The Bus Driver* (1962), or, in this exhibition, *Man Leaving a Bus* (1967), for example, marks this shift in focus, to the road and its importance in daily life. But Edward Ruscha's gas station works, like *Standard Station, Amarillo, Texas* (1963), truly epitomize the gigantic, spectacular or heroic vision of service stations to America's postwar motorists, playing off of the corpora-

tion's advertising, consumers' needs, and the power of big oil in the 1950s and 1960s. Indeed, Allan D'Arcangelo confounds a Gulf sign with the full moon in *Full Moon* (1962) and a Sunoco and U.S. Highway 1 sign with spiritual presences in *U.S. Highway 1* (1963). In these works the luminous signs of big corporations and the federal government preside totally over a dark, empty highway. No people are present; but, when they are, they follow paths leading nowhere. For the duped millions who hurtle down the roadways every day under the gaze of big oil and big government, the beauty of a full moon may be almost as compelling as a big Gulf sign.

Many of the most interesting images in "Made in U.S.A." were gathered in the "American Mass Media" sections. The radical changes in the way individuals see the larger world amidst the mass media were examined thoroughly in several artistic treatments of electronic and print journalism as well as ordinary television programming. The myth-making and hero-constructing potentials of the media are represented well by Mel Ramos's *Superman* (1961) and *The Phantom* (1963–1964), Andy Warhol's *Superman* (1960) and *Triple Elvis* (1962), as well as Roy Lichtenstein's *Popeye* (1961) and Ray Johnson's *James Dean* (1957). Each of these works portrays these fictional or celebrity media heroes as "larger than life" embodiments of great courage and strength. Yet, like Johnson's *James Dean*, which shows Dean with Mickey Mouse-like ears made out of Lucky Strike emblems, each of them also hints at the marketing-based manufacturing of these images as efficiently packaged symbolic commodities.

The vacuous nature of the mass media, at the same time, is marked by works ranging from Vija Celmins's *T.V.* (1965) to Edward Kienholz's *Six O'Clock News* (1964) to Edward Ruscha's *Flash, L.A. Times* (1963). Celmins's gray-toned image of an airplane breaking up in midair reproduces the black-and-white sameness of violent images reduced to a neutral nothingness by television's endless repetition of them. Kienholz's mixed media sculpture portrays an impressionistically styled portable TV with immense rabbit ears pulling in an image of a smiling Mickey Mouse. The packaged pap of network news and the innocuous banality of entertainment programs are conflated here into the same image of a blank-faced Disney

character, posing as a serious journalist. Ruscha's painting, in turn, depicts an immense yellow FLASH on a green background, promising a bulletin of great significance; yet it only delivers a small, upside-down fragment of Dick Tracy from the Sunday comics. The pretense of the mass media conducting serious political debate or intellectual discourse, then, is put into doubt by such art as it spotlights the media's ideological functions as hyped-up spectacle.

The role of the media as new modes of ideological control, however, probably is best represented in the Marilyn Monroe icon in post-1945 American art. Like George Segal's *The Movie Poster* (1967), which depicts one of his plaster people intently staring at a movie poster of Marilyn Monroe, the movie fan-Marilyn Monroe relation typifies the relationship of all media consumers to the mass media spectacle. Just like the poster viewer constructing his own personal vision of Marilyn from the limited but highly stylized information in the poster and his own psychosocial needs, the media work through their consumers co-producing loosely planned ideological effects from their many messages. Ray Johnson's *Hand Marilyn Monroe* (1958) shows an immense upraised hand, shielding, patting, forming a calendar art image of Marilyn in a bathing suit on a background of gathered strips. The pink color, Marilyn's pose, the strip effect in the background highlight the artificiality of Johnson's image, but it also stresses what ultimately is the very personal construction of her image by each individual in this carefully coded way. She is posed in this calculated "sexy" manner, but her fans collaborate in this presentation, forming her image now to fit their continuing expectations that have been set by her previous presentation. Willem De Kooning's expressionistic rendition of her—*Marilyn Monroe* (1954)—telegraphs out the same code. In many respects, Marilyn Monroe essentially represents, as De Kooning's painting shows, a particular cluster of body part images—big eyes, blond hair, full breasts, smiling full lips, broad hips, long legs—swirling together in bright colors. This image summarizes the real nature of media celebrities not as "real people" but rather as conceptual collages of self-identified but mass-produced attributes that media consumers piece together for themselves in flickering mosaics of meaning.

This strange fusion of identical mass production and the unique personal reception in mass media images is made even more clearly in Andy Warhol's *Twenty-Five Colored Marilyns* (1962) or *Marilyn Monroe's Lips* (1962). In these works the basic image of Marilyn's head or lips is "the same," but also uniquely different. In each of the replications, color blotches and poorly registered lines change the basic outline of her face and lips. Each image clearly varies in color, lining, shape, or impression, if only slightly, from each of the other ones. Warhol shows how repeated exposure leads to saturation. Still, even with this overexposure, each image is markedly different as each individual consumer forms a personal reception of Marilyn Monroe in his or her special understanding of her, decoded from television, film, or print images.

Only in the final section of the exhibit, "The American Dream/The American Dilemma," did the examination of post–World War II America begin to reconsider some of the crises and contradictions in modern American life. Allan D'Arcangelo's *Can Our National Bird Survive?* (1962) shows a bald eagle flying against the path of an arrowlike sign on a stars and stripes background that is turning black and blue. The eagle, as it flies against the tide, looks more like a mean, scavenging buzzard than a noble national symbol. A proud eagle's head and one solitary star dominate the painting with the stencil-font caption, "Can Our National Bird Survive?" Implicitly, the rise of militarism and interventionism in the 1950s and 1960s is cast as forces reducing America the proud eagle to America the craven vulture. D'Arcangelo repeats his doubts in *U.S. 80 (In Memory of Mrs. Liuzzo)* (1967), which shows a bullet-riddled U.S. 80 sign against a dark blue and black landscape, all covered with blood stains.

This questioning of America also dominates Robert Indiana's works, like *The Demuth American Dream #5* (1963) and *Alabama* (1965). In these paintings Indiana satirically apes the bright, Day-Glo packaging of mass-marketing imagery to attack the underside of the American dream. The formulaic quality of American mass culture—the American Dream, 1928–1963—is highlighted in four words—DIE, EAT, HUG, ERR. Charles Demuth's *I Saw the Figure Five in Gold* (1928) provides the style and composition of five panels

locked into a cross. In orange, red, and yellow, the expression AMERICAN DREAM, 1928–1963, surrounds a huge star and "5" in the center panel, while in the other panels—DIE, EAT, HUG, ERR— encircle the stars and 5s. Here, Indiana is regretting the simple psychosocial logic of advertising in America that reduces life to one-word commands. Similarly, in commemorating the brutal racial conflicts in Selma, Alabama, he places a map of Alabama done in pink inside two concentric circles with stencil-print lettering. A cross of red stars falls across the map and the two circles, marking Selma in a star. The inscription is not very flattering, namely, JUST AS IN THE ANATOMY OF MAN EVERY NATION MUST HAVE ITS HIND PART. And, anchoring the whole image, ALABAMA is printed out in the same stencil fonts at the bottom of the painting. Playing off meanings set by corporate logos and product posters, Indiana casts southern white racial attitudes with complete disgust into an anatomical dead (end) zone unworthy of association with the rest of the nation.

The centrality of the police in the racial violence of the 1960s is powerfully identified by May Stevens in *Big Daddy Paper Doll* (1968) with the repressive power of the white-controlled state. Big Daddy is a ghostly white figure with a bulldog image imposed on his body and in his face. His various costumes, in turn, are those of a KKK-like executioner, a soldier, a cop, and, apparently, a blood-splattered butcher, which all are the changing guises of the oppressive white power structure at home and abroad. The flip side of this American dilemma surfaces in Ed Paschke's *Purple Ritual* (1967). The Americanness of the power signs used in *Big Daddy Paper Doll* continues in Paschke's framing the famous *Life* cover photo (February 21, 1964) of Lee Harvey Oswald sporting his revolver, mail-order rifle, and Trotskyite newspaper with red, white, and blue bunting and four eagles holding Union shields. For both the forces of "order" and "disorder" in postwar America, power comes from the barrel of a gun.

The other dilemma accompanying the American dream in the 1950s and 1960s, in addition to violence at home, was the growing importance of the military and its use abroad, which now is entering its third generation of mass acceptance. Edward Kienholz in

O'er the Ramparts We Watched Fascinated (1959) plays upon "rocket's red glare" and "bombs burst in the air" connotations of "The Star-Spangled Banner" to display an assemblage of melted electronic components, mutilated doll bodies, and a scorched Union shield embedded into a black background. It mocks the American public's fascination with its nuclearized military's spectacles of power, while showing what must be the ultimate outcome of SAC's final countdowns. The Orwellian struggle of two over-bureaucratized superpowers in the post-1945 era is very well summed up in Neil Jenney's *Them and Us* (1969). In it, two stylized fighter bombers—an American F-106 and Soviet MIG-21—are painted in a dog-fighting fly-by, heavily loaded with bombs and rockets. The continuing struggle of the capitalist and communist superpowers, frozen into an ongoing display of their hot destructive powers in a cold but still competitive war, is made very clear. It shows how both nations perpetually sacrifice their best technological talent and rich bounty of their economies to this sterile display of their deterrent capabilities.

The impact of these transformations on America itself are depicted clearly in Llyn Foulkes's *Death Valley U.S.A.* (1963) and Jess's *The Face in the Abyss* (1955). The America of purple mountain's majesty and fruited plains is shown by Foulkes in Death Valley desolation bordered with a yellow and black danger marker strip on two sides and a belt of spread-winged eagles clutching scrolls with "U.S." on them in their claws. The painting also has scrawled across it, "This painting is dedicated to the American," and jiggles of a vandal's graffiti. The image evokes a prevision of a burnt-out hydrogen bomb crater and the nuclear-winter sky laden with ash rising behind it. Equally disturbing is the ominous apparatus of domination that Jess projects against what looks like a waterfall in Yosemite Canyon. As a bomber wing laden with huge barrels and tiny cranes skims the image, a mechanical head formed out of rotors, driveshafts, gears, and magnetos, but capped with the Statue of Liberty's spiked crown floats against the canyon's cliff face. Miss Liberty (America) now seems to be a robotic "Metropolis" maid dedicated to an authoritarian order of military might and technological growth.

The ambiguity and ambivalence of the American dream, which

also constitutes the American dilemma, probably was best summed up in five very different works. Robert Rauschenberg's *Tracer* (1963) taps the violent but brilliant light of a tracer bullet (the brief American century?) or the identical reproduction of objects in a tracing (the spreading confusion in American public life at the end of the Kennedy years) in a collage of images. A Rubens nude gazing into a mirror, two army helicopters above some jungle landing zone, a bald eagle, a busy street scene with a Coke/cafeteria sign, two caged parakeets, and two floating empty cubes all are jumbled into a white and blue wash of change. Is America merely a self-absorbed and overindulged beauty, a teeming consumerist frenzy, an empty bloc of power in the West opposing another hollow bloc of power in the East, an interventionistic bully lighting into another nation's affairs via airborne assaults, or its old democratic self—the proud bald eagle at the painting's center?

Bruce Conner pursues a similar sense of decay in his *Untitled* (1954–1962) collage. On one side, a rag-tag assortment of junk slapped onto the canvas questions the existing canons of social organization or taste in the current system, while on the reverse side there is a complex collage of bizarre soft porn nudes cut from 1950s "men's magazines." Yet these many strange nude photos also are stamped with consumer-confidence-building seals of approval— "Good Housekeeping Seal," "Certified Washable," or "Examined by No. 1"—and red warning signs—"Weird Tales," "Fragile," and "Warning—You Are in Great Danger." Here Conner is satirizing the sleazy sexuality and moral hypocrisy of the squeaky clean 1950s image, even as he warns everyone about the growing moral deterioration they seem unable to see around them.

Duane Hanson's *Motorcycle Accident* (1969) is a life-size reproduction of a teenage boy on a motorcycle smashed into the pavement— a human roadkill. As the postwar material incarnation of unrestrained freedom, beginning with Marlon Brando in *The Wild Ones* (1954), the motorcycle is a very potent symbol. Interestingly, Hanson's sculpture appears in the same year as *Easy Rider*, which also shows two freedom-seeking American motorcyclists smeared across the road in violent deaths. This hyper-realist structure simulates a shocking, bloody reality in a frozen aesthetic assembly of a

fiberglass figure, a real motorcycle, and an assortment of battered mechanical components. Like America, perhaps, it represents the inevitable outcome of going too fast, ignoring the warnings, grasping too hard at youth, idolizing speed and power. Unless we (America) note this warning, the (fatal or crippling) crash assuredly will occur. And, ironically, as the sculpture tacitly prophesies, the means of the crash (a Honda motorbike from Japan's first invasion wave of consumer goods) will not even be "Made in U.S.A."

The violent nature of the American dream, and its denomination in mass-mediated images, gains critical clarity in Wallace Berman's *Untitled* (1967). In this verifax collage of fifty-six identical shots of a human hand holding a transistor radio, Berman turns the speaker area of the radio into a screen or space for the projection of many images. In the broadcast of radio waves, their individual reception by small portable radios, and the replicative powers of the photocopier, Berman exposes the real nature of "mass" media or "broad" casting as infinitely variable personal narratives, ultimately controlled by the final consumer's peculiar reception of collective images. The speaker/screen space, then, serves as a hieroglyphic panel flashing the dearest images of those who hold it. An astronaut, the pope, the Capitol building, nude lovers, a National Guardsman, Jesus on the cross, a revolver, Buddha, a padlock and key, the Statue of Liberty, a cheetah, orchids, an F-111, an Iron Cross and a tarantula, a rabbit's foot, an engine, a planet, and seven blank spaces are all included among many others as idealized negative prints of some receiver's affirmative reception of personal meaning from the mass media spectacle.

Nonetheless, Andy Warhol's *Jackie (The Week That Was)* (1963) attacks the mass media's efforts to orchestrate the public's emotions in contemporary America. Like every network, paper, or news magazine getting "its own shot" of Jackie, the painting gives several different views; but it also reveals how these varying images actually are all essentially the same story. Warhol shows sixteen Jackie images in four four-by-four cells; yet each cell is composed of two different images taken from familiar newspaper photos. Each image-dyad, however, is the same photo, only flopped to create opposing mirror images. In turn, one smiling Jackie image with JFK behind her and

looking out to the border is in blue; two shocked, grimacing Jackie images looking into the painting's center are white; and the other thirteen Jackie images are all done, like aging newsprint, in a muted yellowish brown. The sense of opposing emotions, disrupted lives, or the difference and identity of the first lady and all Americans in facing violent death that the media played upon in November 1963 is fully recalled by the entire image. The American dream of Camelot (the America that was) ended in Dallas during "the week that was." And, in the aftermath of the media's nonstop documentation of the assassination and national funeral spectacle, many of America's dilemmas emerged full-blown into the nation's consciousness. How can America remain free of foreign entanglements in a world with the USSR? How can the unremitting scrutiny of the television camera fit the old rules of a free press? How can America redevelop the world economy without favoring its foreign trading partners' goods over U.S. manufactures? How can a traditional nativist parochialism be reconciled with national ideas of equality, freedom, and opportunity? How can popular democratic life be conducted on television in a police and garrison state? How can leaders meet face to face with citizens plagued by the ills brought on by rapid modernization? How can individual expression be gained in a marketplace of uniform mass-produced goods? How can tradition be kept alive in an affluent, mobile, consumer-oriented, throwaway society?

The understanding of art in this show, in the last analysis, is strange. Art here has been reduced to a vector of cultural sign value, a belief that continually surfaces in the conscious thematization of iconography in the works selected. Virtually any work featuring Old Glory, a Washington, D.C. landmark, a president, a popular consumer product, or a mass culture hero by definition is recognized as emblematic of an era. As the Stich catalog observes,

> the 1950s and 1960s were decades of extraordinary economic, social, and political change in the United States, and the nation's artists captured both the celebratory aura and the sociopolitical tensions that marked the era. Artists were inspired or affected by new forms of housing and transportation, the enchanced power of mass communications and promotional strategies, the pervasiveness of standardization and conformity, the omnipresence of commercialism and consumerism, the expan-

sion of mechanization and mass production, and the emergence of a shared national identity. As never before, art explored and exposed the lineaments of American culture.[4]

Clearly, in the 1950s and 1960s, things changed radically inasmuch as the rapid proliferation of audio and visual technologies simply made it possible to preserve so many images and sounds of an era, rendering them iconic. Yet, since so many of these images and sounds have been trapped within highly commodified relations, these same iconic traces of an era continually are mobilized to commodify new meanings or make new commodities meaningful.

Beginning in the mid-1960s, the drift toward revolution in the streets and pop art radicalism in the galleries was plundered by business to assign special significance to mass-produced commodities being bought by a street fighting generation with pop art tastes. It has never let up. Today, to sell athletic shoes, automobiles, or kitchen appliances, corporations raid regions in everyone's electronic past, as it is suspended semiotically in audio and visual form, to give value to contemporary commodities, turning even these memories into mere commodities. Art can explore and expose these lineaments in American culture, but it also does so only in the same commodity forms that it cynically exposes or pessimistically explores. Stich's basically extra-historical perspective is very difficult to grasp, given that this era "ended" only fifteen years or so ago. The exhibition's extreme past-tense tone reverberated with pop sociological echoes of Linda Ellerbee in an "Our World" episode or Kenneth Clarke's idiosyncratic philosophy of history from his slick PBS survey of "Civilization," which now are themselves simply electronic memories.

On one plane the "Made in U.S.A." exhibit clearly had all the marks of a mawkish remembrance of the "Way We Were" before the fall. From the Pax Americana of 1945 to 1973, a variety of works from the Truman to Nixon years recalled the outlines of what was to have been "The American Century." The sinews and signs of this empire were shown as being corporate, patriotic, and 100 percent American; yet this belief was false even as those years unfolded. In this exhibition were to be found no glimmerings from the transna-

tional realm or borrowings from the foreign ingredients bubbling up in its soup of signs. Consequently, the exhibit celebrated a very strange, virtually xenophobic version of the 1950s and 1960s in its displays. With the space-time compression of postindustrial life, America became a transnational state of mind as well as a globalized set of sites. Just as American consumer culture and mass media diffused throughout the world system, tremendous new waves of immigrants, influences, and imports washed over the United States in return. "America" from 1880 to 1950 largely was "Made in the U.S.A.," but how can the art of the postwar era be authentically represented without even glancing at the impact of Volkswagen Beetles, spaghetti westerns, Mexican food, the hammer and sickle, the Beatles and the Stones, Third World revolutions, Brigitte Bardot, Sony televisions, or Godzilla movies on American culture? In fact, Stich's exhibition misses how deeply one of the most important attributes of post-1945 American art and culture was *not* its exclusively native derivations, but rather these emergent transnational, multivalent global qualities of American life that have become clearer with each passing year.

The exhibit, on another level, even in seeking to be critical, basically echoed the hysterical, revisionistic, hyper-real Americanism of the Reagan era that explicitly repressed or denied the limits on contemporary America's power and influence to exclaim that "The Pride Is Back," just like in the fifties and sixties. After years of defeat and pessimism, Ronald Reagan's personal aura projected a collective rhetorical vision that persuaded us that "Born in the U.S.A." and "Made in the U.S.A." are not marks of shame, but rather of pride. Not surprisingly, in turn, "generous grants" from the NEH, NEA, the Henry Luce Foundation, the A.T.&T. Foundation, the Best Products Foundation, and California First Bank all were made available to provide "the necessary financial support" for this special re-examination of "modern art" from the standpoint of being "American made."

Ultimately, the exhibition pretended to document how the aesthetic Zeitgeist of the twentieth century crossed the Atlantic to the New World in the post-1945 era, even as America's Marshall Plan billions and NATO forces went the other way. In witnessing the

"Americanization" of modern (world?) art in the 1950s and 1960s, the exhibit's organizer suggests, "It is also possible to realize more fully the art's aesthetic strength and its importance with reference to the mainstream of modernism, especially as this encompasses a shift from a European to an American axis and a defiance of salient modernist precepts."[5] The tremendous vitality of non-American art after 1945, then, is simply ignored, unless it links up with the new accessibility or pop culture twist in these trends of "Americanization." We know that "History" always is written by "the winners." Still, this hyper-real reconstitution of an insular America, which is totally "Made in U.S.A.," shows once again how the meaning of "Art" largely ends up being defined by the intertwined agendas of funding agencies and the curators of art museums, who remain all too eager to freeze-dry an entire era in narrow ideological categories of spectacular display rather than theoretically probing its contradictions in serious, sustained critical arguments.

Soviet Life

Ilya Kabakov's fascinating installation *Ten Characters*, presented at the Hirshhorn Museum, gives new meaning to the policies of *glasnost*. Mikhail Gorbachev has asserted that *"glasnost* is a sword that heals its own wounds,"[1] suggesting here that openness by itself can bring its cleansing solutions to the serious problems that it reveals in society. Kabakov's art, however, tends to do much more, slicing away old ideological veils which cover wounds so deep and so infected that nothing will ever be able to heal them. As it cuts through rusted armor and rotten flesh, this mixed media installation works on many levels along so many different thematic lines that it truly can be overpowering, even after more than one visit, because Kabakov opens up most of the contradictions and conflicts of communist society in the USSR.[2] Indeed, this one installation discloses how much the Soviet people might have to gain from *perestroika* as well as captures how much they could lose in modernizing their society along more Western consumerist lines of organization. By carefully considering the many levels of lament captured within the rooms of the exhibition, one can witness, in a sense, the elaboration of an intense ethnography of everyday life in Brezhnev's "period of stagnation."

The extremely personal and highly idiosyncratic aesthetic profiles of ten fictional characters, which are all different personas of Kabakov's varied artistic talents, sum up most of the conflicts and contradictions of "really existing socialism" as it matured in the Soviet Union during the cold war era. The communal apartment, as it is represented here, becomes Kabakov's metaphorical summation of Soviet life since the 1917 revolution. In its characters, Kabakov gives voice to different sides of his self, but he also reveals more

general feelings about the emptiness and despair lying at the core of the New Soviet Man's and Woman's life. Such communal living spaces were created by *ukaz* during and after the Russian revolution out of the large luxurious apartments held in Moscow by the bourgeoisie and petty aristocracy. Only by dividing them up for collective use could the Kremlin house the millions of new residents coming into the city after the revolution. In the spaces once used by one family, the regime put one household in every room, while forcing all of them to share kitchen and bathing facilities. Inside these close quarters, the peculiar qualities of Soviet communal life evolved in many of the same ways followed by Kabakov's characters.

Born in the Ukraine in 1933 during the height of Stalin's forced industrialization campaigns, Kabakov was trained at the Moscow Art School and Surikov Fine Arts Institute. In the 1960s he was closely associated with the Sretensky Boulevard circle of conceptual artists in Moscow's avant-garde art scene. Yet, his everyday assignments as an illustrator of children's books moved him during the early 1970s into a more *samizdat* style of production as he searched for the outlines of his own artistic project. During this time he began producing his "albums," which are in many ways almost an entirely new genre of artistic invention. These scrapbooklike narrative works about fictional characters are fabricated on unbound pieces of cardboard and then collected together as a story of a life, which individually and collectively detail his critical concerns about the personality and community in Soviet society. By the early 1980s, Kabakov turned this new form of art away from narrow psychological issues to larger questions of collective myths and political ideology, which also underpin many of the unusual stories presented in the *Ten Characters* exhibit.

The viewer enters Kabakov's installation through a weatherbeaten door set in a dour, two-tone gray and maroon wall. These colors are continued inside the apartment, giving it a dark, stuffy feeling along with the recorded soundtrack of kitchen clatter, babbling voices, and foot traffic in the hallways. The whole aura of the exhibit nicely reproduces the almost Third World quality of everyday Soviet life by bracketing one's awareness of cramped, gloomy

rooms, exposed and broken light fixtures, and lack of personal privacy. Arranged along a central corridor, the individual rooms of each tenant are open for inspection along with the more collective spaces belonging to no one in particular but shared by all, like the spaces Kabakov identifies as "The Abandoned Room," "The Empty Room," "The Kitchen," "The Children's Corner," and the corridor itself. The communal apartment form that Kabakov uses here as his aesthetic space is a magnificently simulated microcosm of everyday life in the USSR. Like the collective spaces of the Soviet Union itself, the individual rooms of the apartment are rough-hewn, unstable, and strangely decorated with a mixture of scientific socialist bric-a-brac and the detritus of well-worn material poverty. The effect meets the viewer's "expectations" about Soviet life, as they might have been drawn in the 1980s by patronizing American commercials highlighting the lack of choice and shoddy quality of goods in the USSR's stores and shops. Yet there is also an undeniably rich spiritual or intellectual aura in every room that few average consumers in the West ever come to know. The gallery goers, as they enter this exhibition, come into the apartment as visitors and voyeurs, peeking into and poking at the miserable rag-bag of all the residents' private lives. In this process they can read about and see each tenant's personal mythic visions as the tenants spin them out of the dross of Soviet communal life. Kabakov directly recounts their respective hopes and fears in typewritten commentaries expressed as official correspondence, a neighbor's gossip, individual remembrances, or his own first-person observations.

All of the ten characters are quite interesting, but some displays are much less involved and intricate within the shape of this particular installation. "The Short Man," for example, who is also portrayed as "The Bookbinder," is shown through the contents of ten albums of carefully arranged cardboard sheets put out on the floor of his room. On them, Kabakov, as "The Short Man," has pasted textual excerpts, news clippings, drawings, photographs, and documents that can project an almost theatrical effect as the viewer pages through the play of life in each of them. The descriptive text about this person notes that as he saw these characters, "he suddenly discovered that even these variegated fragments belonged not to his

single consciousness, his memory alone, but, as it were, to the most diverse and even separate minds, not connected with each other, rather strongly different from one another." Thus, "he made a decision: to unite this diversity into a kind of artistic whole, but to allow them to enter into arguments, out do one another, but let all express themselves in turn. Let each of them have his right to vote completely and fully, in complete internal silence, say everything that he knows, and tell his story, and his ideas fully."[3] Kabakov, then, speaks through a character to reveal how he too is a person describing Soviet life through characters. "Whom do they personify?" the narrative asks, and answers, "From the very beginning it's not difficult to guess. They personify the most diverse ideas. Each idea develops to its limit, to its complete manifestation within this character, then becomes extinguished."[4] The ten albums of this fictional character describe the lives of ten other characters; yet these albums also present much of the purpose and reveal some of the logic of this larger installation about the ten characters living in a communal apartment.

Similarly, "The Man Who Collects the Opinions of Others" in another room records the activities of a tenant, who often "engaged in a rather strange occupation: he would throw some object on the floor in the corridor near his door—it could be an old boot, a dirty can of corned beef, a bunch of useless keys, or even a coat or old trousers. He would stand in his room, on the other side of the slightly opened door, with a note book and pencil in his hands and he would wait to see what would happen in the corridor. Someone's footsteps could be heard coming down the hallway. (It's a neighbor or someone he doesn't know going toward the kitchen or bathroom.) Having seen or bumped into the strange object under their feet, each person says something appropriate to the occasion. And he, standing behind the door, immediately writes down in his notebook everything which is said, no matter what: a profound and long utterance, an exclamation of surprise or some filthy curses which are common here."[5] Having collected these opinions, the man then arranged the decor of his entire room to display them. Kabakov's commentary recalls how the man's installation of opinions looked: "From a fairly large sack which was lying in the corner,

he began to take out rather strange, and in general, old and sloppy things—an empty egg carton, a used broom, a plastic package filled with papers, a bunch of keys, a black rag—and he began to hang all of this along his bare walls, as it turned out, on special nails, at even and fairly large intervals from one another. He placed one of these objects, it seems it was an old pair of trousers, on the table. After that he began to take out pieces of paper with short phrases carefully glued on them, which were in a specific order and carefully numbered, and with bits of glue he began to paste these pieces of paper to the wall in such a way that they formed a full circle around each object hanging on the nails. Soon it was as though the room turned into some strange flower store, filled with unique wreaths."[6] These "wreaths" are displayed in terms of many identical cardboard hangings with sheets of white paper pasted on them. In the middle, a pale yellow rectangle is printed with an opinion that he found profound or amusing. The sheets also are all topped with a matching yellow bar, and usually a small colored ink drawing of a stool, a red ball, or a fly. This man believed that opinions occur in definite cycles of "splash, and outburst," "interpretative blossoming," and "dissemination" as these waves move out in widening circles of influence. So the utterances are shown as circles of opinion sheets laced around some everyday object, like a slipper, a rag, an old broom, or a ring of keys, which emblematically display his theory of public opinion formation and circulation.

"The Composer Who Combined Music with Things and Images" is presented through copies of letters documenting a running correspondence between the local people's court and Soviet authorities, the composer's neighbors, and the composer over complaints about "noise" coming from his apartment. In his letter to the local people's court, he claims that "as far as I am able to observe the life that goes on in our apartment (whose inhabitants number roughly 24), we all live extremely apart from one another. . . . Thus I devised musical concerts, which twice a month should take place within the confines of our apartment, in the wide part of our corridor, before turning into the kitchen. This is original chamber music, in which all the tenants of our apartment may participate simultaneously and one at a time. . . . On September 2 and 18 of this

year these concerts took place with complete success, without complaints from anyone, and the atmosphere in our apartment became significantly more healthy and benign."[7] In his room are shown a set of music stands for a "musical-choral oratorio," combining image, voice, and sound, that is performed by him and his neighbors. The purpose of "this noise," as his letter explains, is to draw all of the apartment's tenants and guests into a collective performance that might create "Communality" among all. His two concert programs detail the plans for "Music of the Spheres" and "Golden Subterranean River." Both involve passers-by in the corridor either by stopping them briefly and having them do a reading from texts on the music stands, which are grouped together in two set rows of seven each facing each other under a bottomless glass jar and a drawing of a fly, in unison with the other set of singers or by moving all of them together in leapfrog fashion along another set of stands as they read to simulate a moving "River of Life."

Likewise, the room of "The Untalented Artist" focuses upon the banal aesthetic output of officially commissioned art in the USSR by displaying the work of another one of Kabakov's personas. Showing official notice posters from soccer matches, music performances, and political agitprop, Kabakov ironically paints the art of "The Untalented Artist" as the state-controlled equivalent of Western commercial art produced by self-deluding artistic sell-outs, responding to the whims of the state's art-buying bureaucracies. All of the art is reproduced as large lithographed posters, making them cheap, mass-produced decorations for a proletarian society. Of the six works, three depict unremarkable imitations of neoimpressionist renderings of a forested river gorge, a misty river delta, and a bright parklike scene with big trees. Two others seem to show art students hunched over their projects in a massive art studio and a group of workers engaged in a small debate at the bench. The best one is a close-up of a soccer team's rush against a goalie to score in an intense match. However, "we must be fair to the artist," as Kabakov's remembrances suggest, "who, feeling the scale and significance of the commission, ambitiously gives free rein to his intuition, visual memory, and to his 'elementary art education.' Repudiating pathetic repetitions—even though one might expect

from him entirely standard ideological production which had been turned out many times before—he makes certain elements and images from his imagination. And this often lets him down—many fragments of the notice he executes carelessly, thinking that that's how the 'great masters' work, and others he leaves out, not suspecting that they even existed. But some of them turn out quite well (like the 'game at the stadium' and a few others). What results is a dreadful mixture of hack-work, simple lack of skill, and bright flashes here and there of artistic premonitions and 'illuminations'."[8] Even at its best, such art simply fulfills one of the predictions made by 1960s-era convergence theories about capitalist and socialist societies. "The Untalented Artist" and his bureaucratically commissioned hack work merely mimic the same kind of "decorative" but "energetic" banalities produced under corporate inspiration by Western artists from the LeRoy Neiman school of "action art" or "sports art."

Another room is entirely bare except for an intricate arrangement of strings and pictures for "The Man Who Saves Nikolai Viktorovich." A small oval sheet of paper on the far wall bears a picture of Nikolai Viktorovich desperately treading water at sea. In the middle of the room there are a number of ropes and strings suspended at eye level and attached to pulleys and hooks. A "control panel," which is a music stand, holds directions that tell us how to move a number of objects suspended on the strings, such as a bottle of medicine, some keys, a ball, and a small wooden boat, which are called "gifts," into alignment with Nikolai Viktorovich's picture on the far wall. Given the dimensions of the room, one can move the objects such that they will fit in perfect perspective with Nikolai Viktorovich, and thereby "rescue" him if we put the small boat directly under his picture. So after reading the control panel, "you understand how you can save Nikolai Viktorovich, you literally have the power in your hands. Standing at the panel and having taken the control strings in both hands, locate the piece of paper with the image of the sea there, far across the room, and carefully find the drowning figure of Nikolai Viktorovich. . . . 'As long as you hold the boat near Nikolai Viktorovich, he won't drown, he will float and maybe. . . .'"[9] The occupant of this room was not seen

very frequently, and then one day he suddenly disappeared. Subsequently, new tenants in the room never stayed very long, and even had to cohabitate in it with the "old tenant," who occasionally reappeared. As Kabakov remembers it, the door is always unlocked and half open, allowing anyone to enter into strange relationships with people, like Nikolai Viktorovich, who one actually never would come to know.

While these characters' lives are plainly important, the four remaining rooms of "The Man Who Never Threw Anything Away," "The Collector," "The Man Who Flew into His Picture," and "The Man Who Flew into Space from His Apartment" are truly fantastic. They reveal Kabakov's most complex characters, particularly when set in the context of understanding more about the mythos of Soviet communism.

"The Man Who Never Threw Anything Away" was a plumber, but he rarely was seen around the apartment by anyone. One day when some other plumbers called at the building to do some work, his neighbors forced their way into his apartment and found an immense collection of garbage. Yet the garbage was not "a dump." Instead, it was a collection—carefully organized, cataloged, and arranged in a clearly scientific, if an unheard of or unknown, type of order. Small bits of junk—faucet handles, corks, small bottles, old flatware, jar lids, old eyeglass frames, broken pocket knives, rolled up food tubes, slivers of wood, spark plugs, chain links, bits of cheese, shreds of paper, pieces of wire—were hung on strings or affixed to display boards by the hundreds with short numbered and typed explanatory notes disclosing their origins or importance. Hundreds of different shards of trash are all categorized, labeled, and displayed like a strange science fair project from Mars on different types of earth garbage. In turn each piece was carefully cataloged in curatorial ledgers to further document its importance in this immense garbagological collection. The owner not only assembled the garbage. He also wrote scientific disquisitions about it. As he writes in an article, "Grouped together, bound in folders, these papers comprise the single uninterrupted fabric of an entire life, the way it was in the past and the way it is now. And though inside these folders there appears to be an orderless heap of pulp, for

me there is an awful lot in this garbage, almost everything. Moreover, strange as it seems, I feel that it is precisely the garbage, that very dirt where important papers and simple scraps are mixed and unsorted, that comprises this genuine and only real fabric of my life, no matter how ridiculous and absurd it seems from the outside."[10] He wrote many such manuscripts, ranging from theoretical treatises to personal essays to novels, about garbage, which his neighbors and the gallery goers also can discover in his room.

The room representing "The Man Who Never Threw Anything Away" is, in many respects, the most bizarre and fascinating statement in the exhibition. Like the other characters, it too expresses a side of Kabakov in an imagined other's life. This man clearly gives new meaning to the famous NEP era economist E. A. Preobrazhensky and his theory of "primitive socialist accumulation." Indeed, "The Man Who Never Threw Anything Away" is a systematic archeologist of everyday life, rooting through, collecting up, and arranging systematically the full range of ordinary household trash and turning it into an exhibition of material life, as well as an entirely new discourse about the process of living.

Kabakov's presentation of "The Collector" shows a man obsessed with order and discipline as he builds precise photomontages on large cardboard rectangles out of postcards, magazine photographs, and other printed pieces of mass mediated information. A designer of bureaucratic notices and public propaganda pronouncements, "The Collector" is described in language that seems lifted from Trotsky's paens to communism as "a true creator, an artist in his own way, and there is no doubt that he fulfilled his obligations as a designer. . . . Some sort of more profound and important expanses opened up for him behind such tasks, special shining peaks rose up on the horizon behind the forest of everyday things."[11] The room itself is a clever parody of the spare, spartan appointments of Lenin's apartment in the Moscow Kremlin, showing a simple chair and small desk illuminated from above by a reading light that shines brightly on a new photomontage under assembly. Here, of course, Kabakov's touching account of "The Collector" also ironically parodies early Bolshevik prophecies about communism and the New Soviet Man.

The Collector's strangely grouped postcard montages "combined in harmonious proximity the most diverse subjects and things, things which are far away from each other in both time and meaning. On one and the same piece of paper there were weapons, cats, folk dances, hats, views of cities and paintings from the Tretyakov Gallery, folk crafts and industrial machinery. . . . This was all infinitely confusing and puzzling, but I was already beginning to understand something, my conjecture was breaking through the thick fog more clearly and more confidently . . . Order!"[12] Kabakov here is depicting and lampooning the only universally binding force in Soviet society, which once was presumed to be capable of gluing these disassociated particularities into some meaningful progressive universal: the Communist Party of the Soviet Union. This gaze falls not on the real party, but rather the ideal Leninist image of the party as an omnipotent and omniscient political vanguard. In these flimsy displays of showy images and happy ideals, the viewer sees that "it is order, and it's order precisely because it is ABOVE those relationships and connections which exist between similar, like things, people and phenomena. The power of ORDER is a power which forms new links which are clear and simple. . . . It seems to be, that in making these things the author himself became transparent, he became the ideal conveyor of a force which acted through him when he carefully drew the letters of the headings—that will to universal Knowledge, Order, and Triumph."[13] The carefully designed and meticulously arranged montages are all posted on the wall in a progressive uniform order. Those already assembled suggest the glory of the past and present, while the yet uncovered pieces of cardboard hint at the promise of the still dawning future. As the commentary concludes, "Didn't a certain anticipated and unfulfilled dream sound in them, a dream which was ultimately about a rhythmic silence and harmony, about the merging of everything into a certain harmonious figure. . . . Wasn't that an image of some happy Utopia into which the daily and hourly witches' sabbath ringing all around us was to turn. And who knows, maybe he made the brightest images on his notices at precisely those moments, those terrible moments in our apartment life, when the kitchen battle raged. Was it then that he traced red and blue lines with a ruler to drown out, to cast a spell over that hell?"[14]

The room depicting "The Man Who Flew into His Picture" is an equally simple arrangement of an old wooden armchair facing an immense grayish-white canvas that takes up nearly the entire room. It too takes up the poverty of Marxism-Leninist philosophy put into practice by radical intellectuals in the backwardness of Romanov Russia. A tiny, dark gray human figure is painted on the screen near the middle of the bottom left quarter of it. The accompanying text notes that "he drew himself on the big white board, depicting himself as a small grey figure, barely discernible on the enormous board standing in front of him in the small room. He looks at himself, so small and plain, lost in the huge space of the empty white field, and a surprising state envelops him . . . and at the moment he merges with the little, plain figure that he had drawn. But this figure changes, too. It stops being just a drawn image. Entirely alive and real (though only very small, many times smaller than he—and he certainly knows this) the figure moves smoothly, quietly and uninterruptedly away from him into an infinite depth where the light is shining. And it quickly becomes completely indiscernible in the blinding depth."[15]

As he recognizes these effects, the man also sets up the whole display for a third person, who is, of course, all of us who visit his room. By reading the explanatory notes and watching the chair set before the screen, we might understand how and why the man could fly into his picture as witnesses from "this side" of reality. But, at the same time, invisible others in the room with him speak up, and the man records their voices and words on separate sheets of paper hung on one wall with the directions for "the third person" to witness his flight into his picture. In this one small corner of the exhibit, Kabakov ironically sums up the state of post-1917 Soviet society. Like "The Man Who Flew Into His Picture," the committed faithful few of Soviet society have had the alluring pictures of a communist utopia set before them. Since 1917, the entire populace also have been sitting in their chairs and flying into these pictures, as the party's dialectical materialist doctrines painted them, in "making the transition to communism." And, in so doing, the pictures and their depiction of some original new hopes have been watched continually from without as the pictures have collapsed into chaos and faded into nothingness amid the voices raised

from within about how to proceed. Like this man, every Soviet citizen has been trapped inside the country which flew into its picture, disappearing into the gray void of Stalinist bureaucratic centralism.

The most richly textured and thematically involved segment of the installation, however, is the room of "The Man Who Flew into Space from His Apartment." One looks into this room through a number of boards nailed up by the local Soviet authorities to keep out the curious. On the board barrier, there is an account of the man and his project recounted in eyewitness depositions from his neighbors. As their stories suggest, the man was employed in construction and had been living in the apartment for two years. He had a "Grand Theory" of the universe, which one of his neighbors recalls in some detail: "He imagined the entire Universe to be permeated by huge sheets of energy which 'lead upwards somewhere.' These gigantic upward streams he called 'petals.' The plane of movement of the galaxies, stars and planets does not correspond to the direction of the energy of these petals, but intersects them, periodically passing through them. Thus, the Earth together with the Sun periodically crosses through one of these enormous 'petals.' If you knew this precise moment, then you could jump from the orbit of the Earth onto this 'petal,' i.e. you could enter, join this powerful stream of energy and be whirled upwards with it."[16] He calculated this moment, which he believed would last only twelve minutes, and built an apparatus in his apartment to give himself the initial momentum needed to lift himself—assisted coincidentally by the energy field of the moon, Sirius, and Pluto—into the cosmic forces of the petal.

His room still contains this apparatus. Its Rube Goldberg design consists of four immense, thick rubber bands attached to the walls of the apartment and intersecting under an old metal tractor seat suspended on bedsprings. Stretched down to a locking hook on the floor, this catapult is designed to release at the same time that a small powder charge blows off the ceiling and roof, allowing the man to spring forty meters into the air where he would catch cosmic energies of the petal. On his journey he would be protected by a "space sack," which "was made of clear plastic and was intended to

protect the body in the open cosmos and for travelling in the 'petals.' In the sack there were provisions, an oxygen tank, navigation instruments and other equipment."[17] Apparently, as the hanging shreds of punctured sheetrock above the catapult attest, on April 14, 1982, the man realized his project and flew into space from his apartment. His neighbors were awakened by smoke and the smell of something burning in his room. The door was totally destroyed, and there was an enormous hole in the roof. But the man was nowhere to be found, and his neighbor remembers, "A car arrived immediately from the police station nearby. They started to search for him all over the block, maybe he was lying somewhere or had fallen, but they didn't find him anywhere. . . . Maybe he really did fly away, that sort of thing happens."[18]

The man's apartment, as he left it behind, is a beautiful combination of bedroom, launching pad, space laboratory, and vivid collection of official propaganda posters. The colorful posters are the usual celebrations of Soviet workers, scientists, and youth as well as vivid testimonials to the regime's concern for science, the environment, and economic progress. One particularly clever poster, which Kabakov has appropriated and doctored with his own images, shows Red Square at night full of thousands of people under a clear sky laced by searchlight beams and fireworks explosions. Yet this parody of official Red Square images commemorating V-E Day, Revolution Day, or May Day also includes an immense "rocket," which is actually the Moscow Kremlin's clock tower, blasting off in sheets of smoke and flame next to the Cathedral of St. Basil. This image sits directly behind the catapult seat of "The Man Who Flew into Space from His Apartment." A small model of his experiment also sits center stage in the room, reproducing in scale a number of Moscow buildings by the river against a spring sky as the roof blew off one building to let loose a high arc of twisted aluminum foil representing the man's trajectory into space. Colored pencil drawings above the model show his vision of the energy petals and their forces, while the whole room is littered with household utensils, shreds of paper, plaster dust, and pieces of wallboard left behind in the blast. Ironically, the man's shoes also rest under the catapult as a testimony to the immense forces of "the petals" that

pulled him out of his shoes, his apartment, and his world into the great unknown. In this one room, then, Kabakov ironically takes on the progressive illusions of the Soviet intelligentsia, Soviet science, Soviet technology, and the Soviet space program, framing them as pipedreamers and jury-riggers possessed by delusions, in showing the shabby rooms of this innovative if antiheroic space voyager who truly dared to go where no man has gone before.

The USSR that Kabakov simulates in this installation is also very much like a building one of his characters describes as having been under construction for eighteen years across the street from the apartment: "It is impossible to tell it apart from the ruins of the other buildings which they took down in order to build this new one. This new one, which for a long time now has been a ruin in which some men occasionally swarm about, may at some point be finished, although they say that the blueprints are very outdated and have been redone many times and it even seems that they have been lost, and the first floor is covered with water. . . . Looking at it, it is difficult to understand whether it is being built or torn down, and it may be both at the same time."[19] Given this institutionalized disorder, the various personal worlds that these characters build for themselves within their rooms are actually very sane mechanisms for coping with this almost insane social situation.

Still, the display of this installation at the Hirshhorn during the same months that former President Gorbachev was invested by the Congress of People's Deputies with even greater, indeed almost dictatorial, powers to rapidly transform the USSR along more democratic, capitalistic, and consumeristic lines of organization also gives it an air of prehistoric nostalgia. At times, Gorbachev has looked like "The Man Who Saves Nikolai Viktorovich" as he pulls on the tangled ropes and rotten strings of the party and state to try to save the Soviet Union from drowning in a sea of bloody chaos. Occasionally, before the August 1991 coup, he seemed to be making some headway, but most of the time he clearly was failing miserably. And, as he struggled, the strange phenomenal characters of this communal Moscow apartment, and each of their unique adaptations to the stagnant waters of neo-Stalinism, all were left wandering even farther into the chaotic shuffles of *perestroika*. *Glasnost* may

not continue long enough to track the wanderings of such lost souls, but Kabakov's installation provides a perfect summation of the dismal poverty of contemporary Soviet society. The stories he spins out around his different personas also demonstrate through aesthetic fictions how fully the spiritual brilliance and inventive imagination of people can develop, even after they go on living amidst the material desolation of "a revolutionary society" when the radical spark burns out.

11. HANS HAACKE

Unfinished Business

Much of Jean Baudrillard's critique of contemporary culture plays off the conceptual confrontations he stages between simulation and representation. In *Simulations*, he argues, "The latter [representation] starts from the principle that the sign and the real are equivalent (even if this equivalence is utopian, it is a fundamental axiom). Conversely simulation starts from the utopia of this principle of equivalence, from the radical negation of the sign as value, from the sign as reversion and death sentence of every reference."[1] Imploding reference and representation from within as utopian, Baudrillard denies the potential for linking audiences to referents by words or images, nullifying all political possibilities for ideology, critique, and resistance. Rather than capitulating to the self-canceling silence of simulacra, Hans Haacke tries to cut new tunnels between signs and their referents, opening fresh channels of criticism through the hard rock of ideological indifference. Resisting Baudrillard's essentially nihilistic impulse to shred away all social referentiality at sites of aesthetic reception, Haacke revitalizes different political, economic, and cultural contexts to resituate aesthetic objects, as representational acts, in highly charged zones of symbolic contention.

A decade and a half after his canceled 1971 Guggenheim Museum exhibition, Hans Haacke's first major retrospective show initially was presented at the New Museum of Contemporary Art in New York from December 12, 1986 to February 15, 1987. After closing there, the retrospective has gone on the road to seven other American cities with Haacke presiding over a slightly different presentation on every stop, suiting it to the peculiar atmosphere of each place. In the burgeoning Sunbelt superstate of North Carolina, Haacke's travelling oeuvre was installed briefly in the financial-

administrative core of the spreading sprawl of Charlotte.[2] This stopover featured a good cross-section of Haacke's installations, beginning with earlier work, like his *Shapolsky et al. Manhattan Real Estate Holdings, A Real-Time Social System, as of May 1, 1971* (1971), and extending to some of his most recent pieces, like *Buhrlesque* (1985) and *MetroMobiltan* (1985). Once a sleepy southern industrial town, Charlotte now is adorned with many signs of the same cultural, economic, and political trends that Haacke's art imitates. Thanks to corporate civic-spiritedness in its rising central business district, echoing with the impact of new postmodernist architectural adornments, Haacke's work rolled into a city still reverberating from the collapse of Jim and Tammy Bakker's more or less locally based Praise the Lord (PTL) empire in the late 1980s.

Like the still evolving urban sprawl of Charlotte, Haacke's work largely addresses the unfinished business of corporate and state power as it assumes new, more complex, and image-mediated forms in the rapidly changing current world system. In particular, the rationalization of art as a new means of producing and reproducing value in contemporary capitalism anchors Haacke's critical reappraisals of the ins and outs of today's culture industries. Haacke's works, then, directly rebuke Baudrillard's notions of ecstatic communication leading to endless simulations of reality by recontextualizing objects, ideas, or persons in their specific contexts. Although he cannot import each and every site into the museum, Haacke expertly summarizes the links between public images and private interests, consumer goods and producer evils, professional personas and political agendas in his installation constructs. The cynical mobilization of advertising, public relations, and art and cultural productions by capital to serve its economic and political agendas are all tendencies he seeks to identify, call into our critical consciousness, and, then, resist in his installations.

Haacke holds to the premise of mystification in the production and consumption of commodities in which alienated workers swirl continuously around with the products of their alienated labor in elaborate ideological spectacles. Baudrillard, of course, denies the validity of these premises, seeing such scenes of constant alienation now as being supplanted by obscenes of continuous information

"where there is no more spectacle, no more stage, no more theater, no more illusion, when everything becomes immediately transparent, visible, exposed in the raw and inexorable light of information and communication."[3] While Baudrillard might insist upon living in such communicational obscenes, Haacke's installations acknowledge how extensively most people continue droning away in alienated scenes of incomplete information and distorted communication. Hence Haacke's respecifications of sociopolitical context around his artistic texts struggle to articulate that which rarely is truly transparent, visible, or exposed.

Haacke's aesthetic experiments from the beginning have questioned how substance and form work in modern genres of gallery art. His earliest kinetic sculptures used wind and water as elements of expression. In the late 1960s and early 1970s, Haacke installed news agency teletype machines in galleries, which ran the daily copy rolls out on the floor for viewing, but saved nothing. Other installations in the United States and West Germany were surveys about the gallery visitors' place of birth and place of residence. *Gallery-Goers' Birthplace and Residence Profile, Part 1* (1969) asked visitors to mark their birthplace's with red pins and current residence's with blue pins on maps of Manhattan. *Gallery-Goers' Residence Profile, Part 2* (1970) presented photos of 732 building facades in Manhattan marked earlier in *Part I* with rows of pictures arrayed for every street mentioned. Poll installations from 1969 to 1973 used data processing machinery to conduct opinion surveys on cultural, political, and social issues whose results were regularly updated in the exhibition. *Moma-Poll* (1970) was simply two acrylic boxes with electronic counters that asked for and tabulated "yes" or "no" answers on the question: "Would the fact that Governor Rockefeller has not denounced President Nixon's Indochina policy be a reason for you not to vote for him in November?" At the end of its twelve-week run, 68.7 percent said "yes" and 31.3 percent said "no." The *John Weber Gallery Visitors' Profile 1* (1972) and *John Weber Gallery Visitors' Profile 2* (1973) installations for audience participation also surveyed attitudes on sociopolitical issues as well as views on art as a profession, presenting the results in bar graphs in twenty-one large blueprints.

However, Haacke's most controversial early installations were detailed, if incomplete, exposés on Manhattan real estate dealings: *Sol Goldman and Alex DiLorenzo Manhattan Real Estate Holdings, A Real-Time Social System, as of May 1, 1971* (1971) and *Shapolsky et al. Manhattan Real Estate Holdings, A Real-Time Social System, as of May 1, 1971* (1971). The Shapolsky installation, displayed in the Charlotte exhibit, consists of two maps of Harlem and the Lower East Side with 142 photos of buildings and lots with typewritten data sheets on each address with its title holder, assessed values, mortgage balance, prior owners, and dates of acquisition. An explanatory panel also drew out the network of who held which mortgages where and who issued them. This particular installation and two other works provoked Thomas Messer, then the director of the Guggenheim Museum, to cancel Haacke's one-man show as "inappropriate" for a museum and fire the curator of the exhibition for defending it. While many assumed this reaction was elicited by the Guggenheim's directors, who were believed to have ties to these or other similar slumlords, it is also clear that Haacke's mapping of rentier capital at work in New York was far ahead of its time as political art. This art imitated life too closely, disclosing the deeper realities of exploitative New York real estate development in the city's transition to a service-oriented economy, now known mainly for its overheated art, financial, and property markets.

The cultural codes of everyday ordinary representation embodied in mass media photos, corporate advertisements, and political propaganda are what Haacke brackets and challenges in his artistic productions. These institutionalized modes of distorted communication simultaneously constitute and legitimate power in advanced industrial societies. By appropriating these codes, and countercoding them with critical content or ironic restatement, Haacke questions both the immediate substantive workings of power as well as the deeper formal logics of their naturalized representation. Thus Haacke's works also are deeply entangled in the same sets of communicative assumptions. By mapping out this new politics of representation, whereby power is accumulated or applied through the symbolic production and consumption of meaning, he often balances unsurely between critique and co-optation as he struggles

to turn these logics of power against the process of rationalized communication itself.

In such works, Haacke appropriates the commercial art motifs of major corporations and rescripts their copy, playing off the everydayness of the images as he infuses them with a refunctioned critical text. Prefigurations of this style surface in *On Social Grease* (1975) and *Solomon R. Guggenheim Museum Board of Trustees* (1974), but *Mobilization* (1975) and *The Good Will Umbrella* (1976) are his first ironical matchings of corporate logos with corporate communications or internal memos to generate critical subtexts on corporate duplicity. Both of these works highlight the cynical self-interest with which Mobil's management seeks to associate its otherwise sordid business image with excellence in the arts. Haacke continues these techniques in *The Chase Advantage* (1976), *The Road to Profits Is Paved with Culture* (1976), *A Breed Apart* (1978), *Alcoa: We Can't Wait for Tomorrow* (1979), *Thank You, Paine Webber* (1979), *Mobil: On the Right Track* (1980), *Creating Consent* (1981), *Voici Alcan* (1983), *Alcan: Tableau pour la salle du conseil d'administration* (1983), and *Le must de Rembrandt* (1986). Indeed, the Charlotte exhibition was weighted heavily toward these images and installations as Haacke included in it *Tiffany Cares* (1977–1978), *The Right to Life* (1979), *Wij geloven aan de macht van de creatieve verbeeldingskracht* [We Believe in the Power of Creative Imagination] (1980), *MetroMobiltan* (1985), and *Buhrlesque* (1985).

The appropriation and parody of mass media "advertorials" inspires Haacke's *Tiffany Cares* (1977–1978). Readers of the *New York Times* several days a week can appraise the new wares advertised by Tiffany & Co. on the paper's third page. Until he retired in 1981, Walter Hoving, Tiffany's chairman, personally penned short editorial observations that also were run occasionally in the Tiffany ad space. For the most part, Hoving's thoughts stuck to simplistic celebrations of American capitalism under titles ranging from "Is Profit a Dirty Word?" to "The Truth about Capitalism." In *Tiffany Cares*, Haacke appropriates "Are the Rich a Menace?" from the June 6, 1977 *Times* and etches it onto a large silver-plated copper plate set on velvet in a wood presentation case mounted on a brass pedestal stand. The Tiffany advertorial claims that the rich are, of course,

not a menace, because every million dollars invested in America provides capital for thirty jobs. Likewise, the investment income from the same million, once spent in the economy, may help employ another seventy people. "So, in other words," as the Tiffany ad concludes, "Mr. Rich Man, you would be supporting (wholly or partially) perhaps more than 100 people." In counterpoint, then, Haacke places another etched plate inside the lid of the presentation case with this declaration done in an elegant script typeface: "The 9,240,000 Unemployed in The United States of America Demand the Immediate Creation of More Millionaires." The venal arrogance of the Tiffany Company and its patrons is perfectly captured in an artifact "so tastefully done" they might both accept it in their collections of opulent doodads.

The Right to Life (1979) appropriates the format and image of a Breck Girl shampoo ad to bracket and criticize American Cyanamid's "fetal protection policy." Based upon principles of "protective discrimination," many large corporations previously required that women in their child-bearing years be sterilized in order to keep certain higher-paying jobs working with toxic substances. Otherwise, they were transferred to less hazardous and lower-paying jobs. Haacke's fusion of the Breck Girl's image of squeaky clean innocence with dead-pan copy reading out this corporate policy captures perfectly the evil ironies of American Cyanamid's paternalistic "concern" for women and the unborn.

Wij geloven aan de macht van de creatieve verbeeldingskracht (1980) and *Buhrlesque* (1985) both take on the sanctimonious objectivity of world-famous European weapons manufacturers engaged in the international arms trade. The former appropriates advertisements, posters, and schematic drawings from the Fabrique Nationale Herstal S.A. (FN) trade in small arms and ammunition around the world, matching it with photographs of South African troops and policemen using FN weapons in Soweto (Johannesburg), South Africa, during the 1976 uprisings there. Two end panels are facsimiles of actual FN advertisements in English for machine guns, rifles, pistols, ammo, and grenades. Three bottom panels are reproductions of the FN FAL 7.62-mm assault rifle in different configurations. The three top panels are media texts by FN's Christian Labor

Union denying (with snickers) that FN sells arms to countries at war, a report from the London *Economist* that the Vatican, the Belgian royal family, and other aristocratic families own important shares of FN through the Société Générale de Belgique, and a 1975 interview with FN's director asserting the company sells only to responsible governments and that it has "nothing to do with the use to which they are finally put." Ringed by these panels, the three large center panels mate photos of FN weapons at work in Soweto with advertisements for the FN-Browning Prize for Creativity, administered by FN's public relations department, touting the claim, "We believe in the power of creative imagination." Finally, the whole installation hangs under a black velvet flag emblazoned with the FN logo.

Buhrlesque also identifies another multinational conglomerate, Oerlikon-Bührle of Zurich, with the South African regime. Known internationally for the shoes of its Bally Division, Oerlikon-Bührle also has equipped the South African Defense Force for years with naval cannon, antiaircraft guns, and motorized vehicle armaments. Its chairman and CEO, Dr. Dietrich Buhrle, moreover, is a strong supporter of the arts through the Kunsthaus Zurich. Thus *Buhrlesque* sets out a Bally man's and woman's shoe on their boxes on top of a marble altarlike table with Janus heads done in relief. Red and white candles are set in the shoes, dripping wax over them and their boxes. Underneath the shoes and spread over the table is a black table cloth with embroidery and appliqués of Bally handbags and shoes on one side and Oerlikon antiaircraft guns and fire control systems on the other. The cloth is ringed with outlines of gun cartridges, South African Defense Force badges, and Oerlikon logos intermixed with lines of text listing Oerlikon-Bally and the South Africa Defense Force. Finally, a framed cover page from *Paratus*, a South African Defense Force journal, shows a detachment of South African troops marching on goodwill exercises held in Switzerland during 1984.

Virtually all of Haacke's efforts reexamine how state and corporate support for the arts is engineered purposely to create artistic support for the corporate and state spheres of power. In one way or another, we all live now in a totally administered society in which

even the alleged autonomy of art is destroyed as artworks become permanently mobilized to mystify and/or beautify the power-seeking agendas of state bureaucrats and corporate managerial boards. And, while the business and government caretakers of this totality would have us ignore or repress our apprehensions about their generous support to the arts, Haacke struggles to constantly rewire our circuits, reversing the polarities of our consciousness to at least confront the ironies of these realities.

On Social Grease (1975) excoriates as it memorializes the cynical investments of major corporations in the art world as a public relations ploy. Using six magnesium plates with photoengraved text, Haacke presents piece by piece the logic working in managerial suites with regard to art. On one, Robert Kingsley states, "EXXON's support of the arts serves as a social lubricant. And if business is to continue in big cities, it needs a more lubricated environment." This lubricant, as President Nixon claims on another, also works transnationally, tearing down national borders with images of American greatness: "The excellence of the American product in the arts has won world wide recognition. The arts have a rare capacity to help heal divisions among our people and to vault some of the barriers that divide the world." Actually, the alleged autonomy of art is invisible to capital, according to the plate quoting Frank Stanton: "But the significant thing is that increasing recognition in the business world that the arts are not a thing apart, that they have to do with all aspects of life, including business—that they are, in fact, essential to business." Thus art is an essential asset that must be part of every serious firm's capital accounts. On his plate, David Rockefeller claims, "From an economic stand point, such involvement in the arts can mean direct and tangible benefits. It can provide a company with extensive publicity and advertising, a brighter public reputation, and an improved corporate image. It can build better customer relations, a readier acceptance of company products, and a superior appraisal of their quality. Promotion of the arts can improve the morale of employees and help attract qualified personnel." Art, then, becomes the multipurpose business tool of the current era. Its intellectual content is irrelevant; as Nelson Rockefeller's quotation on artistic appreciation asserts, if it feels

good then it is good. And, finally, as Douglas Dillion observes, it almost always feels good, because art can return "dividends far out of proportion to the actual investment required."

With these plates Haacke exposes a deeper logic, if not the ultimate force, animating corporate capital's enthusiasm for associating directly with the forces of aesthetic representation. Wealthy individuals, of course, have always used art patronage to preserve their ideological interests or exalt their social status. The difference today is that corporate patronage institutionalizes the self-interests of corporations as the essence of contemporary culture; thus "art for art's sake" is always actually art for capital's sake as investment in art enables firms to commodify and accumulate goodwill, public repute, and honored status as integral parts of their business strategies. The power of giving or creating meaning, once ignored by capital, now can be applied as the social grease of good civic standing or productive labor relations within the company. Art buys legitimacy, identity, and acceptance, even when one's corporate product otherwise might be creating corruption, dissatisfaction, and animosity.

Oelgemaelde, Hommage à Marcel Broodthaers [Oil Painting, Homage to Marcel Broodthaers] (1982) has become one of Haacke's most widely recognized works. Playing upon Broodthaers's manipulation of the museum and its workings, this installation includes an oil painting of Ronald Reagan separated by an entire room from a large photomural of a 35-mm shot printed off complete with its film sprocket tracks like a proof sheet. The two images are both bound together and deeply divided by a red carpet. Photos of antinuclear or peace protests often are used in the mural. In Charlotte, however, the installation of the imperious Reagan oil on one wall behind a red velvet rope held by brass stanchions faced down the long red carpet to a huge blow-up of three peasants on a dirt road near San José de Bocay in Nicaragua. The shot was made on July 16, 1987. One man carries a small cross and box. A girl with a bundle accompanies him, and another man bearing a small child's coffin. The regal arrogance and disdain of Reagan's oil portrait in a gold frame under a picture lamp linked by the red carpet of power and authority to the image of three suffering *campesinos* succinctly

sums up the contradictions of the Reagan Doctrine. Like his *The Safety Net* (1982), *Reaganomics* (1982–1983), and *We Bring Good Things to Life* (1983), Haacke uses the image of Reagan, the neo-imperial president, to expose the absurdities and irrationalities of the policies created in his name by the American state. The image of authority accepted as so empowering and renewing behind the red velvet rope in America results, in turn, in resistance or suffering once this renewed power rolls down its red carpets of application and touches its final objects.

Several of Haacke's efforts also focus on the logic of commodification underpinning the production and consumption of art. In this show Haacke presented his *Seurat's "Les Poseuses" (small version), 1888–1975* (1975), which traces the ownership and growing cash value of Seurat's "Les Poseuses" (small version). Haacke's fourteen framed panels each feature a color reproduction of Seurat's painting and a brief bio on its various subsequent owners. Following Seurat's death at thirty-two in 1891, the painting, which basically was unappreciated during the painter's lifetime, was given to his biographer, Jules F. Christophe, who in turn gave it to his son. Acquired after 1892 by B. A. Edynski and Max Hochschiller, it was purchased in 1909 by twin brothers from Belgium, Josse and Gaston Bernheim-Jeune, who were fashionable art dealers in Paris. By now, Seurat had acquired greater interest in the fashion flows of the international art markets, and the painting begins to gain increasing value with each subsequent sale: purchased for 4,000 French francs in 1910 by Alphonse Kann; purchased by Marius de Zayas around 1913 for an unknown price; purchased by John Quinn in 1922 for $5,500; inherited by his sister, Julia Quinn Anderson in 1924; inherited by her daughter, Mary Anderson Conroy in 1934; purchased in 1936 by Henry P. McIlhenny for $40,000; sold at auction in 1970 for $1,033,200 to Artemis, S.A., a Luxembourg art investment and sales partnership, which held a half share with Richard L. Feigen until it was sold in 1971 to Heinz Berggruen for an unknown amount. From 1975 until 1986, Seurat's painting was on loan to the Bavarian State Museum in Munich, then it went on display at the Metropolitan Museum of Art in New York. In tracing this trajectory of ownership in his installation, Haacke reveals the growing

corporate penetration of the artistic world, bringing with it rapidly increasing art prices and the collaborative partnership of art museums seeking the patronage of display by the art investment groups and corporate managers who increasingly hold title to artwork after the 1960s. Indeed, big-money center banks in the 1970s, 1980s, and 1990s have allowed their "high net worth clients" to call upon major lines of credit to buy art works on time, like any other installment loan purchase, ranging from Roll Royces to real estate.

Haacke's works not only reappraise the politics of representation as such, as he plays upon the codes, images, and symbols that generate value or power in society. He also takes to task the entire art world as it has succumbed to corporate penetration and rationalization in order to survive in an era of rising inflation and expectations. *MetroMobiltan* (1985), for example, again explores the mutual use and abuse practiced by art museums, corporations, and the public in the solicitation of corporate support for the arts. These games are well known. Museum fund-raisers sell tables for dinners to major banks and big firms, knowing full well that their company personnel will use them to network deals and conduct business as part of this tax-deductible support for the arts. Likewise, corporations buy good public relations and expansive advertising exposure by subsidizing big-time art exhibitions for "the public good." Haacke wants to reveal how capital is changing society, art, and the museum from the inside, seeping into the molecules of their institutional structure, transforming them from within. He represents this shift by reconstituting the classical entablature of the Metropolitan Museum into a billboard of corporate benevolence and power. This work plainly grasps at and then gives form to the inchoate, undefined, unfixed forces at work in everyday life just behind, beneath, or beyond the surfaces as they continue to transform the economy and society.

This massive installation, then, works at several levels by taking on both big businesses, like Mobil Oil, and the enthusiastic pandering of major art museums, like New York's Metropolitan Museum of Art, virtually to any willing corporate donor. The massive installation mimics the Metropolitan's immense presence on Fifth Avenue with a foundation of eight granitelike blocks under a neo-

classical entablature with an elaborate cornice of alternating muse faces and rondels over scroll arcs. These architectural details are used as signs of an institution drenched in traditional cultural authority. Three banners, appearing somewhat like columns, hang from the architrave in front of a large photomural of an African funeral procession outside Capetown in South Africa. The center banner advertises a 1980 exhibit, "Treasures of Ancient Nigeria," supported by a grant from Mobil. Such a show, of course, epitomizes Mobil's efforts to cloak itself in the aura of good aesthetic citizenship and the prestige of the Metropolitan Museum. Given its extensive petroleum operations in Nigeria, Mobil sees such shows as "giving something back" by popularizing Nigerian art as it piggy-backs its advertising on the art promos. While it touts this side of its African operations, it usually hides its activities in South Africa, like supplying the South African security forces with a significant percentage of their petroleum products. Hence the two banners flanking the Nigerian exhibition banner are drawn from Mobil statements to stockholder pleas for divestiture of its South African assets. One, using Mobil ad typefaces and logos, states, "Mobil management in New York believes that its South African subsidiaries' sales to the police and the military are but a small part of its total sales. . . . Mobil." The other one similarly done suggests, "Total denial of supplies to the police and military forces of a host country is hardly consistent with an image of responsible citizenship in that country. Mobil."

Behind these banners in counterpoint is the photomural of a funeral procession for several blacks gunned down by the police in the Crossroads outside of Capetown. While it extends its art patronage to ancient Nigeria, then, Mobil sells the fuel that South Africa uses to run its cops out into Crossroads or Soweto to shoot blacks. Both are done in the name of responsible citizenship everywhere Mobil operates. Yet, most problematically, the Metropolitan Museum—in order to keep its doors open—swings them wide to such corporate supporters. The autonomous sphere of art, once again, is shown to be a signboard for corporate capital. Haacke appropriates from a museum promotional leaflet, "The Business Behind Art Knows the Art of Good Business—Your Company and the Metropolitan Mu-

seum of Art," a line that he puts on its own scroll in the center of the frieze, above the Mobil banners. That is, the Metropolitan Museum—the self-styled traditional keeper of art's flame—assures its corporate patrons that "many public relations opportunities are available through the sponsorship of programs, special exhibitions and services. These can often provide a creative and cost effective answer to a specific marketing objective, particularly where international, governmental or consumer relations may be a fundamental concern." The installation effectively reduces and combines the contradictions and conflicts of corporate art patronage, revealing how art for corporate managers often simply becomes a new marketing tool to smooth over bumpy issues in public relations. Why? Basically, because art museums sell them the opportunities for making such communications to up-scale art consumers.

With this massive infusion of corporate funds, the cultural place and meaning of the museum gradually has become totally transformed. Rather than serving as a repository of society's accumulated aesthetic work, arranged to make such treasures available and accessible to those publics who would come to enjoy them, the museum increasingly serves as a corporate screen, giving business firms a positive public personality—tied now to art, culture, or enlightenment—that otherwise would appear to be aloof, vague, or threatening. Huge inflows of corporate funding essentially have eroded away the last pretense of art's autonomy. Art today is good for business, and what is good for business is good for the larger economy and society.

Taking Stock (unfinished) (1983–1984) is, in certain respects, Haacke's most unconventional work in that it "looks" like "art." Here, he presents an essentially representational neoclassical oil painting set into an immense gilded frame. Yet it also parodies the regal and imperial images of traditional court painting by representing Conservative Prime Minister Margaret Thatcher in an opulent Victorian drawing room decorated with the signs of her political image consultants, corporate campaign contributors, and the monied scions of the London art scene. The Prime Minister is painted in one of her favorite blue gowns, commonly seen in public relations images, with her head cocked up in the same imperial air as

Reagan in *Homage to Marcel Broodthaers*. She sits on a chair from the Victoria and Albert Museum with Queen Victoria's image stitched into the back. On the table next to her is a small marble sculpture of Pandora by Harry Bates. And behind her, in a grand bookcase, are shelves of books with corporate names, museums, party organizations, and media groups listed on the spines—ranging from Avis, British Airways, Cunard, and Dupont to Nestlé, Playtex, Walt Disney, and Wrangler. At the top of the bookcase are two cracked plates, a pun on Julian Schnabel and his broken crockery canvases, depicting Maurice and Charles Saatchi—the advertising moguls who ran Thatcher's 1979 and 1983 campaigns as well as two of the key art speculators in the 1980s international art market. Saatchi and Saatchi Company has expanded internationally through corporate takeovers to become one of the fastest growing and largest advertising companies in the world, with 150 offices in nearly 50 countries. Along with this growth, the Saatchi brothers also have invested heavily in the art world, creating superstars through their intense patronage, ranging from Schnabel to Clemente to Baselitz to Chia.

The layers of attack in this work are both complex and intense. In a sense, it is a fragmentary summation of power in Great Britain, and to an extent the United States in the 1980s. As we all recognize during today's TV-driven electoral campaigns, image is power. And power is made greater by the signs of authority, prestige, or knowledge coded into the image. Haacke's inscription of corporate names and consulting firm logos on these coded accoutrements of power suggests how popular images of democratic leadership are becoming simply another satisfying corporate product for mass consumer markets. Today's evaporation of the boundaries between art, politics, the media, culture, advertising, and capital media-borne images of authority all can be read in this one image. The brash need of such new unchecked power for the legitimating symbols of traditional authority to cloak their control in the forms and myths of aristocratic/*haute bourgeois* culture all actively seethes within Haacke's painting. In the rich frame of dead imperial forms, a prim middle-class drone like Thatcher absurdly pretends to take on Victoria's aura as she rides along on the backs of Gillette, Johnson & Johnson, IBM and Max Factor as a Saatchi-produced media image.

Haacke's works, then, more fully disclose how big business has closely co-opted art and art museums to serve as a screen for its activities. In one sense, the funding of art exhibitions or the patron-age of artists provides capital with immense and immediately acces-sible surfaces to project positive images of good corporate citizen-ship. Goodyear already has scooped the Fortune 500 on the roving blimp as a PR-gimmick; hence the rest of big business has settled upon bank-rolling the wanderings of major art exhibitions on na-tionwide or intercontinential road shows. Such benevolence con-nects the corporate logo with artistic vision, fusing the business and its marketing dreams with the flowering of artistic excellence. Cap-ital thereby can "prove" its tolerance, wisdom, or civic spiritedness by funding the popularization of esoteric, shocking, or even con-troversial art.

Yet, in another sense, this instrumentalization of art to serve as the screen of big business's good intentions also consciously serves to screen the sordid underside of corporate capital's everyday opera-tions. In seeking to use art as a screen to project its positive corpo-rate images, big business simultaneously puts art into service as a screen to hide exactly how it realizes significant rates of return on equity in slums, arms trafficking, South Africa, or unsafe factories. Haacke's works, from *On Social Grease* to *MetroMobiltan*, show there is no "free lunch" in the art world. Whether they are funded by wealthy individual patrons, corporate public relations funds, or state cultural endowments, museums are an integral component in the present-day management of mass consciousness. At best, Haacke's installations try to freeze into solid material form the cynical spirit of corporate self-promotion, turning the shallow as-sumptions of its smug authority and aggrandized altruism back upon itself with new critical antisystemic derivations.

Art and radical praxis, according to critical theory, share com-mon goals and flow from identical motives; namely, "both envision a universe which, while originating in the given social relation-ships, also liberates individuals from these relationships."[4] Radical political activity and aesthetic creativity both break down the bar-riers dividing society and trapping individuals in conditions of limited freedom. By facing and contradicting unfreedom, as Haacke attempts in his installations, art often can become autono-

mous and critical, if only for a moment. So, through art, "subjects and objects encounter the appearance of that autonomy which is denied to them in their society. The encounter with the truth of art happens in the estranging language and images which make perceptible, visible, and audible that which is no longer, or not yet, perceived, said, and heard in everyday life."[5]

While acknowledging that society, the state, and nature were not made for the sake of satisfying individual human beings, art carries certain truths or points of faith about emancipatory human subjectivity. The world rarely changes, but it can, in fact, periodically be changed. Therefore, art perpetuates the same mythic hopes motivating all revolutionary projects. As Marcuse explains, "Inasmuch as art preserves, with the promise of happiness, the memory of the goals that failed, it can enter, as a 'regulative idea,' the desperate struggle for changing the world. Against all fetishism of the productive forces, against the continued enslavement of individuals by the objective conditions (which remain those of domination), art represents the ultimate goal of all revolutions: the freedom and happiness of the individual."[6] Haacke's works perhaps struggle, in part, to realize political ends that run parallel to Marcuse's linkage of art and radical praxis. Nonetheless, Haacke also recognizes that radical artists and critical art works operate under definite constraints; that is, "while art bears witness to the necessity of liberation, it also testifies to its limits. What has been done cannot be undone; what has passed cannot be recaptured."[7]

Because he believes a free democratic society demands his sort of aesthetic critique to keep it honest about art's place in the consciousness industry, Haacke continues to broaden his attacks and increase their force on these new networks of power. Nonetheless, Haacke's work also has won accolades from a few critics, including Lucy Lippard and Rosalind Krauss, and some of his pieces have found their way into major museums in New York, Philadelphia, Miami, Berlin, Stockholm, and Ghent as permanent acquisitions or parts of major exhibitions. Even though Haacke is still one of the contemporary art world's bad boys, he has managed to escape complete marginalization as well as capitalize somewhat upon his outlaw approach to art production and presentation.

Thus, once again, the underlying strength of the very regime

Haacke is assaulting proves its ideological resilience by assisting him and others to present his fairly critical artistic works to the national art-viewing public. On one level, Haacke's critique uses the same language and communication style as corporate advertisers to make his political points, remaining trapped to some extent within their outlooks and assumptions. And, on another level, Haacke's critical installations, which relentlessly indict the cultural costs of state and corporate funding for the arts, continue on their nationwide road trip courtesy of generous funding from the state and corporate sector. Still, in a sense, Haacke has the last say since the retrospective itself is, as the catalog claims, "unfinished business." On this last level, Haacke ironically countercodes the prevailing categories of museum display behind the entire exhibition. As an installation of installations, the whole presentation does repeat at each stop the same critical questions about art, the state, big business, and the museum raised by both his individual works and the donated corporate dollars used by each gallery to underwrite their display.

Pure War in the Zero World

In his 1969 *Essay on Liberation*, Herbert Marcuse issued a revolutionary manifesto on the behalf of the underclass, the losers, and the outsiders of society, who had been ignored in the radical programs of Marxian socialism.[1] Sue Coe's art is the necessary afterword to Marcuse's call for the 1980s and 1990s. Her work shows how little of Marcuse's vision has been fulfilled as well as why it is even more pressing today. While she may prefer to see herself as a "message artist" rather than a "political artist," her oils, drawings, collages, and mixed media are among today's most savage criticisms of public life under Reaganized/Thatcherized democratic capitalism. The force of her criticism was clear in the exhibit "Police State," which was presented at Virginia Commonwealth University in 1986.[2]

In an age in which Michael Mann "deepens the chroma" on *Miami Vice* to further mystify how the war of all against all has become ordinary Friday night entertainment, Coe's stark monochromatic messages are deeply disturbing. Her work immediately recalls Weimar from our memory. The dark satire and horrified shock of German Expressionism, facing *Mitteleuropa* after the deluge, whisper at us from just behind the frames and mats. Her images of riot police, drug overdoses, CIA torturers, and bloody Pentagon officers appear and reappear as frequently as George Grosz's bloated burghers and Prussian Junkers. Black, white, and gray dominate Coe's art, but she frequently streaks it in yellow and splatters her figures with red, bleeding them into a blackened background of systematic, naturalized fascism. *Bothatcher* (1986), for example, casts Britain's Prime Minister Thatcher and South African President Botha as the two heads of a giant swastika-marked spider

being swept out of Africa and Great Britain by a young boy. Ironically, its antifascist message references those prewar Nazi wall posters that depicted Aryan SA men sweeping deviants, Jews, and Communists out of war-ravaged Germany.

With such stylistic parallels as well as her explicit inclusion of death's heads, storm troopers, and swastikas, Coe subtextually draws Hitlerite totalitarianism into the everyday life of the post-1945 global system. Playing upon the cinema-vision and television-consciousness of post-war generations that equate Nazism with absolute evil, she recodes normal symbols of civic order as signs of dreadful terror, even though the meaning of these symbols is increasingly problematic among audiences who often no longer share common understandings of such historical references. Thus Coe's pictures, like *"We Come Grinning into Your Paradise"* (1982), *How to Commit Suicide in South Africa* (1982), *Woman Tied to a Pole* (1985), *Romance in the Age of Raygun* (1984), *Police State* (1985), or *The Contract* (1985), achieve the ultimate in message or political art: like Bosch, Goya, Orozco, Grosz, or Diego Rivera, they bring a new, dark consciousness to the viewer of how terrible everyday life actually can be behind what normally seems to be.

Conventional theories of world order suggest that a liberal democratic First World is struggling with a bureaucratic centralist Second World for the right to impose capitalism or socialism on the industrializing mixed economies of the Third World. After Auschwitz, Hiroshima, and the Gulag, however, Coe's illustrations reveal how progressive theories about neatly numbered political worlds are a null series that always returns to zero. Her art supports Paul Virilio and Sylvere Lotringer's belief that all states are nothing but war machines, conducting "pure war" against their domestic and foreign populations.[3] Her *Too Late, Greed, The Money Temple* (1985), *Homeless Women in Penn Station* (1985), *Haiti* (1985), or *Union Carbide* (1986) all suggest that a small coalition of big capital, state bureaucrats, threatened bourgeois property owners, and the security forces are now allied against the masses of outsiders, workers, and their sympathizers.

Despite the "defeat" of fascism in the 1940s, Coe's art envisions settings where all worlds have become hyper-fascist—complete

with standing armies, secret security forces, underclass ghettoes, police states, war for profit, secret gulags, and brutalized social relations. In the perversions of power, public life devolves to a base instinctual level in this new all-encompassing Zero World. Behind the official masks of democracy, socialism, or development, Coe sees one deformed face—the police state. In her *Police State* exhibition, the state is a vicious beast, gazing out at the viewer and down upon the riot police "normalizing" mass political behavior with their truncheons. Coe's Zero World is full of such predatory police states, fascist in form and function, which she epitomizes in Botha's South Africa, Thatcherite Britain, and Reagan's America. Their vicious debasement of the poor and powerless is now necessary, because nuclear weapons make foreign conquests much more dangerous. Unable to pursue abroad what Virilio and Lotringer describe as "exocolonization," the modern police state engages in the "endocolonization" of its own citizens or in its immediate sphere of influence to sustain the cycles of capital accumulation.[4] Coe's protest art honestly articulates her own sincere commitments to progressively advancing popular struggles. And, while she constantly reassesses the extent and meaning of her considerable financial success, it is clear from this material success that much of her art is speaking to audiences and patrons far beyond the working class viewers she sees herself addressing. Indeed, the exhibition featured, for example, an entire room devoted exclusively to works by Coe that have run in the *New York Times* op-ed pages—a site rarely visited by the working class or underclass subjects she depicts in her art, but one which wealthy art buyers pass through every day.

Even so, this relentless fascination with the results of violent endocolonization surfaces plainly in Coe's focus on zones of conflict or sites of power, where blacks, women, the poor, punks, or underdeveloped societies confront the police state. For example, in her *Haiti*, vultures dressed as capitalists bleed Haiti with their talons as its citizens try to dislodge them with only a broom. The accompanying text from Malcolm X expresses Coe's vision of capitalist reproduction in the Zero World: "Capitalism used to be an eagle, but now it's more like a vulture. It used to be strong enough to go and suck anybody's blood whether they were strong or not. But

now it has become more cowardly, like the vulture, and it can only suck the blood of the helpless." While Malcolm X also spoke of hopes for real freedom once the poor nations freed themselves from capitalism, which would force the capitalists into collapse as they lost their victims, Coe's art documents how wrong he was. Yet she perhaps also misleads her audiences, much like Malcolm X did before her, by simplistically obscuring the more subtle and ideological ways that capitalism actually works today.

Coe's images reveal some important insights about the workings of transnational capitalism as it now integrates even the state socialist and many Third World nationalist states into the networks of global commodity production and consumption. All states—liberal democratic, Marxist-Leninist, radical Islamic, or military authoritarian—can become oppressive police regimes, waging pure war against the masses to win plunder for the elites. One either is victim or victimizer, target or shooter, prey or predator. Again, echoing Marcuse, Coe's artistic summation of the banality of these evils reveals "one-dimensional man" destroying "humanity" across wide areas of the Zero World. While glimmerings of redemption show up in *NO People's Republic* (1983), *"England is a Bitch"* (1982), *"Welcome to R.A.F. Greenham Common"* (1984), *Your Class Enemy* (1985) or *How To Commit Suicide in South Africa*, it is only the weak hope that more Stephen Bikos, Soweto students, or Greenham Common women will accept martyrdom at the hands of the police state. After the Third Reich, Coe paints today's Pax Americana as just another hyper-rationalized, regressive regime, which frees the reptilian nature of men for rape, murder, lust, and greed in the technological efficiency of Pentagon war machines. Like Marcuse's *One-Dimensional Man*, Coe's oeuvre overstates the negatives to show how evil continuously oozes from the happy positives of corporate consumer culture.[5] In this respect, she also is being unfair about liberal democracy, but her obvious exaggerations highlight how precious such free spaces become for taking direct actions against the state as war machine.

Her representations are anything but photorealistic. She is ardently expressionist, choosing the one part that wholly sums up a bad totality and pushing it to its logically terrible extreme. This

synecdochic style nevertheless finds truths in excess which are tremendously real. Coe's images frequently appear as hard-hitting graphics for newspaper op-ed pieces or magazine cover spreads. Her illustrations, then, can become special sidebars of caustic comment in themselves. And, ironically, many of her subjects—including London punk riots, Biko's "suicide," the Rhode Island gang rape, Bernard Goetz the vigilante, or Malcolm X's assassination—are glossed out of newspaper tabloid headlines. Since brutal atrocities are routine in the Zero World, Coe "refunctions" tabloid headlines and subheads to accentuate how the terror of murder, rape, and assassination become sublime moments to be displayed openly rather than mystified. Thus *Police State*, the painting, the book, and the exposition, is a tableau vivant of pure war waged against subject peoples everywhere. Underneath, we find that South Africa, like Chernobyl or Three Mile Island, is everywhere: U.S.A/Harlem = S.A./Soweto = U.K./Brixton. Agreeing with Foucault, Coe shows how "man is dead," or at least dying in the twentieth century. The world she creates is one in which everyone—dignified human beings as well as free democratic citizens—either already is a *desaparecido* or merely is awaiting the knock at the door.

"We Come Grinning Into Your Paradise" sums up all of these themes. In what could be Gestapo, CIA, SAS, or BOSS headquarters, Coe shows the body of humanity being flailed and flayed alive by smirking, shrieking demonic torturers led by a CIA wolfman, whose hands are gloved in dollar and pound signs. The body is marked by many stigmata. These odious insignia of repressive regimes—a hyena head (Argentina), a rattlesnake skull (Haiti), a rat (Chile), a wasp (El Salvador), etc.—are stamped on the body's thighs and torso. To maintain the consumer paradise, the biopower of the body must be extracted by the endocolonization of capital, the CIA, and their henchmen. Each and every body of humanity will submit to its special discipline and punishment on the torture table or in the marketplace.

This reduction of the body and humanity to a "soft target" also grounds *Baboon Heart Transplant* (1984) and *Pentagon Wound Lab (Soft Targets): If Animals Believed in God Then the Devil Would Look*

Like a Human Being (1985). Here the animal body and human body are reduced to purely instrumental objects for macabre experiments—mixing and matching ape and human hearts, testing small arms fire on farm animals, or trying out crackpot surgical techniques on household pets. Both implicitly cite Nazi medical experiments on death camp inmates—Jews as baboons, cats, or dogs; baboons, cats, or dogs as Jews—during the Holocaust. What once was terrible now is naturalized for celebration on the six o'clock news as medical progress and careful scientific research in the Zero World.

As powerless bodies, women are the ultimate soft targets in Coe's vision of these male-dominated, capitalist war machines. In *The Money Temple*, a nude woman bends over and holds her ankles on a gaming table under the lecherous gaze of male casino players. The police state's pure war of violent degradation against its own population takes the form of rape in her *Woman Tied to a Pole*.[6] Similarly, in *Romance in the Age of Raygun* and *"Woman Walks into Bar—Is Raped by Four Men on the Pool Table While Twenty Watch,"* (1983) the female body on the pool table is humanity on the torture table. In both of these mixed media works, the woman merely is an animate object of domination—the soft target of male sexuality. Pool cues gouge her flesh, cigarette butts are stubbed out on her skin, and sniggering tormentors hold her on the table by her hair. The woman now is reduced to nothing but the squirming prey of lizard-souled men seeking their "entertainment tonight" under the sign of a Miller High-Life can.

Coe's exhibit circulates between the two powerful dipoles of angst and irony. In the realm of angst, art imitates a globalized fascist *Machtstaat*. The *Police State* "book" actually is a trifold portfolio of reproductions that mimics and parodies a secret police dossier.[7] Its inside leaf is a select bibliography of Sue Coe criticism, a photo of the artist, a catalog essay by Donald Kuspit, and an introduction to the artist by the Anderson Gallery director, Marilyn A. Zeitlin. The leaves of the file are banded in black or red like a state police rap sheet. The first sheet is the exhibit's projected itinerary and Coe's curriculum vitae. The second file is an acknowledgments and catalog page, while the third one begins with *The*

Contract, which shows a grinning Reagan with "C.I.A." and "$" stamped on his hands. Billowing like a cloud over a Contra team beheading its civilian victims, he smiles at this special Caribbean Basin Initiative. On the overleaf, a brief précis on U.S. intervention in Guatemala, El Salvador, and Nicaragua anchors a smaller illustration, *El Salvador* (1982). In this image, Central America is a charnel house with "Nixon the undead" gazing with Reagan and Alexander Haig at a very Goya-like death squad executing its victims. Nixon "the undead" in El Salvador, in turn, is overshadowed by Hitler *der Untote* in the entire Zero World.

Yet, on another level in the dimension of irony, the professional packaging of Coe's presentation belies her messages. In particular, Kuspit's politically naive claims in the catalog essay that Coe, first, gives an important voice to the underclass in an oppressive system, and that, second, "to give them a voice is already to begin to overthrow that system,"[8] are totally overdrawn. Coe's pictures reflect how easily and often any established state power can silence strong voices advocating its abolition or transformation. Likewise, Coe's own book *X* on Malcolm X shows that the underclass can and must speak for itself.[9] History already is overburdened with self-appointed "voices" from the middle class or intelligentsia speaking as Jacobin champions of the masses. It may begin nobly enough with a Herzen or Turgenev, but it almost always concludes in Beria, Stalin, or Yezhov. Kuspit assumes that the middle classes and the underclass are separated; therefore, the outsiders need spokesmen among the progressive bourgeoisie to mobilize aid and deliver them relief. Coe, in fact, shows this assumption as a lie, because the Zero World is all of one piece. We all create and/or reside in Ulster, Soweto, Harlem, Ethiopia, or West Beirut.

Moreover, let's face it. Doing some graphics for the *New York Times* op-ed pages or a few gallery showings is not Bolshevik box-car art rolling out to mobilize the proles and peasants of the hinterland. The *Police State* exhibition, thanks to private- and public-sector funding, was slated to appear in seven mainly New South/New West service cities or Midwestern/Northeastern university galleries. More importantly, as the Anderson Gallery's press packet states, "this exhibition, tour, and the 'Police State' catalogue are

supported in part by a grant from the National Endowment for the Arts, a federal agency, Washington, D.C." There is no denying the caustic critique of Coe's works. Yet, police states waging pure war against their own citizens in today's Zero World have little to fear from such diverting sideshows as they travel through a few New Class professional-technical neighborhoods. Part of her work perhaps serves a personal-level political agenda, allowing dispossessed or abused audiences some moments of catharsis, while another part undoubtedly functions as imaginary mobilizations of popular outrage over the violent results of repression, exploitation, and domination. On one level, these effects might constitute victories enough to cap small, partial struggles against the established order. Yet, on another level, the elites, who benefit from this order, also have turned Coe's radical artistic indictments either into extensively collected objects of capital accumulation in contemporary art markets or highly visible expressions of official pathos in the white cubes of assorted art museums.

This strategy of containment is quite surprising, because Coe's art still is savage stuff. In her landscapes of the police state's sites of power, Coe produces many shocking images: Ronald (Raygun) Reagan playing with his MX missile phallus in a warm bath of human blood poured out of headless corpses by CIA butchers; Pope John Paul II in a swastika collar blessing riot troopers at Bobby Sands's deathbed as Margaret Thatcher turns away with bloody hands and breathing fire; England as "Airstrip One" as U.S. bombers depart on a desperate mission perhaps to murder Khaddafi and his family in their beds; Prince Charles in a crown of crosses enjoying oral sex with Princess Di in a crown of spikes during a punk/police riot in London; and U.S. warplanes frying the residents of a mental hospital and kindergarten on Grenada. Yet Kuspit and others fail to see that even these images are not really radical in a world run by state sadists. After mass media consumers take their daily doses of Idi Amin, the Khmer Rouge, Emperor Bokassa, Jonestown, Beirut, Afghanistan, and Central America from their morning papers or nightly news broadcasts, even Coe's art verges on becoming simply political wallpaper. Indeed, if Reagan's own National Endowment for the Arts could subsidize a national tour for

an artist that portrays President Raygun as a he-dog screwing a she-dog Prime Minister Thatcher in Harlem while trashmen throw blacks into garbage trucks, and then package this art as a parody of a secret police file, one must doubt that "The Revolution" already has begun. Instead, such art may function only as Washington's equivalent of Beijing's ill-fated 1979 Democracy Wall: a tenuous place for furtive and flamboyant protest for the very few with access to and understanding of messages that essentially are inaccessible or incomprehensible to the rest of society.

Despite all these doubts, Coe's work in many ways remains an incredibly accurate and shockingly powerful artistic critique of the police state. As political art, its message is so overwhelming that it even paralyzes. If these horrors are only half true, what is to be done? Beyond some lame New Left hopes for the militancy of outsiders, there are no signs of a new historical subject on the horizon, the class-in-itself becoming a revolutionary class-for-itself, blazing a path to redemption. Still, Coe must be respected for this honesty as well. Like Marx, she outlines only a new "critical criticism" for today rather than some half-baked recipes for the future. Her art still could slap us back to our senses. In *Launch/ Lunch: Biological Determinism* (no date), a steel-helmeted Bonzo with many medals ponders two buttons—one marked with an ICBM, the other with a banana. Every day we repress the certain knowledge that we might have only five to twenty-five minutes to live—that is, the time-to-target of an SLBM or ICBM zeroing in on our hometowns. Yet many people already are living violent, subhuman lives at ground zero on the margins of this affluent society. Seeing and fully grasping such messages in Sue Coe's images may be the closest approximation one can have in this life to the final fear and loathing we will know for nanoseconds as our bodies (our soft targets) vaporize in the Police State's thermonuclear final solution.

13. HISPANIC ART IN THE
UNITED STATES

"This Is Not a Barrio"

When the many different movements for civil rights, ethnic pride, women's liberation, and antiwar resistance confronted the American state in the 1960s and 1970s with new claims about popular needs, the state's leadership quickly put the tools of symbolic politics into action. Unable to immediately satisfy most of these groups' material needs and political demands, an entire industry of study groups, neighborhood organizations, citizens' commissions, local development boards, and grievance panels was established by politicians to give the appearance that something of significance was being done in reaction to mass demands without doing anything significant. Non-decision and inaction in these strategies were packaged carefully to appear decisive and active. Simply simulating "responsiveness" to mass demands often was accepted as if it were a meaningful response.

One aspect of this revolution in governance through symbolic means was "discovering" and "appreciating" the art of such aggrieved "outsider" groups to develop their sense of pride as well as a larger recognition of their cultural attainments on the margins of the mainstream society. New categories of art, like "Native American art," "women's art," "radical (student) art," "gay/lesbian art," "black art," "ghetto art," "barrio art," "graffiti art," "Appalachian art," or just plain old "folk art," were suddenly discovered in new discourses of attention, analysis, and appreciation. In turn, these rapid discoveries often were funded generously, if not by liberal corporate foundations, then by city councils, county commissions, state bureaucracies, and the federal government as part of the symbolic rapid deployment forces against popular protest. Since there were no spare resources for providing jobs or decent housing, a

choice was made: let them paint murals in the barrios and ghettoes. In the main, it "worked" as a strategy of both containment and deterrence. Yet, in working, these strategies also have become institutionalized in public budgets, curatorial discourses, and popular expectations of what the art world should be doing.

With a major exhibition that toured in 1988 and 1989 "Hispanic" art gained official recognition.[1] Outside of the Southwest or the Latino neighborhoods of Florida or the Puerto Rican sections of a few northeastern ghettoes, Hispanic art is little known. If it has received any attention at all, it has been cast as an exotic folk art, like the limited treatment given to the *barrio* mural painters in Los Angeles or New Mexican folk art. This exhibit, "Hispanic Art in the United States: Thirty Contemporary Painters and Sculptors," recognized that there are many Spanish-speaking artists who now are working within several different traditions in the United States, but it also stretched too hard and too far to create a unified community where perhaps none really exists.

Like nineteenth-century Germany before its unification, the "Hispanic community" may be more of a state of mind than an actually existing entity, especially given its serious internal divisions and separate cultural identities between the different varieties of "Hispanics," like Mexicans, Cubans, Salvadorans, or Puerto Ricans. Yet, despite its many deep divisions, it is a state of mind with apparently growing aesthetic and cash value. As the many different groups of Hispanics become demographically more numerous, economically more important as markets, and politically more powerful, their artificially constructed unity in public opinion polls and demographic projections is believed, particularly by many outsiders, to be reflective of a deeper, true cultural community. This exhibition, in turn, became something of a national event in 1988. *Time* magazine devoted an entire "special issue" to an extended analysis of Hispanic culture, featuring *Miami Vice*'s Edward James Olmos on the cover and an extended review of the show inside.[2] One of the show's corporate sponsors seeking to create goodwill through its art patronage took out a two-page spread in the September 1988 *Art in America*, touting, "Suddenly a wealth of Hispanic Art is showing up in all the best places." Citing its sweep through

Houston, Washington, D.C., Miami, and Santa Fe, the notice declared, "Taking a new world of Hispanic art across America is a commitment of the AT&T Foundation. Because the diversity of vision revealed by these artists helps us understand how very much alike we all are."[3]

Hence, this show was, as this AT&T promo suggests, produced, consumed, and legitimated within some strange assumptions about a very broadly defined group of artists, namely, those who now work in America but speak Spanish and may have once lived somewhere south of the border. In the exhibition's catalog, *Hispanic Art in the United States*, Octavio Paz's introductory essay accepts the curator's somewhat ecumenical appraisal of the term *Hispanic*. That is, "Concerning the term *Hispanic*: What should we call the various Spanish-American communities living in the U.S.—the Chicanos, Puerto Ricans, Cubans, Central Americans, and so on? It seems to me that the most common term, Hispanics, covers them all in their complex unity."[4] For Paz, "the name of the group recapitulates the dual principle on which we are founded: it is the name of a collective identity composed of internal likenesses and the differences between us and others."[5] Therefore, in "Hispanicness," Paz believes that the realities of some new cultural community are not being largely invented but simply recognized. The organizing frameworks for this exhibit, however, still seem to arise from the agendas of symbolic politics in the modern American welfare state in the late twentieth century rather than some authentic transnational Hispanic community. Unable to lift up the millions of Hispanic Americans already living on the margins in America today as well as the millions more still trying to outsmart *La Migra* to get in, the public, private, and nonprofit sectors fund the art world to respond with symbolic celebrations like this one of "Hispanic" art.

Ironically, and because of cultural productions such as this one, "Hispanicness" gradually is becoming a somewhat meaningful category. If only because Anglo politicians keep hustling the Hispanic vote, corporate capital keeps chasing the Hispanic consumer, and various Hispanic leaders keep hounding the welfare state and not-for-profit sector, the outlines of some recognizable subjectivity are emerging in Hispanic culture. Even *Time*'s pop sociologizing rec-

ognizes that Hispanic music, films, television, food, and style now are used to outline a common niche or new identity for the many diverse Spanish-speaking populations.[6] Denied the possibility of holding to the particularities of their regional and national differences from Cuba, Mexico, Latin America, or New Mexico, Hispanicness serves as an identifiable address to anchor the souls of Hispanics as they are assimilated into the mainstreams of corporate culture. It is this kind of ethnicity, marked by language alone or superficial traits, that Disney might simulate at Epcot Center. Or, like the Busch Gardens theme park, Hispanicness allows, on the one hand, Spanish-speaking Americans "to come and visit the Old Country" without actually leaving the material or cultural frameworks of mainstream American culture, while, on the other, simulating the aura of various Latin American aesthetics for ordinary white-bread Anglos.

Consequently, the exhibition's vision of "Hispanic" art reverberated with the outlooks and assumptions of the modern welfare state's discourses of ethnicity. Just as they yielded to organized pressure groups in the African American, Native American, Appalachian American, and Asian American communities, state-sponsored art fests are recognizing some Hispanic artists. This show simply continues this logic of symbolic politics. Yet, as the work by these thirty contemporary artists shows, "Hispanicness" is merely a label tying together a diverse grab bag that is held closed only by curatorial prerogative. The overarching claim was "This is not a barrio," but the ethno-linguistic frame remained the main premise for its artistic presentation. And, despite the implicit disclaimers, it basically failed. The show floated in what essentially was a sympathetic cultural bureaucrat's or the liberal Anglo intellectual's view of radically different types of art done by Spanish-speaking artists.

As a result, it made about as much sense as doing a show of English-speaking artists from Canada, Hong Kong, India, New Zealand, Australia, South Africa, Zimbabwe, the Falklands, England, and America and calling it "Anglo" art. Hispanics, if they are united, have been unified by their oppression by WASP culture, their experiences with the modern welfare state, and their treatment

by contemporary mass marketing. Mexican-American, Cuban-American, Puerto Rican, New Mexican, Central American, and most Latin American artists all speak some form of Spanish. Therefore, in the curators' vision of symbolic politics and contemporary culture, they all are presented as seemingly constituting an entire new artistic tradition. Yet Hispanics are not a divided people; they are many divided peoples from entirely different countries, traditions, and cultures that no exhibition catalog can unify. The outsider's perspective on Hispanics was a central theme, but it was the curators' own "outsider" view of Hispanics that actually dominated the presentation, even as it strived to move beyond it.

There are some shared images and common themes running through a few of the artists' works, reflecting their common heritage as outsiders in an Anglo culture. The importance of the Church and its religious icons, of course, made its appearance in several works. Likewise, the Hispanics' conflicts with the white power structure and its officials fill several works. And, finally, the syncretic mix of Hispanic and Anglo cultural beliefs in popular culture provides some forms and themes, especially for many of the Chicano and Mexican-American émigré artists whose cultures have been stuck in the shadow of the United States for many decades.

The range of work in the exhibition, then, spanned the full spectrum of possible styles and schools of presentation. There were no truly superb artists in these rooms, but there were some who may yet become great. Still, a number do produce some very interesting pieces. Although his early work often has been placed in the pop art tradition, Robert Graham's current sculptures are fully in the mainstream of contemporary neoclassical practice. On the other hand, Jesús Bautista Moroles's immense granite obelisks and monoliths are fully modernist in their inspiration by modern architecture and design. And Manuel Neri's process-oriented *bas relief* sculptures of the body against planes of color and material seem more 1960s American in a political pop or anticlassicist sense.

Ultimately, the geographic scope of the exhibition was much broader than its technical range. Some fairly conventional expressionist and conceptualist work was presented by Ismael Frigerio, a Chilean; Ibsen Espada, a New York-born Puerto Rican; Carlos

Alfonzo, a Cuban; Roberto Juarez, a Chicago-born Chicano; and Arnaldo Roche, a Puerto Rican. A few of the most powerful images in the show, however, were those of Glugio Gronk Nicandro, or "Gronk," who with Harry Gamboa, Patssi Valdez and Willie Herron formed *Asco* ("Nausea") in 1972. Specializing in antiwar protests, parodies of murals, and Day of the Dead festivities, *Asco* brought out Gronk's performance side. His paintings, however, are extremely vivid, colorful, and stark images done with sharp lines and full designs, dominated by absence, loss, and chaos. *La Tormenta* (1985) shows a woman in a black, full-length, backless gown in a fuzzy black-and-white room silhouetted against a deep red window. Staring out the window with a powerful intensity in the posture of her figure, she is a perfect representation of painful anxiety. Likewise, *No Nose* (1986) shows the bottom half of a woman's face with four red roses under where her nose should be, and *Broken Blossoms Beads* (1986) depicts a woman wrestling with a grimacing/grinning skull, breaking her string of beads in the process.

Gilbert Luján's installation *Our Family Car, 1950 Chevy* (1985–1986) is a perfect expression of how *Chicanismo* can blend with Anglo popular culture in an icon of icons. The 1950 Chevy is brightly painted in a taxi-cab yellow with blue, green, and red designs blending Chicano images with the shooting-fire decals of 1950s hot rodders. Swirls of chiles, buffalo heads, lone wolves, and Indian maidens bedeck the car's sides and roof, while the dash is done out in electric blue and chili embellishments. Set within a corral on desert sand, Luján's creation also provides some 2-D cacti and desert plants with a dancing couple of zoot-suited wolves jitterbugging the night away. In one piece, Luján colorfully captures and ironically understates the popular perception of "Hispanic" art by using the mass audience's association of Hispanics with food, lowriders, zoot-suiters, the Southwest, and outsiderness in one totally effective icon of icons. Maturing in East Los Angeles, Luján's imagination is grounded in images from corporate mass culture and the worship of the automobile in California, putting him fully in the mainstream of recent Chicano art. Using wolves and wolf images, his acrylics on archival board constructions, like

Beach Couple at Santa Monica (1986) and *Hot Dog Meets La Fufú con su Poochie* (1986), extend these images in showing scenes from every-day life in Los Angeles.

Luis Jimenez's fiberglass and bronze sculptures as well as his installations, like *Honky Tonk* (1981–1986), continue Luján's focus on *Chicanismo* in depictions of working class life along the border in the Southwest. *El Chuco* (1984) and *Cruzando el Río Bravo* (Border Crossing) (1986) are rooted in the night life and economic challenges of daily living in the Southwest today. Once derided as an example of vulgarity and bad taste, Jimenez's work actually memorializes very accurately the preferences of many people in the region for color, energy, and activity. Frank Romero's *Still Life with Red Car* (1986), *Toto* (1984), and *Fritzmobile* (1984) also fit within this *Chicanismo* tradition of popular culture—much like John Valdez's *La Butterfly* (1983), *Preacher* (1983), and *Fatima* (1984), or César Augusto Martínez's *Hombre que la Gustan las Mujeres* (1986) and *El Bizco* (1985), which provide sharply defined shots of characters found every day in many communities all across contemporary California and Texas.

Popular culture for Hispanic artists, however, does not simply mean the Anglo honky-tonk bar or Chicano lowrider culture as it is celebrated by Gilbert Luján, César Augusto Martínez, and Luis Jimenez. It also denotes the folk culture and ethnic particularity of the Catholic Church with its multiple influences on family, personality, and community in Mexico and the American Southwest. In fact, a good many of the artists presented in the exhibition work within folk art traditions. New Mexican Felipe Archuleta's folk sculptures of animals are fabricated out of cottonwood, wire, twine, and other household materials, while Puerto Rican Gregorio Marzán's colorful mixed media constructions of lizards, insects, birds, and mammals echo his thirty-two years of working as a toy and doll maker in New York City. Félix López's carvings of saints are strikingly powerful and colorful sculptures fashioned out of aspen, pine and cottonwood and colored with natural pigments. Like Félix López, Luis Elgio Tapia works in the Santa Fe area and continues in the traditions of religiously inspired sculptures of re-ligious figures. Although he also works on traditional furniture and

carves figures of saints, he is most recognized for his death cart constructions—inspired by the processions of the Day of the Dead—and carved church altar screen, or *reredos*, installations. His *Reredos* (1986) is an immense installation, fashioned out of aspen and pine constructions with direct primary colors that are simple but overpowering. Pedro Perez's sculpture constructions, like *God* (1981) and *La Esmeralda* (1982), are crazy mixed media fabrications of many different colorful materials that playfully frame wild-eyed, almost batty-looking cartoon figures at their core.

Rudy Fernandez's fascinating painting-sculpture constructions are inspired by the traditional designs of *retablo* art, which usually featured the two-dimensional images of saints painted in intricate frames. His works, like *Waiting* (1985), *Mocking Me* (1985), and *Entangled* (1986), are done in wood, lead sheeting, and canvas. The images are almost commercial in their slick coolness. Hearts done in paint, wood, and lead recur in his work as do bright, vibrant colors of Southwestern deserts. Each one is marked with a white saguaro in a black heart on a red heart floating mysteriously in the composition. *Waiting* (1985) combines cacti, floating hearts, a bird, and neon borders in a lead frame. *Sal si Puedes* (1985), however, combines all his images into one complete summary. Surrounded by a large lead frame with three black hearts done in relief on the left side, a carved beavertail cactus with a lead-bound heart impaled on it frames a rooster behind the painted prickly pear cactus, which are both being dripped in blood from a human hand. Expectancy, quiet violence, and uncertainty dominate his images.

Carmen Lomas Garza's folk paintings, like *Sandía/Watermelon* (1986), *Abuelitos Piscando Nopalitos* (1979–1980), *Nopalitos Frescos* (1979), and *Curandera barriendo de susto/Faith healer sweeping away fright* (1986), are direct, simple works that look almost like Chinese proletarian art in their scale, composition, and color, as they depict scenes of everyday life in Southwestern Mexican-American neighborhoods. Similarly, her installation *Día de los Muertos Ofrenda: Homage to Frida Kahlo* (1978–86) is a vivid mixed media installation featuring construction paper cut-out designs, plates of food, a beer bottle, beads, a paper cut-out death cart, painted skulls, and various household accoutrements as an homage to the painter Frida Kahlo.

Along with Carmen Lomas Garza, the show includes only two other female artists. Patricia Gonzalez, a Colombian-born painter whose work echoes with influences from Henri Rousseau, and Lidya Buzio, a Uruguayan-born sculptor, whose landscape/architectural paintings on earthenware forms are original and striking. A bit constructivist in their conception, Buzio's works are carefully done and unusual studies in the techniques of painting, pottery, and design. As with many of these Hispanic artists, the styles of Gonzalez's and Buzio's more modernist and expressionist contributions seemed somewhat out of place in the exhibit. Yet, because they share the Spanish language with the more regionalist, American-born Hispanics, they too are made into equally "outsider" expressions of some ineffable but inescapable Hispanic vision.

Most of the artists included in this show speak to and for Southwestern Hispanics—New Mexican Hispanos, Mexican émigrés and illegals, Californian and Texan Chicanos. Demographically, this segment of Hispanic America today is the largest and most important, constituting nearly two-thirds of all Hispanics in the United States. Compared to many Cubans, for example, Mexican-Americans tend to have lower family incomes, hold fewer managerial and professional jobs, and are less likely to be college graduates. The socioeconomic profile of Mexican-Americans "fits" Anglo society's outsider image of Hispanics. Not surprisingly, then, their particular group identity and values often are taken as the definitive signs of "Hispanicness" by the larger Anglo culture. This show had a polite scattering of Cubans, Puerto Ricans and other Latin Americans in the exhibition. But the bulk of the exhibits belied its projected itinerary—opening in Houston, then on to Washington at the Corcoran, Miami at the Lowe Art Museum, Santa Fe's Museum of Fine Arts and Museum of Folk Art, Mexico City at El Centro Cultural del Arte Contemporáneo, and ending at the Brooklyn Museum in New York City.

The agendas of symbolic politics, then, intruded thoroughly into the composition and tour program of this exhibition. Of the thirty Hispanic artists included in the show, a clear edge was given to Hispano and Chicano art from America's Southwestern states as well as émigré artists from Mexico. The dominant imagery for

many of these artists is Mexican culture and its lost territories in Aztlan, stretching from the Pacific across the American Southwest to the Gulf of Mexico. Rather than touring Cleveland, St. Louis, Omaha, Portland, Little Rock, or Atlanta, where a fresh look at Hispanic art might be a new and meaningful experience, it—like any symbolic good pitched at an ethnic voting bloc—visited the denser concentrations of many different Hispanic communities in Texas, Washington, D.C., Florida, New Mexico, and New York. In addition, it served a double duty as a cultural export, "proving" symbolically Anglo America's deep appreciation of Hispanic culture to art patrons in Old Mexico.

Echoing the political strategies of the 1960s and 1970s, in turn, it made these sojourns with public funding and foundation support from AT&T, Atlantic Richfield, and the Rockefeller Foundation. In the last analysis, the show presented interesting and important glimpses of some promising contemporary artists. Yet it completely failed to make its overarching themes very convincing. By celebrating so fully the colorful, folkish, and regionalist groundings of these Hispanic artists, the show unfortunately became ensnared in the very stereotypes that it was seeking to explode from within. As the Mexican-American market and voting bloc emerge as the hot new demographic targets of the 1990s, this kind of aesthetic celebration telegraphs the coming colonization of these "Hispanic" life worlds by outside commercial and political forces. Where *Time* magazine sees "Hispanic" culture "breaking out of the barrio," one instead witnessed in this show, and many others like it, more of the rapidly advancing breakdown and breakup of the unique regional cultures that have sustained the production of these diverse artistic traditions.

Despite its dutiful declarations to the contrary, this show exposed how thoroughly the concept of "Hispanic" itself loosely glues together tremendous conflicts and contradictions. When looked at from without, on one level, as has already been suggested above, the idea of Hispanic culture is itself a weak containment zone barely able to capture and corral the contradictory identities and agendas of all the different Spanish-speaking groups, like Mexicans, Cubans, Salvadorans, Nicaraguans, Chileans, and so forth, now

living in the United States. On a second level, this tendency reflects the struggle of racial and ethnic groups in America since the 1960s as the federal bureaucracy and social activists both attempted to define and defend particularistic categories of social/cultural/racial/gender status as ideological addresses for benefits from the welfare state. Likewise, on a third level, corporate and political operatives, beginning most directly during the Nixon administration, seized upon such demographic labels as representing mass consumer markets and partisan political loyalties at which carefully engineering public relations might pitch products to boost market shares or electoral margins.

Beyond these external contradictions, however, the notion of Hispanic also bears many internal conflicts. In one sense, ethnic authenticity can be used to revitalize cultural pride and reaffirm personal worth. Yet, at the same time, "Hispanic" appears to be part of an artificially induced panic by some Mexican-Americans, Cuban-Americans, Chilean-Americans, Salvadoran-Americans, or Argentine-Americans to find a hefty demographic niche—comparable to the bureaucratically ratified niches occupied by Asian Americans or African Americans—and in this case a niche that mispresents their real cultural identities to themselves and others. In a second sense, these categories of self-imposed racial uniqueness or cultural identity often evoke and protect repressive or conservative elements in the culture, like the Church, macho patriarchy, the past, or rural simplicity, which the dominant Anglo culture also likes to see all Hispanics embracing and accepting as forces of social control as well as the proper signs of Hispanics' alleged "backwardness."[7] And, in a third sense, the aesthetic reduction of Hispanic ethnicity to a narrow range of ritualized symbolic identity, grounded upon long-gone or even mythical signs of authenticity, in itself does tremendous violence to the real diversity, richness and mystery of the many different Hispanic traditions. Yet, since the expectations of agencies, art galleries, and rich patrons are primed with these dubious notions of "Hispanicness," the artists still are trapped into grouping their visions around this symbolic golden mean of taste or face further poverty, greater obscurity, and worse neglect.

Tracing the Silhouettes from the Shadow of

the Silent Majorities

Guy Debord in his *Society of the Spectacle* argued over twenty years ago that the substance of modern life is, in fact, essentially "insubstantial" as society has become a collage of spectacles. What were once genuine cultural practices have been hollowed out from within and without as more and more individuals accept inauthentic mass mediated spectacles as their daily forms of life.[1] In the intervening years, Jean Baudrillard has claimed that "the social" itself has totally dissipated into a loosely structured chaos of many individuals forming and reforming endlessly in shifting silent majorities.[2] And, in the shadow of such silent majorities, Baudrillard sees the spread of cultural decay and political desolation as these individuals privately pursue their empty satisfactions in the sign flows of spectacle.

In many respects Roger Brown's painting and sculpture can be seen as art forms that attempt to imitate "life" in the society of the spectacle.[3] Brown's painting brings to mind a very diverse group of inspirations, ranging from American regionalists (Georgia O'Keeffe, Grant Wood, Edward Hopper, Thomas Hart Benton, and Marsden Hartley) to European surrealists (Magritte, Chirico, and Balthus). The influence of vernacular American architecture, comic strips, traditional woodcuts, and old toys also is apparent in many of his recurrent motifs. Brown's early works mainly deal with cityscapes and landscapes, presenting scenes of theater interiors, movie house exteriors, skyscrapers, and various natural settings. In works such as *Untitled (Theater Interior)* (1968), *Special Purpose* (1969), and *Central City* (1970), the forms of the cinema illustrate Brown's early interest in the silent majorities' fascination with the spectacle of modern life. His dark human figures in *Special Purpose* all are converging in the streets on a theater exterior, appar-

ently preparing to enter, while white figures in the surrounding buildings' windows emit little cartoon squiggles of surprise, anger, motion, doubt, and cursing. Likewise, his figures in *Central City* look out of two Edward Hopper-like "Nighthawk" diners at a theater entrance where all streets converge at the city center. *Untitled* depicts the fusion of spectacle and spectatorship as it looks in on a handful of isolated figures in a darkened theater watching a bedroom scene. Life is not lived, but watching is accepted as if it were living by the couch potato culture of mass media audiences.

Virtually all of Brown's paintings express this fusion of the spectator's alienated position and the flow of reified events. The indirect lighting, two-dimensional isometric perspective, and stylized figures cast every composition as a constant screen, which can call up a variety of different politically charged images in a consistent frame of visual motifs. He mixes, matches, and remixes these motifs—silhouette people with a 1940s look, art deco high rises, rich yellow windows in blue-gray walls, luminous clouds, sawtooth grass, standardized trees and bushes—in a complex and iconoclastic style that provides immediate accessibility to an entirely new world. Nonetheless, Brown investigates the alienation, emotional numbness, and the anomie of individual life in our world by portraying how the inhabitants of his world are losing their ability to become involved and engaged responsibly in a culture that is based increasingly upon spectacle.

The perspective Brown employs in most of his works, then, is that of the powerless outsider looking in on what is happening to himself as he watches himself looking in. Each painting reconstructs the unconscious screens of representation we all accept in the ever present images, films, and videos of spectacle-driven societies, which also function as the anchoring, defining, and framing points for the events Brown is painting with ironic criticism or silent rage. His strangely drawn trees, people, skies, buildings, and other tropes of composition mimic the gaze of the electronic media. Like the TV camera, his paintings seem to sum up complex events and issues in highly conventionalized shots, shopworn metaphors, and simplified graphics to move information to the masses. In doing so, he brings back into critical consciousness some of the distorting

practices of the media that we now all accept unconsciously as natural.

Beyond the artificialities of the city and the media, some of Brown's depictions of natural subjects are both subtle and direct in their beauty. *Pastoral Camouflage* (1974) sets tiny cattle and people under a Midwestern horizon-to-horizon panorama of rolling fields, sweeping Magritte-like clouds, and shadow patterns tracing across the ground. *Buttermilk Sky* (1974) moves these themes into warm yellow hills covered with squat spherical trees that are saluted by a few figures, including a cowboy with hat in hand on a rearing horse; yet this all enfolds under an ominous, gridlike sky. *Contrail Crucifix* (1975) shows jet contrails crossing over a desert scene done in rainbow colors, like some Southwestern cliff face changing in the sunset from yellow to red to blue. *Misty Morning* (1975) evokes echoes of Grant Wood's or Thomas Hart Benton's hills and trees with a truck rolling down a snaking road in the morning mist. And he directly models his *Memory of Sandhill Cranes* (1981) from a sighting of some cranes at his Lake Michigan dunes beach house and an old Japanese drawing he saw reproduced in the *New York Times*.

While his ironic outlook is not as obvious in these treatments of landscapes or natural subjects, it does, nonetheless, surface plainly in many other nature-oriented works from the 1970s and 1980s like *Sequoia* (1971), *Nassau County: A Time-Photo Alteration* (1973), *Quilted Landscape* (1973), *Safariland* (1973), *Volcanic Fields with Film Crew* (1975), *The Lewis and Clark Trail* (1979), *Irrigation of Eastern Colorado* (1981), or *Surrounded by Nature* (1986). Each of these paintings depicts the senseless objectification and commodification of nature's bounty or beauty to promote the limited designs of humanity. *Sequoia* appropriates the image (commonly circulating in a thousand tourist ads and nature shorts) of a sequoia tree with a road cut through its base. With these human "improvements," the timeless existence of another living organism is reduced to a curio—"one of Nature's oddities"—by the trappings of organized tourism—floodlights, billboards, parking lots, scenic viewpoints, and the ubiquitous intruding highway that draws spectators from all directions to view it. His unhappiness with the reduction of nature and its creatures to a spectacle is repeated in *Safariland*, which blatantly rips off

Henri Rousseau's jungle paintings with their lions and sleepers, as a sealed camper truck rolls through an artificial jungle park past pacing lions that watch the sleeping tourist ignore their habitat as he is driven through it to another tourist attraction. *Nassau County, Quilted Landscape*, and *The Lewis and Clark Trail* are stark send-ups of land speculation and natural exploitation, decrying the enclosure, paving over, subdivision, and cutting over of fields and forests simply for the sake of appropriation of greater profits. Once it is done, Brown shows the empty desolation of clearcut forest, fenced range, and suburban ticky-tackies that is left by "development."

The mass media and its endless streams of intense images mark Brown's most basic thematic grounding throughout his artistic development. Spectacle and its disassociated qualities of dramatic theater, banalized destruction, and personal desensitization clearly underpin Brown's well-known "disaster" paintings. Although they are not openly political, *Tropical Storm* (1972), *Midnight Tremor* (1972), *Ablaze and Ajar* (1973), and *Yellow Alert* (1975) document Brown's interest in how episodes of catastrophe are packaged, sold, and consumed as mediated, conventionalized products in popular journalism. His compositions allow us to stand seemingly outside time and space as he shows people, autos, furniture, and trees tumbling through the air around crumbling, swaying, and burning buildings even as some of their residents blithely ignore the disastrous event itself. This theatricalization of natural disaster is underscored by Brown with the large, stagelike ground-floor windows of his buildings, which have big stage curtains drawn back to reveal a black void. Brown's more politically charged paintings, in turn, begin to explore this void.

D-Yard Attica (1971) and *War Zone* (1971) are his reactions to the intense coverage of the Attica prison uprising and simmering international crisis in the Suez that same year. *Assassination Crucifix* (1975), *Assassination of Aldo Moro* (1978), *Jonestown* (1980), *Contemporary de Sade: John Wayne Gacy* (1981), *Wreck of the Ocean Ranger* (1982), and *Solidarity Commemorative* (1983) all are immediate expressions of shock, rage, or disgust with the senseless death and destruction that are the media's main fare. Brown's more political paintings, then, are directed at disclosing some of the essential

qualities of today's electronically packaged political reality. With the exception perhaps of *Tourists Beware: New Buffalo Speed Trap* (1985), which depicts the local fuzz in New Buffalo, Michigan (where he maintained a studio-residence) shaking down tourists for speeding, Brown is not present at these events with easel or sketch-book in hand. Nor, he observes, are we, the voting public or assembled citizenry, on hand to act as responsible, rational agents. Instead, we are all absent or hidden in our own homes backlit as shadows on the shades. At best, we stare at events happening on the mediated screens of television, *Time*, FM radio, *USA Today,* or the streets of cities as our autos, airplanes, or trains speed past.

Brown's art tries to capture and distill out the cultural substance of these electronically generated forms of civic life. Even his *The Entry of Christ into Chicago in 1976* (1976) depicts the local advent of Jesus in the Second City as a civic spectacle for the enjoyment and edification of the city's masses. As Jesus arrives downtown on a flatbed truck, he is greeted by a welcoming committee of Mayor Daley, folksingers, a Catholic churchman, and local dignitaries as a small, scattered crowd gathers on the street. Yet life in the sky-scrapers, homes, and shops largely goes on. Some spectators in the windows watch the spectacle of the Second Coming, but as many or more continue their daily routines—eating, dancing, waitress-ing, talking, ringing up purchases. Ironically, most only stand and watch Jesus, as if he were an astronaut or Bears quarterback in a ticker-tape parade, knowing after they spend a few seconds to take in the scene that they will examine its reality and significance more fully on their sets after work, since the view is always better (and more real) "on TV." Only one lone woman places a palm frond in his path, and very few even wave back at him. Jesus himself is, in fact, merely a fascinating but passing oddity that can be enjoyed more leisurely on tape during the six o'clock news.

This media-denominated perspective also appears in *American Landscape with Revolutionary Heroes* (1983). Brown lines up six great heroes of the American Revolution—Hamilton, Franklin, Jeffer-son, Washington, Marshall, and Madison—against a dark backdrop of his stylized plants and clouds (the same images used in *The Turbulent Sixties*, also in 1983), but he places their heads in the

shadows. Only the lower quadrants of these heroes' faces are dimly lighted, the rest is hidden, like the anonymous news sources interviewed in television news exposés or mock confessional product promos urging people to switch detergents. Although a slight glow emanates from all six of them, the picture is one of their historically important image and political influence now fading away into obscurity and irrelevance.

Although a few politically charged paintings, like *War Zone*, *D-Yard Attica*, and *Assassination Crucifix*, were produced by Brown in his earlier years, the bulk of these works have been done in the past decade, beginning with *Chain Reaction (When You Hear This Sound You Will Be Dead)*, *Capitol City*, and *Assassination of Aldo Moro and The Terror of the Red Brigade*, which all were done in 1978. In the *Assassination of Aldo Moro*, Brown casts Rome, like Chicago accepting Jesus, as largely indifferent to the cold-blooded Red Brigade execution of Moro. Ten cars with shot-up corpses litter Rome's streets, but Moro's car is parked near the Vatican with the pope praying from a window, "Lord listen to us," and four terrorists surveying the carnage. Moro's body is in full color and detail, but the populace, the terrorists, and the pope all remain as silhouettes under a dark, overcast sky.

Capitol City (1978) is a large (72.75 × 120 in.) canvas of Washington, D.C. centered on the mall. An inner glow lights up the Capitol, the mall itself, the Washington Monument, and the reflecting pool at the Lincoln Memorial. Yet the White House, the monument buildings, the museums, and the government buildings along Constitution, Independence, and Pennsylvania Avenues are all reduced to a less than life-size scale on a par with the city's ordinary homes. The perspective shows downtown D.C. rising to the horizon, looking almost like the rows of townhouses on San Francisco's hills. And in the streets, yards, and parks, Washingtonians go about their routines, including a little girl, a man and a woman (Amy, Jimmy, and Rosalynn Carter?) waving and looking up from the White House lawn. It is, indeed, a very "Carterite," down home, small town view of Washington after and before the imperial presidencies of Nixon and Reagan.

Juxtaposed with *Capitol City*, Brown's *Chain Reaction* is par-

ticularly powerful. About the same size (72 × 98 in.), it portrays a nuclear bomb explosion in the midst of a small city and surrounding countryside turning the clouds and sky black and orange. As in Brown's disaster paintings, the buildings' residents seem basically oblivious to the event, but hordes of small human silhouettes, like little black ants fleeing a giant can of Raid, are scurrying into the countryside away from ground zero as the mushroom cloud envelops them. Clouds and country are painted as imbricate arcs, running in reverse and seemingly forming a vise that will smash the terrified crowds in heat, smoke, and debris.

In bringing the nature of political conflicts to life, Brown registers his strong distaste for the concentrated bureaucratic, corporate, and professional powers that manage the society of the spectacle. *Land of Lincoln* (1978) shows three titan skyscrapers—the Sears Building, the Standard Oil Tower, and the John Hancock Building—towering past the clouds and over Chicago's loop and its antlike inhabitants as the shadows of these corporate giants darken what once was the land of popular egalitarian democracy. *The Decline and Fall of the American Empire* (1985) shows similar powerful forces at work destroying the common man in six panels—a real estate agent choking a homeowner in front of his house, Uncle Sam choking a taxpayer before the Capitol, a periwigged judge choking a doctor outside a hospital, a doctor choking a patient outside the hospital, a banker choking a farmer between his fields and the bank, and, finally, a corporate executive choking a consumer outside of a power plant. In all six panels, the average consumer/citizen/client is on his knees helpless to stop his exploitation.

The Modern Story of Life: A Civics Diatribe (1982), however, is plainly Brown's most overtly political painting in its marriage of twelve cells of fablelike text to three time-line panels, illustrating the state of Soviet, Chinese, and American relations as the backdrop of civil turmoil in the United States since the 1960s. On one level, in the lands of Camelot (the United States), the bear (the Soviet Union), and the panda (Communist China), good and evil, strong and weak, effective and ineffective leaders maneuver for power over each other after World War II. On another level, "an idealistic young leader" (JFK), "a new leader" (LBJ), "a leader of questionable char-

acter" (Nixon), "good but weak leaders" (Ford and Carter), and, finally, "a knight riding an elephant . . . out of the west" (Reagan) all struggle to contain the expansion of the bear and panda, while working to purge Camelot of injustices. And, on a third level, "the media or press," "the big companies like feudal lords," and "the protest groups . . . looking for new causes" all are shown inducing a carnivalesque paralysis in democracy that obscures the growing exploitation of the common man as the corporate giants and the bear benefit from the weakening of democracy, justice, and free enterprise in Camelot. Ultimately, Brown's critique on its highest level ties these strands together in an indictment of media-driven societies of the spectacle. His last cell concludes:

THE PARALYSIS OF THE GOVERNMENT THAT RESULTED FROM ALL THIS SERVED THE BEAR WELL. IT WAS NOT FOR THE MEDIA OR PRESS TO SEE ANY OF THESE PROBLEMS. THEY WERE TOO BUSY WATCHING FOR GAFFES BY THE ACTOR-KNIGHT OR FINDING CHARACTER FLAWS IN THE YOUNGEST BROTHER OF THE ASSASSINATED YOUNG IDEALISTIC LEADER. IT WAS OBVIOUS THAT WHILE THE PRESS KNEW A LOT ABOUT JOURNALISTIC TECHNIQUES, THEY KNEW VERY LITTLE ABOUT THE SUBJECTS THEY PURPORTED TO COVER. IT WAS MUCH EASIER TO SENSATIONALIZE TRIVIA, THAN TO DEAL WITH SUBSTANCE. WOULD ALL THE PROBLEMS OF CAMELOT EVER BE SOLVED? WOULD ALL CAMELOT'S NEIGHBORS BE DELUDED INTO DOMINATION BY THE BEAR, OR WOULD THEY PUT ASIDE THEIR ENVY OF CAMELOT IN ORDER TO SEE THE VIRTUES OF ITS AGE OLD SYSTEM? FOR THE ANSWER TO THIS AND OTHER QUESTIONS WE MUST WAIT FOR TIME TO PASS AND ANOTHER PAINTING.

Brown's political stance here is ironic, populist, critical, but clearly not leftist in any programmatic socialist sense. In his images the protest movements of the 1960s, 1970s, and 1980s appear to be both excessive and destructive. Indeed, for Brown, like many middle Americans, the United States has its problems, but, on balance, it is "still great to be born in the U.S.A." As a southern-born, Midwestern-based, Chicago artist with strong affinities for Southwestern and Appalachian regional styles, it is not surprising that Brown is suspicious of the *engagé* intellectual pretensions of many East Coast artists. This side of his personality is clearly outlined in

Museum without Paintings/A Commemorative of the Re-opening of the Museum of Contemporary Art (1979), *Giotto and His Friends: Getting Even* (1981), and *Silly Savages (We Will Sell No Painting before It's Dry)* (1983), which all explicitly skewer the vapid cocktail party circuit, art criticism hegemony, and trend-setting power of the New York art scene. With these paintings Brown excoriates the faddish artificialities of big city philistines to exalt the virtues of regional artists in the heartland, which is his means of "getting even" with crazy Manhattan artists caught up in European neoexpressionism.

His best lampoon of self-important intellectuals, however, is *The Latinization of North America: Latin-American Intellectuals of the Spanish Privileged Class Direct Their Marxist Terrorist Movements from Safe Quarters in Mexico City and Colombia While Their Indian Peasant Recruits Do the Fighting and Dying. Meanwhile, North American Intellectual Counterparts Forsake Their Stable Puritan Heritage of Representative Government in Imitation of Spanish-American Anarchy* (1983). Although the title obviously gives most of the story away, the painting itself is an excellent visualization of how modern Marxism-Leninism often seems to mimic in jungle fatigues an American 1950s "man in the gray flannel suit" type of corporate behavior.

Revolutionary headquarters is shown in Mexico, tied into the United States and Central America through webs of phone lines. In the executive suites, little cigar-puffing Castro clones toil away at fomenting unrest among the *gringos* to their north and the Indian *campesinos* to their south. In the United States, bodies are blown out of exploding buildings across the nation, while bands of militants give clenched-fist salutes in front of mountains and nuclear plants. Down in Central America, obscure guerrillas shoot it out in dense jungles with no clear sense of winning or losing. Yet, back in Mexico, the radical leadership pursue their upper echelon tasks: one daydreams with his feet on the desk under a Marx portrait, one seems to phone in an atrocities story to the media about another cadre with no hands, one types away at a propaganda tract, and one cariocas along with a Carmen Miranda dancer, admiring the fruit sampler on her head. Brown jabs pointedly on several levels at both the cynicism of professional revolutionaries and the gullible Cu-

banophilia, Russophilia or Sinophilia of naive sixties radicals ready to stand shoulder-to-shoulder with any Third World "revolutionist." Still, he also clearly bemoans the peasant victims in the field, who truly suffer in the military designs of white, middle-class intellectuals waging their wars, like aristocratic or bourgeois generals, from faraway headquarters in complete comfort.

Despite his apparently critical attitudes, Brown's political stance actually is very problematic. His *Presidential Portrait* (1985), for example, expresses this ambiguity perfectly. It shows Ronald and Nancy Reagan as giant heads floating in the clouds above a typical American subdivision with neat little houses, neighborhood residents, and a moving van. Still, what do the immense hovering heads mean? Are the clouds light or dark? Are the president and first lady distant and self-obsessed or are they concerned and caring? Is the moving van moving people in during prosperity or out in a recession? Are the people saluting or cursing their leaders? What is the ideological subtext? Ultimately, it can be read both ways; however, Brown's own spin on the image does seem positive, indicating a tendency toward rekindling "traditional American values."

Unfortunately, Brown is not working in a political vacuum, and his traditionalist cultural goals also link up directly with the conservative agendas of the Reagan administration's "New Beginning" in the 1980s. There are traditional American values, and, then, there are "traditional American values." Traditional American artists rarely painted the citizens of the United States as little, black, antlike people absently staring at the glitzy spectacles staged by big corporate, political, or scientific powers that dominate them from administrative office towers high above the clouds. Does the revival of "traditional values" in America mean popular participation, progressive values, face-to-face democracy, small town community, and real self-reliance, or does it really mean the resurrection of lynch mobs, Christian bigotry, white power, Social Darwinism, and official benign neglect?

In recoiling from the society of the spectacle, and the massive social transformations of modernization in America since the 1930s, the Reaganauts and neoconservatives also have failed to recognize how extensive (and probably irreversible) these changes are. And

Brown's apparent nostalgia for 1940s fashions, art deco buildings, and regionalist visions of nature is no real substitute for the now long-gone ways of life that produced such symbols. If the old-time traditions and values are merely distant memories having no resonance in post-1960s America, then what is really being (or even can be) "rekindled"? Perhaps nothing is afoot but the new agendas of corporate capitalism and the bureaucratic state for managing public affairs as vast spectacles of power as they fill the vacuum left by dying traditions. Instead of providing for the real welfare of the masses, must they dress up forced austerity in the practice of old-time virtues, like hard work, personal sacrifice, and self-reliance, to cushion the silent majorities' dread as their standard of living erodes away?

In the final analysis, Brown falls short of systematically criticizing the society of the spectacle or identifying all of its serious flaws. Instead, he sticks to his populist, regional roots, casting doubt on castles in the air built by radical intellectuals and holding true to his vision of traditional Midwestern virtues.[4] Still, in tracking the silhouettes cast by the shadows of the silent majority, Brown presents fresh perspectives on the continuing eclipse of American democracy in the expanding sweep of the spectacle. Although the stability of their basic political intuitions is quite troubling, his works do have an innovative aesthetic significance that must not be ignored.

The Ecstasy of Communication

While it is always dangerous to take artworks as nothing more than a social theory inscribed or embodied for some wider aesthetic reception, Robert Longo's art often can be connected closely to Baudrillard's reading of contemporary media-driven culture.[1] This linkage gives both Longo and Baudrillard greater communicative impact. In the ecstatic communication of informational society, Baudrillard redefines the boundaries of knowing and being as derivatives of "private telematics: each individual sees himself promoted to the controls of a hypothetical machine, isolated in a position of perfect sovereignty, at an infinite distance from his original universe; that is to say, in the same position as the astronaut in his bubble, existing in a state of weightlessness which compels the individual to remain in perpetual orbital flight and to maintain sufficient speed in zero gravity to avoid crashing into his planet of origin."[2] Standing in the shadow of the silent majorities, one might, in turn, see each of Longo's works visualizing and then concretizing one more free play of signifiers in the ecstasy of cybervideo communication. Observing these Baudrillardian bubbles of broadcast imagery, Longo also recognizes how each individual subject "becomes a pure screen, a pure absorption and resorption surface of the influent networks"[3] patched into their private telematic apparatus of televisions, personal computers, telephones, and fax machines.

This take on Longo, however, is perhaps only true by half. Rather than accepting at face value this familiar postmodernist spin on the latest Baudrillardian worldview, which often leads only to inert daydreaming in some anorexic ruins about what prove only to be cool memories, Longo's work also can be seen as contradicting Baudrillard, taking the political offensive, aggressively hitting

back, like Coe or Haacke, against the pervasive deadhead complacency engendered by televisual democracy and spectacular capitalism. In one sense, Longo's artistic assemblies do playfully combine and collide various bizarre images almost indiscriminately. Still, he also seems intent upon freefalling by himself through the current scene's electronic fuzz and video snow, much like the flying yuppie in his "Bizarre Love Triangle" New Order video, in search of some remnant of rational bedrock for staging a meaningful critical resistance.

A product of today's televisual society, Longo also has personally invested a great deal of talent in short movie experiments, music videos, and performance works, above and beyond his figurative gallery art. While the directorial presence of most music videos on MTV, VH-1, or TNN usually remains fairly unacknowledged, Longo has won considerable attention for directing several music clips, including some MTV identification break or channel logo pieces. Given his intense fascination with images from film and pop music, the music video clip is a perfect meeting ground for expressing many of his artistic and critical talents. In this field of endeavor, his sense for directing experimental cinema and mass culture television can be observed in his short film *Arena Brains* (1987) as well as music videos, like Rubén Blades's "Hope's on Hold" (1988), Vernon Reid and Living Colour's "Middle Man" (1988), World Saxophone Quartet's "Hattie Wall" (1987), R. E. M.'s "The One I Love" (1987), Megadeth's "Peace Sells" (1986), New Order's "Bizarre Love Triangle" (1986), and Golden Palomino's "Boy (Go)" (1986). Each of these works is closely matched in style and mood to his visual and plastic art creations; likewise, several of his paintings and assemblies, including *Arena Brains* (1985), *Machines in Love* (1986), and *Command* (1986), draw upon glancing images shot as scenes in his films and videos. Finally, Longo also has developed some intriguing dramatic performance works that exploit the symbolic range in different multimedia formats to examine issues of order, power, and meaning. These efforts include *Empire: A Performance Trilogy* (1981), *Killing Angels: A Performance in Two Parts* (1987), and *Solid Ashes: A Collaborative Theater Work* (1988). While these efforts are all extremely important as artistic projects, it is Longo's pictorial un

dertakings, mixed media constructions, and sculpture work that should be looked at most closely.

Longo's most enigmatic as well as perhaps emblematic works are his very unusual *Men in the Cities* series of charcoal, graphite, and ink drawings on paper, usually titled individually as *Untitled*, done mainly from 1979 to 1981. Playing off the pose of ambiguity first exploited in his appropriation of a single scene from Rainer Werner Fassbinder's 1976 film *The American Soldier* in his own enamel on cast aluminum sculpture *The American Soldier* (1977), Longo depicts everyday human forms in ambiguous events of violent suspension. In this series, for example, many images of different young, professional "beautiful people" in business clothes or evening attire are shown all decked out in totally fashionable normality; yet each one's stance jolts out all akimbo as if the figure is caught completely cold by a sudden hard blow or large-caliber bullet. Simulations of simulations, the collection of cues in each picture points toward an act of staged mass media dying. Since violence and death are marked today by particular televisual conventions, a peculiar look or specific stance, summarized by twisted contortions or anguished halts followed by collapse, usually "means" death. In TV dramas, "the good guys" shoot "the bad guys" with large-caliber handguns straight-on in the face, leaving little red dots on their foreheads, the shock of defeat in their eyes, and all of their heads still sitting on the shoulders. Something, however, escapes these simulations. And the strange stillness of Longo's pictures speaks profusely about these gaps of meaning; wonderings about absence as high-velocity projectiles apparently hit live tissue. Such reality becomes a gap, which rarely is filled on film or always gets edited out for television. Someone like Barbara Kruger fills these aporias with graphic captions, stating in words what the gaze suggests; however, in *Men in the Cities*, Longo looks, coolly and quietly, at what is absent or silent in the spectacular arts of simulated dying. Gaps in the scenes of TV dying become even more obscene, because the showers of blood, hunks of organ, bits of bone, and raggles of scalp blown all over the walls or bystanders in real dying never make it up to the scenes on the screen. Instead, audiences coolly look through the camera lenses, simulating shootists' and artists' eyes, at the jolts and jerks of collapsing flesh to sign silently these missing elements of action.

Longo continues these images later in several larger and more complex works, including *National Trust* (1981), *Now Everybody (For R. W. Fassbinder), I.* (1982–1983), *Master Jazz* (1982–1983) as well as his film, video, and performance works. But *National Trust* clearly ends the particular style of this series as it links, for the first and last time, in a triptych, a charcoal rendering of a man and a woman on two opposite panels, who are obviously fixed face-up and face-down finally by death, linked by the dominating force of a relief casting in aluminum, showing a massive high-rise building's executive top stories and tying the two panels together. Still, Longo continues some of his sense of their frenzy and struggle from these early drawings by relocating them to a venue of cast aluminum sculpture during 1982. *Corporate Wars: Walls of Influence* (1982), for example, memorializes the ugly war of all against all in contemporary corporate corridors where professional life all too often is solitary, nasty, brutish, and short. Sandwiched in between two immense lacquered wood and steel forms, suggesting the ziggurats of corporate power, Longo places a massive central panel of screaming, struggling, squirming spirits all dressed for success and out to kill. Male and female, young and old, weak and strong, this panel freezes the hurly-burly of the marketplace as the thrashing anguish of tortured souls along the lower rungs of hell; yet he also nicely projects this information age inferno into heaven by revealing what really transpires in the sky behind the images of cool professional competence ordinarily projected across the soaring corporate monoliths' walls of influence.

After seeing these series, it is clear how exhaustively Longo looks at most aspects of the world through a television screen. And, like the rush of signs gained by rapidly flipping through the dial, many of his images ally apparently unrelated but still temporally and spatially contiguous images. This accelerating space compression and temporal flow, which flashes by in split-second totalities of image, voice, and sound on television screens, is freeze-framed in works like *Still* (1984), *Tongue to the Heart* (1984), and *Rock for Light* (1983). These works all are bounded by the culturally coded information we swim through each day in our own private telematic bubbles. Like a montage of channel hopping or signal zapping, Longo fixes here a montage of traces left burning continuously in

the retina as dead coals of meaning even as other fresher images constantly burn over them. Colliding orthogonally and obliquely on the conventional two-dimensional plane, their constituent signs hang off and beyond the representational plane. Ultimately, only film and tape may enable one to capture how all films and tapes affect the individual sensorium and collective culture, but Longo's figurative art shows how they can be bracketed and braced as distinctly different styles of art work as television's commodity aesthetic becomes a more pervasive televisual aesthetic of commodities.

In taking the perspective of the looker before Longo's work, one might be seen assuming the infinite but indefinite hover point of ecstatic communication, in which, according to Baudrillard, "our private sphere has ceased to be the stage where the drama of the subject at odds with his objects and with his image is played out: we no longer exist as playwrights or actors but as terminals of multiple networks."[4] Televisual communication directly prefigures this shift, and much of Longo's project aesthetically approximates "a receiving and operating area, as a monitoring screen endowed with telematic power, that is to say, with the capacity to regulate everything by remote control."[5] Grazing through the visual aisles of electronic imagery, one consciously flashes through and vividly remembers pieces, parts, particulars in a fragmentary mosaic formed in the mind's eye alone with perhaps little or much meaning. As watchers, we link these assemblages of images, dimly remembering them loosely fixed by our consciousness in time, although they are still running continuously off in parallel channels along disparate meaningless misdirections that we ironically try to meaningfully redirect simply by attending to them.

Several of Longo's works are almost nothing more than clever aesthetic puns about national preoccupations or cynically amusing summations of popular mythologies in one simple construction with many complex references. *End of the Season* (1987) shows a red-enameled steel cross floating upside down over a black linoleum field with seven chromeplated cast bronze footballs hanging down under the field and behind the cross. *Death and Taxes* (1986) presents a death's head split down the middle, but opening into a

long bureaucratic hallway of the tax collectors' office doors that ends up against an immense sky-blue expanse of one dollar bills. *In Civil War* (1986) depicts a loose geographical outline, twisted out of steel rod, of the U.S.A., floating over a silk-screen blowup of a bloody trench scene done in a daguerreotype after the Battle of Fredericksburg in Virginia. Yet, suspended below the photo and behind the U.S.A., are eighteen baseball bats. *Camouflage in Heaven: Swans* (1986) lines up seven chrome-plated human busts on tall inverted trapezoidal pedestals against a peaceful formal garden scene pierced by a massive Cor-ten steel pyramid rising out of the garden on one side and a field of ceramic bathroom tile on the other.

Samurai Overdrive (1986) combines a crystalline prow of green plexiglass with a high-gloss, oblique-angle rendering of chrome rod on a large black field with five flows of what look like bits-and-bytes of numerical code divided by four neutral zones with a black silhouette of a samurai warrior ready to strike with his sword held overhead—all of which is grouped together by a massive red-enameled steel rod outline of an electric guitar running across the whole immense structure. *Now Is a Creature: The Fly* (1986) fuses a side view of a crouching male nude, screaming in a rage of pain, as it braces under a massive steel assemblage of wing sheets along what once was a human spine. *Sword of the Pig* (1983) groups a cross/sword/pointer with a yellow-tone drawing of a muscle-bound nude male torso and photo blowup of America's Safeguard A B M site now sitting abandoned and inert on the Great Plains. The massive work *The Fire Next Time (For G. B.)* (1988) is a vast expanse of thin graphite over cast aluminum, divided by a cascade of red plexiglass flame flowing down its mottled black face. And *Black Planet (For A. Z.)* (1988) is a huge black steel bubble with a thick clotted fall of black neoprene tubing, tumbling all out of its face from a large round hole, which suggests unrealized potential lost prematurely forever.

Similarly, *Ornamental Love* (1983) combines three very different panels—one of oil, metal, and linoleum on wood; one of charcoal, graphite, and ink on paper; and one of cast bronze—in a single massive collision of signs. The largest section shows a collapsed freeway viaduct tumbled down on top of a deserted road. The next

panel in a cloying blood red tone captures a hard kiss of such violence that the two lovers seemingly are struggling to resuscitate their souls in their mouth-to-mouth engagement. Finally, the last section is a kitschy bouquet of roses frozen in a gold-tone bronze relief. *We Want God* (1983–1984) continues these associative dis-associations with its grouping in one rectangular whole of a young boy's face shading into two other smaller panels—one of seven tightly grouped wooden boards with an image of a leafless tree branching across each board and one of marble photo-etched with silhouettes of Red Army soldiers firing from a trench and rushing into battle with fixed bayonets. Many of Longo's constructions also make direct allusions to figures in popular culture, like David Byrne in *Heads Will Roll* (1984) or Lenny Bruce in *Lenny Bleeds: Comet in a Bomber* (1984). On the other hand, *Pressure* (1982–1983) allegedly depicts Longo himself struggling with the public persona produced as part of his artistic project and his ephemeral place in the highly institutionalized processes of professional success. *Culture Culture* (1982–1983) juxtaposes two heavily coded iconic bits: an acrylic painting of an equestrian statue and a charcoal drawing under red plexiglass of an old man, who is actually Longo's father, talking on the telephone. This attitude of absence or misdirection denoting presence or direction also grips *Joker: Force of Choice* (1988). In this construction, four massive steel wedges nearly collide on the axis of a negative, absent, and inverted cross, which in turn impels in its emptiness these Cor-ten steel masses to hang in this spatial stasis. Hinting at unfulfilled desires for a now forgotten or even misshapen source of solace, the sculpture's gestalt essentially constitutes an anti-cross or negative idol—beyond but from the old icon—still to be chosen or yet to be enforced.

While these works occasionally might have the aura of Rosen-quist or a sense of Dali about them, they actually are much more televisually derived. Indeed, they fold in on themselves, like the implosions of representation and reality cast by the end of the social in the shadow of the silent majorities.[6] Each panel, every section of such works objectifies a real channel hop or imagined station zap, which could replay as such in a single still afterimage spun from several successive flips. *Machines in Love* (1986) pushes this collision

of subjectivity with disciplinary efficiency almost to the final limit as it underlays a silk-screen image of a couple kissing beneath a huge red apparatus of wheels, spars, gears, cams, and shafts erupting out of the two-dimensional mechanism. The violent face-sucking kiss of *Ornamental Love* recurs in this work, but only now in faint purple tones and even more darkly oppressive forms. On one level, it is as if some real breath of life could be taken by human tongue and lip from another to make the machines more living and loving presences. On another level, it appears as though the intense, three-dimensional red energy of these standardized, mechanical beings ultimately underpin the false one-dimensional personality of modern individuals.

Dumb Running: The Theory of the Brake (1988) exactingly frames the influence of all these forces in a severely threatening kinetic sculpture. Composed of twenty closely integrated steel cylinders coated in gold leaf and mounted in the gallery wall on recessed steel supports, the assembly spins the cylinders at incredible speeds only to intermittently brake them to a sharp stop. Standing before it, one immediately is drawn emphatically into and under the rollers of this wall-mounted juggernaut. Its spin, sound, and sight approximate many forces: the rush of daily events, the unrelenting demands of everyday commerce, or perhaps the hyperintensive activities of living in the society of spectacle. All of them, in any event, can cruelly crush souls with unrelenting indifference. A motorized metaphor for modernity or a spinning simile of its electronic simulacra, *Dumb Running* hits the viewer with an ultra-high-speed impact. As the installation hums along, this very attractive, miniaturized Jagannatha immediately draws a big clump of viewers, pricking that dim empathic awareness of everyone who feels what may be Krishna's will pulling them under the juggernaut's rollers in their struggle for power, position, and privilege.

Hum: Making Ourselves (1988) materially constructs metaphors of contemporary authority in the form of a massive analog switchboard of multicolored, bundled wire jacks leading out of a single portal flanked by shiny hemispheres. Hinting at the unobtrusive covers of TV security cameras, the mirrored hemispheres are the eyes with no eyes of central control, feeding its impulses along

individualized conduits of direction, information, and domination to the terminal circuits of individual existences trapped in a uniform grid of standardized plug packets. Subtextually a *1984* or *Brave New World* image, this work points everyone toward looking for the real sources of self in the tangled circuitry of corporate power. It is this faint hum of continuous process, singing in the machinery and circuitry of overpowering anonymous structures—and not acts of personal autonomy, working in the realm of rational moral action—that gives each and every self its subjectivity today. Here Longo illustrates how the apparatus of authority always can "reach out and touch someone" to enforce its designs in closed loops of power generation and application. The panoptic gaze of power as well as the closed circuits of cybernetic command constitute the fictions of subjectivity that we so foolishly judge to be our own unique personalities. Masklike, it hovers on the silent shafts of its own self-generated force as a closed system of self-contained control, growing and feeding from its own energies. Using paint, metal, wood, plastic, or film, these interpretations of implosion do capture small flashes of Baudrillard's ecstatic communication with all of its ambiguity, conflictuality, confusion.

Perhaps showing also the impact of such normalizing dynamics in the rush of cultural commands across the everyday world, Longo's *Untitled* individuals in the *Men in the Cities* series spin, reel, or tip into stances of cool shocked confusion. In all of their stark blandness, these images are fundamentally terrifying. These bodies, despite all the usual suggestions of normality, are completely crushed, twisted, collapsed. Contorted into knarled poses, seemingly desiccated by the cool dryness of Longo's charcoal rendering, these cold figures droop across the gallery walls like hunks of yuppie jerky. Once breathing and bleeding slices of live humanity, they now unconsciously hang curled around the unseen barbed wire of their upwardly mobile professional lives or limply sag dead and dry in the white glare of our gaze. On one level, these images appear to be evening news shooting victims or televisual targets of dramatic body blows. Yet there are no exit wounds, no sign of weapons, no blood and guts on their clothes. The simulated violence and/or death is the clean, bloodless, neatly timed script of TV pain and

movie dying. Yet, on another level, as Longo represents the images themselves, our gaze painfully becomes the obvious source of each final blow. To look is a hit, a shot, a strike, nailing dead-on each figure that is looked at, making each glance a pull on the trigger. Thus, after our gaze simulates the televisual *coup de main*, these damned souls are still left hanging, turning, drying in the cold glare of modern mediascapes; the undetected meat hooks of normality we all might feel tearing every day at us are ripping and jabbing these men (and women) in the cities as our gaze passes over their forms.

In acknowledgment of this violence in American society, which invites its youth "to be all that you can be" by flying helicopter gunships or driving main battle tanks against assorted Third World foes, Longo presents *All You Zombies: Truth before God* (1986). An intense study in the brutal pornography of naked power stripped down to its most violent essence, Longo's zombie appears to be caught, like the hurt figure of *Now Everybody (For R. W. Fassbinder)*, by the same staggering blows seen hitting the jerked souls from the *Men in the Cities* series. Yet this figure is much more—a high-tech Lucifer spinning on a motorized platform in the chaos of war, assassination, and terror that is its and our contemporary Pandemonium. What can human subjectivity be after Oppenheimer's invocation at the Trinity test site when he whispered for all of humanity Vishnu's words from the *Bhagavad Gita*: "I become death, the Destroyer of Worlds"? Longo perhaps answers with this sculpture, which nets snippets of every perverse signifier swimming around in the psychosocial sinkholes of contemporary subjectivity. Using children's toys of war and violence in the casting, Longo sums it all up in a single bronze casting: a post-Hiroshima subjectivity tied to transnational corporate culture that stalks through life as a zombie avatar of terror.

As an identical subject-object of modern rationalization, it becomes a dialectic of enlightenment in itself. Indeed, *Zombies* seems to caricature Delacroix's *The 28th July, 1830: Liberty Leading the People* as the animate form of its body exposes, like Delacroix's Liberty, its left breast and holds aloft a tattered banner of revolution on a broken spear. Yet the torn hammer-and-sickle flag on the spear shaft flaps aimlessly at the beast's side as the massive spearhead is

rammed into its exposed rib cage. No longer the sweet muse of reason, this being is a devil of total administration with a face and body made up, like every modern boy's transformer toys, out of plastic terrors. The skin is scales of Lincoln-head pennies, its guts are inchoate clumps of meat, the torso is swarming tussles of plastic toy soldiers, and its face holds two wild, fanged eel-like mouths. Snarling at the terror seen by its bionic eyes and sniffing the chaos with its monkey nose, the zombie being is tumbling to its knees even as a bizarre demonic hand pushes out of its heart, trying to grab the air or the viewer to pull itself back to its feet. Hitched together by chains, leather straps, and machine gun cartridge belts, the zombie rages wildly as a cybermechanical hermaphrodite struggling against (or for) its own impalement as the focus of its existence. Brandishing an electric guitar neck as a sword, breathing through a backpack of circuit boards, gasoline engine parts, and rubber tubes, bearing an Uzi and revolver as parts of its very flesh, the zombie has snakes crawling from its neck, insects as its hair, and boils on what little flesh covers its bionic bones and sinews.

While this image is horrible, terrifying, demonic, it also is comfortably familiar. Each feature, every attribute is a comfortable citation of stories, pictures, and values streaming across the screens of the global mass media every day. Its toy-soldier guts push up from so many warm childhood memories, its semi-Viking/semi-Samurai helmet can be worn imaginatively in scores of mystical swordplay movies, its weaponry protects the good guys in nightly TV teleplays, its knee guards are on every NFL football player, and its grotesque face has close family resemblances to those wild space creatures seen in *Aliens*. All of these abstracted and isolated image-fragments from Longo's works are fractalized hunks of ordinary everyday video codes. As no more than pixel fuzz, we flash them for nanoseconds across our sensoria, seeking some glimmerings of conscious meaning. Daily broadcasts of our teletraditions are rife with these tropes: what are they, what do they mean, what are they doing? Longo correctly grasps that they ultimately may be the ugly clues of a friendly fascism being encoded into the quotidian banalities of videoculture. His art imitates not life but the mediascapes upon which we move and act as if they are lifescapes. Yet these

banal constants from daily TV programming are, at the same time, fearsomely fused in an overpowering image of sublime horror, which might be taken as our century's (simulation of) *Laocoön*. All Longo does here is creatively collate almost every trace in the disciplinary discourses that trundles through everyone's daily consciousness, often turning all of us, in some respect, into one of the living dead. We secretly suspect how much the animated cyberspaces of such coercive subjectivity write themselves into everyone's somatic form and mental substance, leaving behind these vivid flashes of truth before God.

Today, as Baudrillard claims, "the religious, metaphysical or philosophical definition of being has given way to an operational definition in terms of the genetic code (DNA) and cerebral organization (the informational code and billions of neurons)."[7] Therefore, even as Longo's artistic judgment spins out these insights, our DNA itself and the neuronic base of the informational code are mutating into monstrous barbarisms—revolvers, Uzis, regiments of soldiers, swarming insects, machine gun belts, and the small change of the realm are slipping directly in our chromosomes and synapses. We become, in turn, bionic androids: video eyes, electronic brains, cybermechanical organs, and stainless steel bones pull together naturally with real flesh in this subjectivity. That is, the truth before God now assumes material form. "From a biological, genetic and cybernetic point of view, we are all mutants. Now for mutants there can no longer be any Last Judgement, or the resurrection of the body, for what body will one resurrect? It will have changed formula, chromosomes, it will have been programmed according to other motor and mental variables, it will no longer have any claim on its own image."[8] The mutations, then, manifest all of their formulae and read out each of their programs as they totter along in Longo's aesthetic incarnation of the *Zombiegeist*.

Longo's gaze, then, moves us from scenes of alienated subjectivity to obscenes of transparent information. "Obscenity begins," according to Baudrillard, "when there is no more spectacle, no more stage, no more theatre, no more illusion, when everything becomes immediately transparent, visible, exposed in the raw and inexorable light of information and communication."[9] Longo's

zombie on its pedestal is also fixed in the center of a brightly painted backdrop, arcing halfway around it, which depicts the empty boxes and seats of an elaborate five-tiered opera house interior. As this illusion of stage, spectacle, and spectatorship evaporates, the visible obscenity of zombie subjectivity can condense simultaneously into concrete form. Somewhat painfully, as *All You Zombies, Still, Hum: Making Ourselves, Sword of the Pig,* and *Arena Brains* may illustrate, at this juncture in the development of modern society "obscenity is not confined to sexuality, because today there is a pornography of information and communication, a pornography of circuits and networks, of functions and objects in their legibility, availability, regulation, forced signification, capacity to perform, connection, polyvalence, their free expression. . . . It is the obscenity of that which no longer contains a secret and is entirely soluble in information and communication."[10] Very much like Longo's zombie, all of the current scenes on the transnational obscene fascinate us in a cool, communicational ecstasy of their genetic coding, fractal attributes, and transparent emptiness that are both totally terrifying and yet completely comforting all at the same time.

16. CULTURE AND COMMENTARY

Riding the Hoverculture

It often is said that every people gets the government it deserves, and during the eighties the peoples of the Western world got Thatcher, and Reagan, and Nakasone. Perhaps it is also true that every people gets the art that it deserves, because in the 1980s these same societies had to view a lot of the art that was included in "Culture and Commentary: An Eighties Perspective," which was presented at the Hirshhorn Museum at the close of the decade.[1] Hardly exhaustive, arguably not even representative, this disappointing collection essentially highlighted only some of the more visible and most glitzy manifestations of what circulated in the New York art scene in the Age of Reagan. In many respects even the Los Angeles Museum of Art exhibition "Forest of Signs," and the Whitney Museum retrospective "Image World: Art and Media Culture" were far more representative examinations of where art did or did not advance along several fronts during the 1980s.[2]

The disappointment begins with the somewhat grandiose and very general title of the exhibition, or "Culture" and "Commentary" in "An Eighties Perspective." Actually, more "culture" and "commentary" in, of, and about the 1980s could be had from most of the shows discussed in the previous chapters than would be gained from this exhibition. Yet, after creating these grand expectations about the show's scope and significance, the organizers cautioned the exhibition's visitors that, in fact, the collection had much more limited objectives. Actually, as the curator, Kathy Halbreich, asserts, it only focused on a handful of artists "whose expressive voices have developed fully during the decade—Laurie Anderson, Siah Armajani, Francesco Clemente, James Coleman, Tony Cragg, Katharina Fritsch, Robert Gober, Jenny Holzer, Jeff Koons, Sherrie

Levine, Yasumasa Morimura, Reinhard Mucha, Julian Schnabel, Cindy Sherman, and Jeff Wall. The effort is not to survey the artistic comings and goings of the 1980s as much as to locate a particular set of intellectual concerns that have informed the cultural dramas of the past ten years and influenced artists whose work best comments on those societal changes."[3] Even this sociological rationalization, however, proves to be quite problematic. Very few of these figures really are *Wunderkinder* any more. Indeed, figures like Jenny Holzer, Julian Schnabel, Laurie Anderson, James Coleman, Cindy Sherman, Jeff Wall, and Sherrie Levine were already making their marks in the 1970s. Given its curatorial charge, and the stated agenda of reexamining art in the 1980s, this exhibition excluded many other artists who had as much, if not a great deal more, to say about the eighties, including Mark Kostabi, Robert Longo, Barbara Kruger, Robert Mapplethorpe, David Salle, Sue Coe, Hans Haacke, Haim Steinbach, Mierle Ukeles, Matt Mullican, Krzysztof Wodiczko, or Tim Rollins, to mention only a few.

Only a relative handful of the decade's "major artists" were included, and even they are not all of the usual suspects one might expect to round up for an overview of art in the 1980s. Nevertheless, the exhibition accurately did indicate how "transnationalized" and "homogenized" the art scene has become. In addition to Americans from all over the United States (who all now live and work in New York), the exhibition presented the work of Japanese, Irish, and Canadian artists, two West German artists, and a British artist who lives and works in West Germany, an Italian born and trained artist who works and lives in New York City and Madras, India, and an Iranian artist who lives and works in St. Paul, Minnesota. Recognizing these tendencies from the 1980s is most important. Even though there was this element of global diversity in the show, it was also immediately apparent how pervasive the banalizing influences of the global mass media and professional art training have become. For the most part, all of these artists are keyed into basically the same aesthetic discourses, cultural codes, and stylistic trends. Similarly, they all are slogging through a common set of small, international art networks, which all are tied into the same inner core of the world's major museums, galleries, and art jour-

nals. Once one reexamines the culture and reconsiders the commentary embedded in these works, it appears plainly to be not much more than the culture of *Artforum* or the commentary of *Art in America* that dominates their discourses. Yet it was the absence rather than the presence of the 1980s, particularly in contrast to the 1950s and 1960s of the "Made in U.S.A." show, that was so striking here. Many of the works displayed have no explicit reference to anything or anyone in "the eighties." Instead, many of them echo or shadow images cribbed from modernist visions of politics, art, and culture of the 1920s through the 1970s. This recombinant style of aesthetic expression illustrates some of the contemporary art scene's confusion about its critical mission. If this material represents the decade's best and brightest, then the larger society still has not yet faced a good, bright critique from the art world.

These artists reveal much about the insularity and inaccessibility of the 1980s arts scene. As the catalog's own narrative often indicates with a quip or a quote from Roland Barthes, Marcel Duchamp, or the artists themselves, it is almost impossible to fully "appreciate" any of these works without slipping in the soup of stylized semiosis that became so de rigueur in the eighties. Without a B.A., M.A. or M.F.A., one almost need not enter the show: like almost everything else in today's hyper-credentialized society, it takes the union card of university training even to get complete access or to gain full appreciation at the exhibition. Also very much in keeping with the young urban professional ethos of the 1980s, the exhibition's catalog devotes 34 pages of its total length of 195 pages to each artist's extensive professional resume, detailing a brief bio, selected solo exhibitions, group exhibitions, and bibliography for every artist. Given the weak material that the show and the artists displayed, this discursive exercise perhaps attempts to validate—in the correct yuppie codes—the "real proof" of each artist's personal importance, professional connections, and market position that really justifies inclusion in this review of the decade. Finally, all of these artists are products of the post-World War II education industry. Of the sixteen, only Clemente's credentials suggest any serious disinterest in university work, and even he formally studied art and architecture at the University of Rome. All

of the other fifteen artists are closely certified with many years of study and/or several degrees from the colleges of their choice. Thus we now can begin to see and judge some of the most visible products created in the 1980s by a few of the B.F.A.s and M.F.A.s churned out during the cold war in America, Europe, and Japan.

If anything, the show displayed some of the diversity in artistic media that artists in the 1980s used as vehicles for aesthetic expression. Beyond installations, painting, photography, and sculpture, the show also included video art by Laurie Anderson and James Coleman. Laurie Anderson's video *O Superman* (1982) ran continuously in the exhibition in nine-minute clips. This performance art, pop song, animation, and video presentation plays with light, sound, image, and speech around a phone call placed on an answering machine, which becomes a meditation on the family, the state, the economy, the media, and the world all reported through electronic technology. Although it actually is more of a successful popular music single from "the entertainment world" of MTV and FM radio, *O Superman* also is probably the most effective example of the new possibilities for "the art world" that this show struggles to identify.

James Coleman's *So Different. . . . And Yet* (1979–1980) also plays with the electronically mediated construction and communication of meaning. This video installation is set apart and behind Laurie Anderson's more open display, inviting viewers aside to watch a multilayered retelling of a story by a young woman in a green dress about the green dress, a mystery, a woman's account of several unusual events, and Ireland—all against the backdrop of music from a piano being played behind her. The woman is both the story and storyteller, the tempted and temptress, the image and the image maker, inviting viewers possibly to reexamine all such images and their meanings as they eavesdrop on her storytelling.

Reinhard Mucha's *Gruiten* (1985, reworked 1989) was the first work confronted by viewers entering the show's display space. Missing all of his usual ingredients of stacked chairs, toys, ladders, fans, and light fixtures, this minimalist work is a massive combination of ten thick wood bars, separated by thin metal bars and sealed together as a tight box in a fully enclosed glass case. By parodying

the frame, the box, the mass, and the glass so commonly assumed as elements in our ordinary reception of art, the sculpture pushes viewers to question what they will see, how they see it, and why they might expect such components in their viewing. While these elements are not really hidden in most art displays, this work problematizes their silent mission "inside the white cubes" of museums by putting nothing more (or nothing less) than a finely crafted, ten-decker sandwich of highly finished wood and steel slabs, shaped as an oblong box, at the center of attention as sculpture. Katharina Fritsch's appropriations of everyday bric-a-brac, like *Katze (Cat)* (1981–1989), *Gehirn (Brain)* (1981–1989), *Madonna* (1982), *Vase mit Schiff (Vase with Ship)* (1987–1988), or *Seidenschal (Silk Shawl)* (1987–1988), also are directed at bracketing and challenging everyday codes of commodification and valorization in art as well as the larger society.

Continuing his hallmark of engaging the art viewer in an accessible, open connection with his work in a functional fashion, Siah Armajani's installation, *Sacco and Vanzetti Reading Room #4* (1989–1990), provided many nooks and crannies for gallery goers to sit down and rest. Its shelves, in turn, were lightly stuffed with recent books, the day's newspapers, and the latest magazines for visitors to read. This mode of "bringing reading materials" to "the people" hints at a populist/anarchist spirit, and its construction materials openly suggest a retro throwback to rough 1920s industrial settings. The design has a very hard edge, which smacks of a futurist faith in technological salvation while it gives a knowing nod to the stuff of prison architecture. In the wood gridwork and the brusquely laid out seating arrangements, one also is reminded of electric chairs or the gallows. Ultimately, the polished steel plate, olive-drab painted wood, and harsh lines make it seem like part of a bad, postapocalyptic punk movie, as if it were the national library of Thunderdome, awaiting Mad Max, the Ayatollah of "Rock-n-Rollah," or some other member of the road warrior reading public to drop by and browse through its racks. Its connections with our world today or the southern European, urban immigrant communities of the 1920s are even more difficult to discern.

Jenny Holzer's language-based works, including *Truisms* (1977–

1979) in six photostatic reproductions as well as five different carved marble benches with *Selections from Truisms* (1987), are designed for display in the public sphere. Using short, sloganlike statements, she displays these sentences and sentence fragments in many of the familiar mass advertising venues—T-shirts, electronic signs, caps, posters, benches, plaques, and stickers. Holzer's work is clearly the most accessible material in the show. Not being content to share her vision with only elite art publics, she tries to get her message out to mass publics on the street. By exploiting the imperative voice of mass advertising, she uses her "truisms" to expose the essentially arbitrary and conventional nature of truth, showing how power and capital turn such truistic, arbitrary conventions into the deeply held "truths" of society.

Jeff Koons's work, on the other hand, essentially is living proof of one of Holzer's truisms, namely, "money creates taste." The former commodities trader continues to apply his former skills as a middle man or dealer in packaging his slickly conceived aesthetic products. By now, his "methodology" is well known: this managerial aesthete meticulously interviews scores of actual craftsmen to physically produce his artistic ideas, he masterfully whips up a major market for his products in extensive media build-ups, and then he mercilessly exploits their curiosity value for maximum profit. Not content to live out his life by the old familiar scripts of the artist as an avant-garde revolutionary, living in poverty, gaining no appreciation from the public during his life, and coming into his fame near or after his death, Koons milks his artistic products for every last cent and every little bit of celebrity as a minimogul of aesthetic manufacture. To display some of his "artistic range," the exhibition included *New Shelton Wet/Dry 5-Gallon, New Hoover Convertible Doubledecker* (1981–1987), *Jim Beam J. B. Turner Train* (1986), *Two Balls 50/50 Tank* (1985), and *Bear and Policeman* (1988).

Tony Cragg's sculptures, by way of contrast, are more inventive and thought-provoking. His *Mortar and Pestle* (1987) of cast aluminum and *Generations* (1988) from plaster of Paris are bizarre expressions using exaggerated proportions and unusual size for their effects. *Generations*'s pile of huge, white, elongated seedlike hulks—stacked against and under an ominous mushroomlike core—broods

with bizarre mystery, like a cache of alien pods from the movie, *Invasion of the Body Snatchers*. His *Real Plastic Love* (1984) and *Mercedes* (1982), however, are interesting assemblages of found items. *Real Plastic Love* shows a conventionally color-coded silhouette of a kissing, embracing couple—the man is formed from bits of blue plastic, while the woman is made out of pink plastic pieces that Cragg picked up near his home in Wupperthal, West Germany. *Mercedes* represents the world-famous logo of a three-pointed star in a circle that is used by Mercedes-Benz, but this particular version is fabricated out of bottles and bricks that Cragg picked up off the street after a demonstration against Henry Kissinger's visit to West Berlin in 1982. By fusing the sign of one of West Germany's largest corporate enterprises with the weapons used by its street-fighting, anarchist *Autonomen* resistance, Cragg tries to say something about the Federal Republic, its ties to Washington and world markets, domestic political contradictions, and the struggle to create meaning in the 1980s through acts of both politics and consumption.

The political irrelevance of this exhibition's art is perhaps best summed up in Robert Gober's and Sherrie Levine's racism installation, *Untitled Collaboration* (1989–1990). Playing off "the hanging man/sleeping man" motif that Gober displayed in 1988 as the hand-painted ticking of a doggie bed pillow in *Untitled (Dog Bed)* (1987), and as wall coverings in *Hanging Man/Sleeping Man* (1989), this new installation presented an entire room with this design put on its wallpaper. On one level, the work might be seen as a clever disquisition on racism in America. The wallpaper endlessly repeated an alternating flow of two images—a shirtless white man sleeping peacefully in bed with a shirtless black man hanging from a tree limb after being lynched. The point apparently is that America is so resigned to racism that it has become an innocuous wallpaper in the contemporary polity, disturbing no white man's sleep as lynching victims swing from trees. Yet, treating it as wallpaper also tends to leave it hanging ineffectually as nothing more than an ironic interior decoration.

On the far wall, there were six copies of Levine's painting *"Untitled" (Mr. Austridge: 6)* (1989). Done on wood, and appropriated from the cartoon *Krazy Kat*, it portrays an ostrich sticking its head

into a can of sand placed on a little push toy. An empty closet dominated another wall, Gober's *Untitled Closet* (1989), suggesting perhaps that racism lurks in a doorless closet always able to pop in or out. Ironically, the missing door, we may remember, is placed in exactly the same spot in Gober's *Utopia Post Utopia* (1988), indicating a double world with the missing parts from this scene sequestered elsewhere in a "no place." The opposite wall featured three bags of cat litter, Gober's *Kitty Litter* (1989), touted as having "superior absorbing and deodorizing" powers, such as one might need to cover up nasty messes like racism. On the last wall were hung three of Levine's untitled appropriations of Walker Evans's 1930s sharecropper photos, hinting at the link in American racism between the oppressed rage of poor rural whites and the mindless violence directed by them against poor rural blacks. Finally, in a stroke that was apt in more ways than one, a large wax light bulb was suspended in the middle of the room from the ceiling. It was unable to shed any light on the problem of racism; yet, unlike this installation, it did not, at least, further mystify its workings with more intellectually ineffectual, if almost inane, social critiques. This kind of empty criticism, which conveniently taps into upper-class, Northern alibis to problematize racism in terms of violent acts associated with the rural Southern poor, does little to transform an entire society that engages in racist acts or sees this sort of assemblage as a significant protest against racism.

Jeff Wall's mural, entitled *Young Workers* (1978–1983), seems almost as innocuous at first glance. Composed of eight large, identically sized and boxed phototransparencies lit from behind to lend them an extraordinary, heroic appeal, the work simply shows very ordinary-looking young people with all their physical blemishes and particular idiosyncrasies hanging out in the open. Each of them is shot from the left side and slightly from below as he or she looks off and up—perhaps into the mythic workers' paradise? Four are male, four female, four are apparently from "racial minorities," four are apparently "white." Their clothes, hairstyles, and personal appearance all are individually distinct, but also blandly conformist. In arranging them in this fashion, Wall questions how we generate meaning from images and images from fragmentary signs. By

posing his *Young Workers* in this almost patented pose of Lenin gazing into the future or devoted Komsomols facing their revolutionary duties, Wall fiddles around with the visual mythologies of mass mediated discourses. These images carry some of the signs of "young workers." Yet, at the same time, they actually appear to be something more like "young consumers," similar to those that McDonald's or Coca-Cola might bring together in one of their periodically staged paeans to the wonders of the capitalist marketplace. Cloaked in the signs of advertising-based or propaganda-style photography, Wall's photo images ironically reveal baseness not nobility, banality not superhumaness, blandness not vitality.

Clemente's immense paintings also seem to be as much out of place as Schnabel's in this look at 1980s art. In a group of artists often identified as being very postmodernist, he seems too neoexpressionist or crypto-modernist to be included with the others. With Clemente, we again see the narcissistic male artist imposing his personal stylizations of the homeless mind, ungrounded self, and wounded soul as he grasps for ultimate knowledge through art. Of course his bricolage of Hindu mythology, modern poetry, Hellenistic motifs, Indian folk arts, European aesthetic tropes, and contemporary studies of the body with a mystical polymorphous perversity seems to pull him toward the postmodern camp. Still, his cross-cultural constructions play upon many of the old modernist myths about big thematic forces, like "the outsider," "the East," "India," "forbidden arts," "sexuality," "the mystic," and "the body," to project an important aura of revolutionary otherness still apparently opposed to the identity logics of advanced capitalism. While his *Hunger* (1980) and *Sun* (1980) obviously have "Third Worlder" qualities, his *Porta Coeli* (1983), *Perseverance* (1982), and *Miele, Argento, Sangue (Honey, Silver, Blood)* (1986) come off as tough-minded compositions done along very modernist, neoexpressionist lines.

The prominence given to Julian Schnabel's works in this show of 1980s art nicely reinforced many of the art world's traditional prejudices, which are surviving even into the "postmodern" 1980s and 1990s, such as favoring painters over artists working in other media and highlighting a widely lionized *enfant terrible* over other less

mediagenic but equally meritorious artists. The exhibition devoted an entire immense room to seven of his more representational canvases from the 1980s. *Jacqueline the Day after Her Wedding* (1980) is a direct, full frontal inquisition of his wife, appearing somewhat world-weary, if not pained, by this moment's being forced on to the canvas. Likewise, *Portrait of Andy Warhol* (1982) exploits his subject's trendy and lurid public personas in being painted prismatically on black velvet. Set to one side of a barely visible cross, he appears with the wounds he suffered during the infamous assassination attempt against him; yet, on the other side of the cross, there is a blizzard of pink paint strokes that blends into Warhol's body. *La Spiaggia* (1986) continues this full frontal interrogation of the subject as does his own *Self-Portrait in Andy's Shadow* (1987). This work, along with *Portrait of Anh in a Mars Violet Room* (1988), *Anh in a Spanish Landscape* (1988), and *Portrait of David Yarritu* (1988), is done in Schnabel's signature style of paint over broken plates. The texture of the broken crockery and dinnerware bound by Bondo across the old two-dimensional, modernist painting plane perhaps echoes metaphorically the bytes and bits, cells and chromosomes, photons and pixels upon which this current age is being built. This drift, however, still remains to be decoded.

Like Schnabel and Clemente, Sherman is allocated an entire room in the show. Once again, we see her photosimulations of feminine figures envisioned in the frame of familiar societal conventions. Clothing, poses, looks, hairstyle, body language all are studiously set off by particular signs to heighten the effect. All of them are titled as "untitled," and they span a range from *#70* (1980) to *#177* (1987). Where the earlier images feature Sherman in her various plastic personas, from a Marlo Thomas or Mary Tyler Moore clone in *#74* (1980) to a (he?)(she?) devil in *#109* (1982), the more recent pictures, like *#168* (1987), stage a total evacuation of her from the viewer's gaze. Instead, in *#168* all that is left is a fine dust in the skeletal-muscular outline of a young woman collapsed in a dress-for-success suit next to the instruments of cybernetic/informational labor—a telephone, video monitor, printer, key board, and computer. Sherman's work provides snapshots of recognition from the unreal videos of our lives, in which self-identity and social

purpose are wrapped around seductive, mass mediated images to the point that we, like Sherman's poses, often cannot tell what is emulation and what is real.

Cindy Sherman's photographs are frequently celebrated for their transcendence of domineering "male" techniques, in which the photographer separates himself from and objectifies the photographic subject, usually female, through his mannered aesthetic gaze. Yasumasa Morimura also moves beyond these conventions in his artistic combinations of photography, painting, and sculpture. Playing off of Marcel Duchamp's female alter ego Rrose Selavy, the pun name from *eros c'est la vie*, which also was the subject of Man Ray's well-known 1921 photograph of Duchamp, Morimura mixes history, race, gender, style, and media in his photographs of himself. In *Doublonnage (Marcel)* (1988), he becomes Rrose Selavy only doubled with two hats, four arms, and four hands. In *Doublonnage (Portrait C)* (1988) and *Doublonnage (Portrait D)* (1988), Morimura presents himself with his head in a bowl of flowers—in natural skin and flower tones in *C* and in a metallic glaze on his skin and the flowers in *D*. His images are actually quite powerful as he becomes both the object and subject of production, the photographed and the photographer, the seen and the seer all set with his head in a bowl as if it were some sacrificial offering. His *Portrait* series continues these cross-racial, cross-cultural, cross-sexual, cross-stylistical combinations in a photomontage of him, doubling or opposing pieces of his body with the figures of classical nude maidens appropriated from European paintings. Like Sherman, he exploits the boundaries and divisions staked out in the mass media by continuously stepping back and forth between artistic genres and gender roles in building these bizarre pastiches of costumes, props, paintings, photographs, and sets for representation in large, Type C prints.

Either ironically or subconsciously, the curator admits to many of these shortcomings in the various artists' works in the organization and lay-out of the exhibition's catalog. To hook the reader's attention, the cover design features a four-by-four photo matrix whose cells and columns reproduce close-up details of the AIDS virus under microscopic magnification, the explosion of the Challenger space shuttle, a microprocessor chip, and a 1,000 yen bill.

Here, then, are some of the truly dramatic developments or clearly transformative forces of the 1980s that fail to show up in the art-works displayed in the exhibition itself. In addition, these images are used as leitmotifs within the subsections of the catalog where Kathy Halbreich, the curator, struggles to define the big picture in the emerging informational society of the 1980s by tracing the impact on art of telecommunications, electronic media, cybernet-ics, conservative politics, the Pacific Rim, Marxism-Leninism's col-lapse, and the days of easy money. This brief overview leads into the individual profiles of the artists and their work; most of the bios are hyperactively overdrawn in that special kind of almost in-frasonic semiotic speech that gives art criticism such a reputation for impenetrability. Afterwards, and again to make the points not really made by the artists, there are five short follow-up essays featuring Maurice Culot on the media and society, Vijak Mahdavi and Bernardo Nadal-Ginard on genetic engineering, AIDS, and society, Michael M. Thomas on money and society, Sherry Turkle on computers, and Simon Watney on images and sexual identity. Only in the ancillary write-ups from the catalog does one even begin to confront any of the culture and hear some of the commen-tary of the eighties.

In truth, as this discussion suggests, very little of the culture and none of the important commentary of the 1980s pops up in the show. Like much of everyday life in the 1980s, the conceptual packaging of this exhibition became as large a part of the story as the aesthetic substance of the images and shapes on display. As a result, what surfaced in the curator's display of the artists' intentions are vague ruminations about the power of mass media. Almost all of these artists are grappling in some way with the mass mediation of ordinary realities for profit and power in contemporary society. Whether looking again at its signs and signals, like Wall, Fritsch, Cragg, Coleman, or Sherman, or seeking its roots in personality formation and social cohesion, like Anderson, Levine, Armajani, Holzer, or Morimura, the implosion of traditional culture in pres-ent-day informational societies grounds a great deal of their respec-tive aesthetic projects.[4]

With the exception of Laurie Anderson and perhaps Koons, Le-

vine, and Sherman, none of these artists is really famous in the larger culture and commentary of the 1980s. Instead, what we see here are professional insiders ranking the "rising stars" or "big names" of yet another highly complicated field of professional-technical labor, whose understandings of fame are essentially "careerist." Reputation emerges as a product of one's treatment in the professional art press, the overall marketability of one's work, and the frequency counts of each one's numerous showings at prestigious venues of display. Rather than truly producing art that has defined their age and is widely known, if not understood, by many ordinary laymen, perhaps like Picasso in the 1930s, Pollock in the 1950s, or Warhol in the 1960s, these artists are busy slaving away in the little worlds of their New York, Dublin, Osaka, or Düsseldorf studios in order to move their products in the New York, Frankfurt, Tokyo, or London galleries to the upper-echelon art buyers making acquisitions during this or that year.

Their art does not define an era; it only describes some of the peaks in a long bull market. During an age of instantaneous obsolescence, we already can witness in this exhibition some of "the golden oldies" of the 1980s becoming "historical" even before the advent of the 1990s. Their importance cannot be judged by their cultural impact on the larger society as much as it is measured in terms of a young professional's marks of glory: gallery hangings, museum showings, and art press gushings. Consequently, this peculiar understanding of culture and commentary in the 1980s should be matched to models drawn from automobile magazines, the fashion press, or audiophile literature rather than remaining grounded in modernist myths about avant-garde artists hurling radical culture shocks against the stolid bourgeoisie.

What we see here are mass culture and televisual politics as they appear to chi-chi artists, who are making their long march through the art schools and Soho. We only hear the faintest echoes, as was true in much of art world in the 1980s, of more radical political moments from the 1960s, 1940s, 1930s, or 1920s in "clever" parodies or "shocking" appropriations of shopworn modernist ideas, which have been getting more threadbare every day in scores of college art programs across the nation. And most of this appropria-

tional remanufacturing of earlier images and ideas in the techniques of the present is done without really making very many value-adding improvements. Instead, like Ronald Reagan's White House, quite a few of these artists simply are recycling images, ideas, and impressions from long established, imperfectly remembered, but not truly forgotten conventions of meaning, which also are now shared in some sense by mass audiences in contemporary informational society. In other words, with only a couple of minor exceptions, this work is not much more than hoverculture, floating aesthetically over a chaotic landscape of political upheaval and economic collapse on cushions of self-produced hot air.

17. THE POLITICS OF IMAGES

Art Criticism as Cultural Criticism

David Carrier argues in his recent controversial book, *Artwriting*, that the practice of contemporary art writers has many peculiar properties, but in the end three tendencies continually resurface: "(1) the present-day function of art writing is to advertise art; (2) unlike art history, art criticism has not been able to establish its place within the university; (3) this art writing remains largely unaware of its essentially rhetorical dimensions."[1] Moreover, he continues to observe quite accurately that the current-day art market is essentially still grounded in the confines of New York amidst the Manhattan gallery system and art journals edited in the city. In fact, he suggests that "even were great art shown in Pittsburgh, it would become known in the artworld only if it were written about in the New York journals."[2] In making all of these observations about art criticism, Carrier carefully uses the word "artwriting" in fairly broad reference to written texts produced by both art critics and art historians as their contributions to the discourses of art criticism and art history.[3]

There is a great deal of truth in Carrier's claims; however, in concluding this book it now should be clear that the "art writing" here has directly contradicted almost all of them. First, none of these studies ever appeared "in the New York journals." Instead, they have been published in *Art Papers*, one of the nation's most dynamic and more eclectic art publications, which is based in Atlanta. Second, while some of these art shows passed through New York and a few began in New York, all of them also were shown much more widely outside of New York. Therefore, each of these studies has paid close attention to the geographic settings, political implications, and cultural possibilities of an art showing staged in

cities like Chicago, St. Louis, and Washington, D.C., as well as Phoenix, Charlotte, Santa Fe, and Richmond. Third, not one of these art writing pieces has ever intentionally "advertised" an artist or consciously "pushed" a commercial gallery. Instead, each piece has reacted critically to the different types of art exhibitions staged at state, university, or corporate venues as "public services" or "educational events," while recognizing fully the vital valorization functions played by such museums in today's art markets. Fourth, each of these studies warily has watched over the sweep of its own rhetoric. Each chapter critically reexamined artists, artworks, and art exhibitions as players in an intertextual/polyvocal show, recognizing that no critical narrative can escape its own unexplored meanings, silent contradictions, unseen conflicts, and inarticulate ironies. While seeing that each critique in itself is caught rhetorically within its own representations, my political interpretation has sought to unravel ideologies in the art exhibition, the artworks, and the artist's vision as their various possible meanings appear to unfold in the show.

Because it is neither lifestyle journalism nor art history, art criticism is difficult to assign any permanent institutional address or fixed intellectual credibility. More often than not, as Carrier asserts, "criticism must be a part-time activity for people with other jobs."[4] Carrier might be completely correct in concluding "that ultimately art critics are just rhetoricians; they construct convincing-seeming texts but offer no real arguments."[5] This position, however, is actually far too extreme. Carrier stakes out this claim much too narrowly and defends it far too lightly to be truly convincing. In fact, art criticism can also be an important form of cultural and political criticism, and this sort of politicized cultural critique must delve into the real conflicts over ideology, domination, and resistance in contemporary states and societies.

Artworks and art exhibitions should be considered as complexly coded texts, which are always scripted out against a backdrop of larger cultural forces and political institutions. As texts, individual artworks, when displayed in highly organized art shows, pull together an unstable combination of fragmentary mythologies, polyvocal meanings, and diverse values. These texts in turn are never

under the total control of their artistic authors or curators. On the contrary, they are finally fulfilled or completely created only in their reading by art-viewing audiences. The meaning of their intricate assemblies of aesthetic signs is never present, as Terry Eagleton maintains, "in any one sign alone, but rather is a constant flickering of presence and absence."[6] In these flashes of significance, the viewer/reader/critic constantly must carve "them up, transpose them into different discourse, produce his or her semi-arbitrary play of meaning athwart the work itself" as viewing/reading/ criticizing incessantly shifts one's position "from the role of consumer to that of producer."[7] Art exhibitions must, therefore, be seen as another irresistible screen of power over which race the outlines of mythic desire or the projections of violent repression.[8]

Once art objects enter into exchange as commodities in the capitalist marketplace, they can exist freely as markers of unstable exchange value in the market's permanent circulation or as enduring indices of exhibition value in the museum's theaters of accumulation.[9] In either role they also can become instrumentalized in ephemeral ensembles of artifacts to instruct audiences about whatever discursive projects their curators wish to affirm. While these discursive designs can never be guaranteed 100 percent effective, they still can influence significantly the cultural thinking of many different audiences. Hence, the empty pretense of the art object's autonomy, along with the distorted subtexts of disciplined discursive instruction that often hide in this aura of aesthetic autonomy, must be criticized to expose the mystified agendas of cultural coercion that inform these political projects in art. Artwork can be understood fully only in its various social and political contexts, and the grounding of art in society only makes sense in relation to its present-day cultural and political roles as revealed by discourses of critical interpretation.[10]

Museum exhibitions, as I have argued, do not simply present uncontestable eternal facts, even though the narrative rituals enacted by their formal styles of presentation would have viewers believe they do. Actually, the rituals of museum showings are intensely charged with rhetoric and they are always intended to guide their many diverse audiences to particular constructions of

the aesthetic texts formally presented in these settings. As a result, when one confronts showings of artworks today, "the function of criticism is to refuse the spontaneous presence of the work—to deny that 'naturalness' in order to make its real determinants appear."[11] Indeed, "gallery space," as Brian O'Doherty maintains, "is no longer 'neutral.' The wall becomes a membrane through which aesthetic and commercial values osmotically exchange. There is a further inversion of context. The walls assimilate; the art discharges."[12] Here, my interpretations in this book attempted to get inside "the real determinants," while dodging the dangerous explosive discharges of common myths about museumological objectivity to consider how art shows serve, at least in part, as shows of force, creating new rhetorical ranges where many new ideological forces, semiurgic energies, and symbolic powers all can roam.

Looking at art in this fashion is, of course, wholly in keeping with Pierre Bourdieu's interesting observations about "vulgarity" and "terrorism" in today's scientific discourses about aesthetic topics. "Vulgarity" stems from transgressing "the sacred boundary which distinguishes the pure reign of art and culture from the lower region of the social and of politics, a distinction which is the very source of the effects of symbolic domination exerted by or in the name of culture."[13] Terrorism, on the other hand, arises out of "peremptory verdicts which, in the name of taste, condemn to ridicule, indignity, shame, silence . . . men and women who simply fall short, in the eyes of their judges, of the right way of being and doing."[14] A new sense of critical awareness follows directly from seeking the important insights of vulgarity as I have explored how exhibitions of "high" art and culture fit into the "low" agendas of society and politics. Because the mythic purity of culture is exploited to create the apparently contaminated realities of domination, having an appreciation for Bourdieu's vulgarity becomes a necessity in cultural criticism. Yet terroristic judgments must be avoided, because supposedly "right ways" of seeing and doing, empowered only by the arbitrary authority of taste, often wrongly condemn the artistic work of men and women to suffer unwarranted dismissal from more formalist styles of criticism. I have tried to avoid silencing anyone in the name of aesthetic taste, but I also

have not avoided developing a political critique merely because some more conservative version of aesthetic theorizing might take it as vulgar.

Museum exhibitions, whether they deal with George Caleb Bingham or Robert Longo, look and feel in many ways like political tracts. Even though the curators may not have intended to produce an essentially political text, almost every art show is highly charged with expressions of power. As we now know, the artist as maker "has limited control over the content of his or her art. It is its *reception* that ultimately determines its content."[15] And any viewer's understanding of this content's meaning largely is generated within the social context of the museum. Therefore, as this book indicated, it is essential to read the aesthetic texts of art exhibitions in terms of local, national, or even international political contexts.[16] Some artists are aware of their political implications as they present their art works. Others virtually ignore them; but, when situated in specific curatorial narratives or museum displays, such political dimensions become crystal clear. Consequently, my interpretations here have approached artists, their artwork, and the art exhibitions that display them as fragments of political discourse suitable for being read and reread for their volatile ideological/political meanings.[17] Art exhibitions, when considered in their political context, can be seen as intense semiurgic courses of aesthetic legitimation, disciplined disinformation, ideological containment, or mythological manipulation.

Therefore, my critical theorizing about art exhibitions as displays of mythic power or shows of legitimizing force also has not settled into the methodological thickets of art history. All human discourse finally gets down to hunting and grunting for some sort of plausible closure or small shards of sensible meaning.[18] Yet situating an artist in the context of a larger stylistic school or judging whether this painted trope expresses that artist's real intentions simply has not been enough for this analysis. Others might admire taking such tasteful, but often deadly, discursive turns and even organize their professional debates around these issues. Such art historical discussions, however, often center so exclusively on the art object's figure, the artist's apparent intentions, and the style

movement's reputed requirements that the truly fascinating questions surrounding the social ground of art, the psychosocial context of artistic subjectivity, and the ideological manufacturing of an aesthetic school's attributes get totally lost in the rhetorical fog.[19]

On the other hand, my talking here about the political implications of art works in contemporary American society, in the last analysis, fits into larger discourses about power, ideology, and wealth. As Steiner admits, "the root of all talk is talk. Talk can neither be verified nor falsified in any rigorous sense."[20] His goals, however, are to find some foundation for determining a sense of enduring quality in the prevailing politics of taste by resorting to an historical vision of evolutionary aesthetic consensus. My goals have been much different: to connect art criticism to cultural and political criticism. As a strategy for dealing with the ineluctable undecidability of interpreting the significance of aesthetic texts, I tap into larger issues of social critique, political theory, and cultural demystification as they have been framed by critical theory. Such discursive strategies, as Steiner notes, might fly in the face of art's continuing evaluative canonization by small, oligarchic networks of self-empowering aesthetic encoders.[21] Unfortunately, the canons of verification and refutation deployed in these established orders of professional aesthetic debate, in the end, often talk almost everything to a tasteful, but still very ugly, death.

The allegedly sacred qualities of art might appear to insulate aesthetic imagery and artistic discourse from the social or political sphere; however, we must regard any discourse, as Foucault suggests, "as a violence which we do to things, or in any case as a practice which we impose on them."[22] Thus in the apparently innocent forms of artworks, whether they are O'Keeffe's nature paintings or Wright's designs for imaginary buildings, there are rigorous prescriptions about identity, purpose, value, and action that exercise powerful effects upon those who accept their subtle scripting of subjectivity. Political agendas, individual needs, and social objectives can take on a naturalized imperative force as aesthetic representations of the sublime or beautiful, whose reputedly sacred qualities, in turn, render their ideological effects even more stealthy. Art criticism can lead us down many roads in search of

new understanding, but the infrequently walked path cut by critical theory now promises some of the greatest prospects for gaining new theoretical insights about art's role in contemporary states and societies.

In the master discourses of museums' myth-making, as Victor Burgin argues, "the canon is what gets written about, collected, and taught; it is self-perpetuating, self-justifying, and arbitrary; it is the gold standard against which the values of new aesthetic currencies are measured. To refuse the discourse, the words of communion with the canon, in speaking of art or in making it, is to court the benign violence of institutional excommunication."[23] Since my studies essentially are outsider/outlaw writings, I also have refused to abide by these canons in this book. Instead, my critiques slip into the terrain of cultural politics, looking for the powers flowing through aesthetic discourses, constituting artistic canons, and enforcing sanctions of institutional authority. By examining why the dominant discourses work to contain voices of dissidence as well as how dissident voices act to resist discourses of dominance in artistic exhibitions, the canon can be contested. And, in challenging such aesthetic values, the most sophisticated workings of political power, which continually cycle through the discursive grids of aesthetic canonization, can be subjected to a systematic cultural and political critique.

NOTES

1. GEORGE CALEB BINGHAM

1. Based on the exhibition "George Caleb Bingham," National Gallery of Art, Washington, D.C., July 15 to September 30, 1990.

2. Walter Benjamin, "The Work of Art in the Age of Mechanical Reproduction," in *Illuminations*, ed. Hannah Arendt (New York: Schocken, 1969), p. 225.

3. Throughout his career, Bingham's life largely was one of constant motion as he searched up and down the Missouri and Mississippi for portrait commissions, across the Midwest and Atlantic seaboard for some larger aesthetic purpose, and then finally all over Europe for new stylistic inspiration and professional acceptance. For additional discussion see Paul C. Nagel, "The Man and His Times," in Michael Edward Shapiro et al., *George Caleb Bingham* (New York: Harry N. Abrams, 1990), pp. 15–51.

4. See Nagel, "The Man and His Times," and Elizabeth Johns, "The 'Missouri Artist' as Artist," in Shapiro et al., *George Caleb Bingham*, pp. 15–51, 93–130.

5. As his success grew, he also became more involved in Missouri politics, standing for election as a Whig for the state legislature unsuccessfully in 1846 and successfully in 1848. However, Bingham's first wife died the same year as his election. This event was the first in a series of personal crises that ultimately derailed his most creative activities by the late 1850s. While he remarried in 1849, to the daughter of a University of Missouri professor that James Rollins discovered for him, he broke with the Art-Union in 1852, after having sent twenty works to them for reproduction, over a critic's slighting of his work. The end of this lucrative personal arrangement forced Bingham to go more and more into the business end of his craft. From 1852 to 1860, he oversaw the engraving and sale of his own work, but the time required by such entrepreneurialism severely undercut his creativity. By 1857, Bingham finished the last of his great works, *The Jolly Flatboatmen in Port* and *Stump Speaking*. After living on and off in Philadelphia during the early 1850s, in 1856 he sailed to Europe, where he lived briefly in Paris and then in Düsseldorf from 1856 to 1859. In Germany Bingham's powers as an artist actually seemed to de-

cline. He began to emulate stiffly an artificial academic style of painting then prevalent in Düsseldorf that made his work far more stilted and mechanical.

Dabbling in politics and selling engravings preoccupied Bingham after his years in Europe. Living in Missouri during most of the Civil War, Bingham enlisted in a Federal military reserve regiment in 1862 and served as the state treasurer from 1862 to 1865. His last political painting, *Order No. 11* (1866), was not nearly as masterful as any of his earlier work as he posed its images entirely within the more artificial styles he observed in Germany. So after the Civil War he mostly contented himself with doing portraits. In 1875, he served as adjutant general of Missouri to mediate property disputes from the Civil War, and in 1878 he was made a professor of art at the University of Missouri. His second wife died in 1876, and he married a third time in 1878. No longer able to work or paint owing to serious health problems, Bingham died in July 1879. See Nagel, "The Man and His Times," pp. 15–51.

6. See, for example, Donald Worster, *Rivers of Empire: Water, Aridity, and the Growth of the American West* (New York: Pantheon, 1985); Robert G. Athearn, *The Mythic West in Twentieth Century America* (Lawrence: University Press of Kansas, 1986); William Goetzmann, *New Lands, New Men: America and the Second Great Age of Discovery* (New York: Viking Penguin, 1986); Patricia Nelson Limerick, *The Legacy of Conquest: The Unbroken Past of the American West* (New York: Norton, 1987); Marc Reisner, *Cadillac Desert: The American West and Its Disappearing Water* (New York: Viking, 1986); Kirkpatrick Sale, *The Conquest of Paradise: Christopher Columbus and the Columbian Legacy* (New York: Knopf, 1990); Richard W. Slatta, *Cowboys of the Americas* (New Haven: Yale University Press, 1990).

7. For additional discussion of the important role of art in mobilizing these social forces, see William H. Goetzmann and William N. Goetzmann, *The West of the Imagination* (New York: Norton, 1986), and Chris Bruce et al., *Myth of the West* (New York: Rizzoli, 1990).

2 . FREDERIC REMINGTON

1. Roland Barthes, *Mythologies* (New York: Hill and Wang, 1972), p. 118.

2. Based on the exhibition "Frederic Remington: The Masterworks," St. Louis Art Museum, St. Louis, Missouri, March 11 to May 22, 1988.

3. See Doreen Bolger Burke, "Remington: In the Context of His Artistic Generation," in *Frederic Remington: The Masterworks*, ed. Michael Edward Shapiro and Peter H. Hassrick (New York: Harry N. Abrams, Inc., 1988), p. 39.

4. Eleanor Clift, "You're Going to Miss Me," *Newsweek*, November 21, 1988, p. 29.

5. See, for example, Sidney Blumenthal and Thomas Byrne Edsall, eds., *The Reagan Legacy* (New York: Pantheon, 1988); and B. B. Kymlicka and Jean V. Matthews, *The Reagan Revolution* (Chicago: Dorsey Press, 1988).

6. *The Washington Post*, January 30, 1991, p. A14.

7. Ibid.

8. Ibid.

9. Lou Cannon, "Reagan Says U.S. Should Lead Colonization of Space," *The Washington Post*, September 23, 1988, p. A3.

10. Ibid.

11. *The Washington Post*, January 30, 1991, p. A14.

3 . FREDERIC EDWIN CHURCH

1. See Bill Devall and George Sessions, *Deep Ecology* (Salt Lake City; G.M. Smith, 1985); Kirkpatrick Sale, *Dwellers in the Land* (San Francisco: Sierra Club Books, 1985); and Michael Tobias, ed., *Deep Ecology* (San Diego: Avant Books, 1985).

2. See Arne Naess, *Ecology, Community, and Lifestyle: Outline of an Ecosophy*, translated and revised by David Rothenberg (Cambridge: Cambridge University Press, 1989); and Arne Naess, "The Shallow and Deep, Long-Range Ecology Movement: A Summary," *Inquiry* 16 (1973), pp. 95–100.

3. At the same time, Church's new-found popularity in the 1980s and 1990s also might be seen as part of the same romantic conservatism that has sparked fresh interest in George Caleb Bingham, Frederic Remington, and other mythic imaginations of the Old West or preindustrial America. In representing the wonders of primitive nature, Church also, in a sense, parallels Remington's studies of the frontier, which capture settings, people, and ways of living as they are dying or disappearing. Hence, Church also could be regarded as performing the only sort of preservationist work with nature that big business in the Reagan-Bush era will readily accept, namely, painting pictures of its lost grandeurs to awe future audiences with nature's once rugged qualities. Since these features now exist in Church's painted archive of primitive settings, then such sites of rugged natural beauty can be settled, mined, developed, or spoiled to meet the demands of modern markets. This more nihilistic reading of Church, and the entire Hudson River School, unfortunately can also be pieced into the political context of the present. Just as owning a Remington (with its romantic summation of the Old West) now is a high-status badge of taste for the

New West corporate managerial cadres so busy with the despoliation of the West's remaining resources, acquiring a Church (with his sublime sense of nature's spiritual dimensions) might designate a fashionable caring for the earth by modern business entrepreneurs so intent upon commodifying every last inch of the earth's wild regions.

4. Based on the exhibition "Frederic Edwin Church," National Gallery of Art, Washington, D.C., October 8, 1989 to January 28, 1990.

5. For additional discussion, see Stephen Jay Gould, "Church, Humboldt, and Darwin: The Tension and Harmony of Art and Science," in Franklin Kelly et al., *Frederic Edwin Church* (Washington, D.C.: National Gallery of Art, 1989), pp. 94–107.

6. See "Introduction" in Franklin Kelly et al., *Frederic Edwin Church*, pp. 12–75, for further details on Church's career and life.

4. THE WEST EXPLORED

1. Based on the exhibition "The West Explored: The Gerald Peters Collection of Western Art," Roanoke Museum of Fine Arts, January 20 to April 15, 1990.

2. Another excellent treatment of these same general themes was presented in the exhibition "Myth of the West," Henry Art Gallery, University of Washington, Seattle, September 16 to December 2, 1990. See, for additional detail and discussion, Chris Bruce et al., *Myth of the West* (New York: Rizzoli, 1990).

3. *The West Explored: The Gerald Peters Collection of Western American Art* (Santa Fe: Gerald Peters Gallery, 1988) p. 10.

4. Ibid.

5. *The Washington Post*, August 19, 1991, p. B7.

6. Ibid., p. 8.

7. Ibid.

5. GEORGIA O'KEEFFE

1. Karl Mannheim, *Ideology and Utopia: An Introduction to the Sociology of Sociology* (New York: Harcourt, Brace & World, 1936), p. 87.

2. Based on the exhibition "Georgia O'Keeffe: 1887–1986," National Gallery of Art, November 1, 1987 to February 21, 1988, and Dallas Museum of Art, July 31 to October 16, 1988.

3. See, for additional discussion, Roxanna Robinson, *Georgia O'Keeffe: A Life* (New York: Harper & Row, 1989); Lloyd Goodrich and Doris Bry, *Georgia O'Keeffe* (New York: Praeger/Whitney Museum of American Art,

1970); Barbara Buhler Lynes, *O'Keeffe, Stieglitz, and the Critics, 1916–1929* (Ann Arbor: UMI Press, 1989); Jan Garden Castro, *The Art and Life of Georgia O'Keeffe* (New York: Crown, 1985); Katherine Hoffman, *An Enduring Spirit: The Art of Georgia O'Keeffe* (Metuchen, N.J.: Scarecrow Press, 1984); and Georgia O'Keeffe, *Georgia O'Keeffe* (New York: Viking, 1976).

4. Mannheim, *Ideology and Utopia*, p. 205.

5. Ibid., p. 194.

6. FRANK LLOYD WRIGHT

1. The most intricate and involved of these many exhibitions were presented at the Phoenix Art Museum. They included shows of Wright's own architectural drawings as well as selections from his collection of Japanese prints and textiles. See Bruce Brooks Pfeiffer, *Frank Lloyd Wright Drawings* (New York: Harry N. Abrams, 1990).

2. Based on the exhibition "Frank Lloyd Wright: In the Realm of Ideas," National Museum of American History, Smithsonian Institution, Washington, D.C., July 1 to September 30, 1988, and Scottsdale Center for the Arts, December 2, 1990 to April 7, 1991. Also see *Frank Lloyd Wright: In the Realm of Ideas,* ed. Bruce Brooks Pfeiffer and Gerald Nordland (Carbondale: Southern Illinois University Press, 1988).

3. See, for example, Frank Lloyd Wright, *An Organic Architecture: The Architecture of Democracy* (London: Lund, Humphries, 1939).

4. See Frank Lloyd Wright, *An Autobiography* (New York: Duell, Sloan and Pearce, 1943); and Robert C. Twombly, *Frank Lloyd Wright: His Life and His Architecture* (New York: John Wiley and Sons, 1979).

5. See Frank Lloyd Wright, *The Natural House* (New York: Horizon Press, 1954).

6. On this political dimension in Wright's work, see Frank Lloyd Wright, *The Living City* (New York: Horizon Press, 1958), as well as Frank Lloyd Wright, *When Democracy Builds* (Chicago: University of Chicago Press, 1945).

7. AMERICAN IMPRESSIONISM — CALIFORNIA SCHOOL

1. T. W. Adorno, *Aesthetic Theory* (London: Routledge & Kegan Paul, 1984), p. 9.

2. Based on the exhibition "American Impressionism, California School," Fleischer Museum at The Perimeter Center, Scottsdale, Arizona, on continuous showing.

3. *Masterworks of California Impressionism: The* FFCA*, Morton H. Fleischer Collection*, 2nd ed. (Phoenix: FFCA, 1987), p. 17. For an alternative perspective on California Impressionism see Patricia Trenton and William H. Gerdts, *California Light 1900–1930* (Laguna Beach, Calif.: Laguna Beach Art Museum, 1990).

4. *American Impressionism: California School* (Phoenix: FFCA, 1989), p. 3.

5. Ibid.

6. These dynamics of shopping for art seem to derive directly from Marx's notions of estranged labor as the basis of capricious consumption. As he argues in *Economic and Philosophic Manuscripts of 1844*: "There is a form of inactive, extravagant wealth given over wholly to pleasure, the enjoyer of which on the one hand *behaves* as a mere *ephemeral* individual frantically spending himself to no purpose, knows the slave-labour of others (human *sweat and blood*) as the prey of his cupidity, and therefore knows man himself, and hence also his own self, as a sacrificed and empty being. With such wealth the contempt of man makes its appearance, partly as arrogance and as the throwing-away of what can give sustenance to a hundred human lives, and partly as the infamous illusion that his own unbridled extravagance and ceaseless, unproductive consumption is the condition of the other's *labour* and therefore of his *subsistence*. He knows the realization of the *essential powers* of man only as the realization of his own excesses, his whims and capricious, bizarre notions. This wealth which, on the other hand, again knows wealth as a mere means, as something that is good for nothing but to be annihilated and which is therefore at once slave and master, at once generous and mean, capricious, presumptuous, conceited, refined, cultured and witty—this wealth has not yet experienced *wealth* as an utterly *alien power* over itself: it sees on it, rather, only its own power, and not wealth but *gratification* [is its] final aim and end." See Robert C. Tucker, *The Marx-Engels Reader*, 2nd ed. (New York: Norton, 1978), pp. 100–101.

7. *Masterworks*, p. 5.

8. Ibid., p. 8.

9. Ibid., p. 7.

10. Ibid., p. 8.

8 . JAPAN — THE SHAPING OF DAIMYO CULTURE

1. See Roland Barthes, *Empire of Signs* (New York: Hill and Wang, 1982), pp. 3–8.

2. *The Washington Post*, October 30, 1988, p. G1. Also see, for additional discussion, Yoshiaki Shimizu, *Japan: The Shaping of Daimyo Culture, 1185–1868* (Washington, D.C.: National Gallery of Art, 1988).

3. For several early predictions of these events, see William Ouchi, *Theory Z: How American Business Can Meet the Japanese Challenge* (Reading, Mass.: Addison Wesley, 1981); Ezra Vogel, *Japan as Number One: Lessons for America* (Cambridge, Mass.: Harvard University Press, 1979); Herman Kahn, *The Emerging Japanese Superstate: Challenge and Response* (Englewood Cliffs, N.J.: Prentice Hall, 1970); and, Zbigniew Brzezinski, *The Fragile Blossom: Crisis and Change in Japan* (New York: Harper and Row, 1972).

4. *The Wall Street Journal*, January 30, 1989, p. A8.

5. *The Washington Post*, May 17, 1989, p. A6.

6. This show opened at the Sackler Gallery on May 27, 1990 and ran through September 9, 1990 before moving on to dates in San Francisco and Los Angeles. See, for more detailed consideration, Ann Yonemura, *Yokohama: Prints from Nineteenth-Century Japan* (Washington, D.C.: Arthur M. Sackler Gallery, 1990).

7. *The Washington Post*, February 21, 1989, p. A19.

8. See, for example, *The Washington Post*, January 12, 1989, p. A16.

9. *The Washington Post*, February 21, 1989, p. A19.

10. Ibid.

9. MADE IN U.S.A.

1. Based on the exhibition "Made in U.S.A," Virginia Museum of Fine Arts, Richmond, Virginia, October 6 to December 6, 1987.

2. See Sidra Stich, *Made in U.S.A.: An Americanization in Modern Art, The '50s & '60s* (Berkeley: University of California Press, 1987), p. 2.

3. Ibid., p. 77.

4. Ibid., p. 207.

5. Ibid., p. 4.

10. ILYA KABAKOV

1. Cited in Richard Sakwa, *Gorbachev and His Reforms, 1985–1990* (Englewood Cliffs, N.J.: Prentice Hall, 1991), p. 66.

2. Based on the exhibition "Ilya Kabakov: Ten Characters," the Hirshhorn Museum and Sculpture Garden, Washington, D.C., March 7, 1990 to June 3, 1990.

3. Ilya Kabakov, *Ten Characters* (London: Institute of Contemporary Arts, 1989), p. 34.

4. Ibid., p. 35.

5. Ibid., p. 9.

6. Ibid., p. 11.
7. Ibid., pp. 26–27.
8. Ibid., pp. 16–17.
9. Ibid., p. 38.
10. Ibid., p. 44.
11. Ibid., p. 31.
12. Ibid.
13. Ibid., p. 32.
14. Ibid.
15. Ibid., p. 7.
16. Ibid., p. 13.
17. Ibid., p. 14.
18. Ibid.
19. Ibid., p. 46.

11. HANS HAACKE

1. Jean Baudrillard, *Simulations* (New York: Semiotext(e), 1983), p. 11.
2. Based on the exhibition "Hans Haacke: Unfinished Business," Knight Gallery/Spirit Square, Charlotte, North Carolina, January 15 to February 27, 1988.
3. Jean Baudrillard, *The Ecstasy of Communication* (New York: Semiotext(e), 1987), pp. 21–22.
4. Herbert Marcuse, *The Aesthetic Dimension: Toward a Critique of Marxist Aesthetics* (Boston: Beacon Press, 1978), p. 71.
5. Ibid., p. 72.
6. Ibid., p. 69.
7. Ibid., pp. 68–69.

12. SUE COE

1. Herbert Marcuse, *An Essay on Liberation* (Boston: Beacon Press, 1969).
2. Based on the exhibition "Police State," Anderson Gallery at Virginia Commonwealth University, Richmond, Virginia, January 1986 to March 1986.
3. Paul Virilio and Sylvere Lotringer, *Pure War* (New York: Semiotext(e), 1983), pp. 1–30.
4. Ibid., pp. 91–117.
5. Herbert Marcuse, *One-Dimensional Man: Studies in the Ideology of Advanced Industrial Society* (Boston: Beacon Press, 1964).
6. See Sue Coe and Holly Metz, *How to Commit Suicide in South Africa* (New York: Raw Books and Graphics, 1983).

7. Sue Coe, *Police State*, with texts by Mandy Coe and essays by Donald Kuspit and Marilyn Zeitlin (Richmond, Va.: Anderson Gallery/Virginia Commonwealth University, 1987).

8. Ibid.

9. Sue Coe with text by Judith Moore, *X* (New York: Raw Books and Graphics, 1986).

13. HISPANIC ART IN THE UNITED STATES

1. Based on the exhibition "Hispanic Art in the United States: Thirty Contemporary Painters and Sculptors," Museum of Fine Arts, Santa Fe, New Mexico, July 30, 1988 to October 2, 1988.

2. See "Magnifico! Hispanic Culture Breaks out of the Barrio," *Time*, July 11, 1988, pp. 46–84.

3. See *Art in America* 76, No. 9 (September, 1988), pp. 14–15.

4. See Octavio Paz, "Art and Identity: Hispanics in the United States,"in *Hispanic Art in the United States: Thirty Contemporary Painters and Sculptors*, ed. John Beardsley and Jane Livingston (New York: Abbeville Press, 1987), p. 13.

5. Ibid., pp. 15–16.

6. See *Time*, July 11, 1988, pp. 46–87.

7. This subtle racism slowly sweats out of even the apparently positive press purchased by AT&T to tout this show to art-viewing publics. When it exclaims, "Suddenly a wealth of Hispanic Art is showing up in all the best places," AT&T also is perhaps voicing the Anglo audience's shocked tacit protest, "We always have kept them out, so why did we let them into 'the best' places?" Obviously, as this show illustrates, it is either because they do art that looks like plain old European modernism or because they paint flaming *chilis*, hot *chicanas*, or new wave *lobos* that symbolically reemphasize their marginal identities, traditional values, and separatist tendencies. By taking Hispanic art all across America, the AT&T Foundation was showing Anglos, blacks, Hispanics, or Orientals how very much *unlike* we all are, and thus reaffirmed the unequal division of power, privilege, and position among Hispanics that follows from not being *like* Anglos.

14. ROGER BROWN

1. See Guy Debord, *Society of the Spectacle* (Detroit: Black and Red, 1983), paragraphs 1–72.

2. Jean Baudrillard, *In the Shadow of the Silent Majorities . . . Or the End of the Social and Other Essays* (New York: Semiotext(e), 1983), pp. 1–61.

3. Based on the exhibition "Roger Brown," Hirshhorn Museum and Sculpture Garden, Washington, D.C., August 13 to October 18, 1987. This exhibition at the Hirshhorn marked the first stop on a four-city tour of this first major Roger Brown retrospective. After closing in Washington, it continued on to La Jolla, California; Miami, Florida; and, then, Des Moines, Iowa in 1987 and 1988. The exhibit was fairly comprehensive. It featured some of Brown's earliest paintings from 1968 as well as his latest works from 1986, including several of his fascinating sculptures, like *Wolf City* (1986), *Skyscraper with Pyramid* (1977), *Bridge City* (1975), and *Tarred and Feathered* (1974). However, the main focus of the exhibit was on his paintings and their thematic evolutions over the last two decades.

4. In a sense, Brown's aesthetic seems to anticipate and articulate the same conflicted support given by Christopher Lasch to ordinary, lower-middle-class populism as an antidote to upper-middle-class intellectuals' programs of progressivism. See, for additional discussion, Christopher Lasch, *The True and Only Heaven: Progress and Its Critics* (New York: Norton, 1991).

15. ROBERT LONGO

1. Based on the exhibition "Robert Longo," Museum of Contemporary Art, Chicago, February 17 to April 22, 1990.

2. Jean Baudrillard, *The Ecstasy of Communication* (New York: Semiotext(e), 1988), pp. 15–16.

3. Ibid., p. 27.

4. Ibid., p. 16.

5. Ibid., pp. 16–17.

6. Jean Baudrillard, *In the Shadow of the Silent Majorities . . . Or the End of the Social* (New York: Semiotext(e), 1983).

7. Baudrillard, *The Ecstasy of Communication*, p. 50.

8. Ibid., p. 51.

9. Ibid., pp. 21–22.

10. Ibid., p. 22.

16. CULTURE AND COMMENTARY

1. Based on the exhibition "Culture and Commentary: An Eighties Perspective," Hirshhorn Museum and Sculpture Garden, Washington, D.C., February 8 to May 6, 1990.

2. For additional discussion, see Catherine Gudis, ed., *A Forest of Signs: Art in the Crisis of Representation* (Cambridge, Mass.: MIT Press, 1989); and

Marvin Heiferman and Lisa Phillips with John T. Hanhardt, *Image World: Art and Media Culture* (New York: Whitney Museum of American Art, 1989).

3. Kathy Halbreich, ed., *Culture and Commentary: An Eighties Perspective* (Washington, D.C.: Smithsonian Institution, 1990), p. 16.

4. For an overview of the cultural politics of such systems, see Ben Agger, *Fast Capitalism* (Urbana: University of Illinois Press, 1989); and Timothy W. Luke, *Screens of Power: Ideology, Domination, and Resistance in Informational Society* (Urbana: University of Illinois Press, 1989).

17. THE POLITICS OF IMAGES

1. David Carrier, *Artwriting* (Amherst, Mass.: University of Massachusetts Press, 1987), p. 110.

2. Ibid.

3. Ibid., p. 141.

4. Ibid., p. 120. This is true of my craft as an art critic. My "day job" is with a large state university as a professor of political science, and my usual beat there takes me into the areas of political theory, comparative politics, and international political economy. Not surprisingly, these vocational occupations have, in turn, colored my practices at the craft of art criticism. Over the course of the last five years I have visited many museums all over the country to view a wide range of art exhibitions. Yet when viewing many of these collections in their social context, I immediately saw how forceful a show of art could be as an artful show of force, whose qualities should be investigated through the interpretive discourses of a political critique.

5. Ibid., p. 123.

6. Terry Eagleton, *The Function of Criticism: From the Spectator to Post-Modernism* (London: Verso, 1983), p. 128.

7. Ibid., pp. 128, 137.

8. For additional development of these themes as well my approach to critical analysis, see Timothy W. Luke, *Screens of Power: Ideology, Domination, and Resistance in Informational Society* (Urbana: University of Illinois Press, 1989); and Timothy W. Luke, *Social Theory and Modernity: Critique, Dissent, and Revolution* (Newbury Park, Calif.: Sage Publications, 1990).

9. See Terry Eagleton, *The Ideology of the Aesthetic* (London: Blackwell, 1990), pp. 1–12.

10. See George Steiner, *Real Presences* (Chicago: University of Chicago Press, 1989), pp. 21–50. Marcuse, for example, argues that the truth of art can escape, if only partially, its given historical context, and acquire an autonomous vantage for guiding critical transformation. Therefore, Mar-

cuse claims, "the truth of art lies in its power to break the monopoly of established reality (i.e., of those who established it) to *define* what is *real*. In this rupture, which is the achievement of the aesthetic form, the fictitious world of art appears as true reality." *The Aesthetic Dimension: Toward a Critique of Marxist Aesthetics* (Boston: Beacon Press, 1978), p. 9. Neither the virtues of its content nor the elegance of its form alone can drive these forces. Instead, Marcuse asserts, "the aesthetic transformation is achieved through a reshaping of language, perception, and understanding so that they reveal the essence of reality in its appearance: the repressed potentialities of man and nature. The work of art thus represents reality while accusing it." *Aesthetic Dimension*, p. 8.

11. Terry Eagleton, *Criticism and Ideology: A Study in Marxist Literary Theory* (London: Verso, 1976), p. 101.

12. Brian O'Doherty, *Inside the White Cube: The Ideology of Gallery Space* (Santa Monica, Calif.: Lapis Press, 1986), p. 79.

13. Pierre Bourdieu, *Distinction: A Social Critique of the Judgement of Taste* (Cambridge, Mass.: Harvard University Press, 1984), p. 511.

14. Ibid.

15. O'Doherty, *Inside the White Cube*, p. 89.

16. See Suzi Gablik, *Has Modernism Failed?* (London: Thames and Hudson, 1984), pp. 20–54.

17. See Janet Wolff, *The Social Production of Art* (New York: New York University Press, 1984), pp. 49–70.

18. Many of these notions also are discussed in great detail by Eagleton, *The Ideology of the Aesthetic*, pp. 366–415. Also see Douglas Kellner, *Postmodernism Jameson Critique* (Washington, D.C.: Maisonneuve Press, 1989); and Ben Agger, *The Decline of Discourse: Reading, Writing, and Resistance in Postmodern Capitalism* (New York: Falmer Press, 1990).

19. See Carrier, *Artwriting*, pp. 42–77.

20. Steiner, *Real Presences*, p. 61.

21. Ibid., p. 68.

22. Michel Foucault, "The Order of Discourse," *Language and Politics*, ed. Michael Shapiro (New York: New York University Press, 1984), p. 127.

23. Victor Burgin, *The End of Art Theory: Criticism and Postmodernity* (Atlantic Highlands, N.J.: Humanities Press, 1986), p. 159.

Adorno, T. W., 4, 91
Agger, Ben, 245, 246
Akihito, Emperor, 114, 117, 118
Alfonzo, Carlos, 182–83
Anderson, Laurie, 213, 216, 224
Anderson Gallery (Richmond, Va.),
 169, 242
Archuleta, Felipe, 184
Arizona, 79–90, 21–92, 101–3
Armajani, Siah, 213, 217, 224
Arthur M. Sackler Gallery of Oriental
 Art (Washington, D.C.), 110, 241
Art Institute of Chicago, 47, 68, 71
Artschwager, Robert, 121, 124
Art Papers, ix, 227
Autry, Gene, 54, 55, 65

Baldessari, John, 125
Balthus, 189
Barthes, Roland, 4, 27, 107, 215
Baudrillard, Jean, 4, 152, 153, 189, 200,
 204, 208, 211, 212
Beard, William Holbrook, 62
Bearden, Romare, 124
Bechtle, Robert, 128
Benjamin, Walter, 11, 12
Benton, Thomas Hart, 189, 191
Berman, Wallace, 132
Bierstadt, Albert, 98
Bingham, George Caleb, 9–26, 231
Bischoff, Franz A., 96
Bodmer, Karl, 59
Bordieu, Pierre, 230
Borein, Edward, 62, 65
Botke, Jessie Arms, 96
Brandriff, George, 96, 98

Braun, Maurice, 97
Brown, Roger, 2, 189–99
Brush, George DeForest, 63
Buffalo Bill Historical Center (Cody,
 Wyo.), 30
Burgin, Victor, 233
Bush, George, 6, 26, 28, 29, 30–1, 36,
 37, 39, 48, 107, 108, 115, 117
Buzio, Lidya, 186

Carrier, David, 227–28
Celmin, Vija, 125, 126
Charlotte, N.C., 153, 228
Chicago, Ill., 29, 68, 71, 72, 77, 80, 83,
 89, 193, 194, 195, 196, 228
Church, Frederic Edwin, 40–51
Clapp, William, 97
Clarke, Alson Skinner, 97
Clemente, Francesco, 165, 213, 215, 221
Coe, Sue, 2, 169–77, 200, 214
Coleman, James, 213, 216, 224
Communism, 34, 37, 137–51
Conner, Bruce, 131
Cragg, Tony, 213, 218–19, 224
Cunningham, Imogen, 75

Dalí, Salvador, 206
Dallas, Tex., 68, 77, 78, 80
Dallas Museum of Art, 68, 238
D'Arcangelo, Allen, 128
Deas, Charles, 60, 62
Debord, Guy, 4, 189
de Chirico, Giorgio, 189
De Kooning, Willem, 127
Delacroix, Eugène, 123, 209
Demuth, Charles, 70, 128

Denver, Colo., 68, 78
Duchamp, Marcel, 215, 223

Eagleton, Terry, 229, 246
Eastman, Seth, 60
Environmentalism, 40, 47–51; and deep ecology, 40, 50–1; and Earth Day, 47, 49
Espada, Ibsen, 182
Estes, Richard, 123, 124

Farny, Henry F., 63, 64
Fascism, 169–78
Fassbinder, Rainer Werner, 202, 203, 209
Fernandez, Rudy, 185
Fleischer Museum at the Perimeter Center (Scottsdale, Ariz.), 91–103, 239
Ford, John, 75
Forsythe, Victor Clyde, 96
Foucault, Michel, 232, 246
Foulkes, Llyn, 130
Frigerio, Ismael, 182
Fritsch, Katharina, 213, 217, 224

Gable, John, 98
Gablik, Suzi, 246
Garza, Carmen Lomas, 185, 186
Gene Autry Western Heritage Museum (Los Angeles), 54, 55
Gifford, Sanford R., 60
Gilcrease Museum (Tulsa, Okla.), 102
Gober, Robert, 213, 219, 220
Gonzalez, Patricia, 186
Gorbachev, Mikhail, 34, 137, 150
Graham, Robert, 182
Gray, Percy, 97
Greenberg, Clement, 33, 74
Grooms, Red, 124
Grosz, George, 169, 170

Haacke, Hans, 2, 100, 152–68, 200, 214
Hanson, Duane, 131
Harris, Sam Hyde, 98, 99
Hartley, Marsden, 70
Hays, William Jacob, 62
Hirohito, Emperor, 110, 114, 115, 117

Hirshhorn Museum and Sculpture Garden (Washington, D.C.), 137, 213, 241, 244
Hollywood, 25, 28, 36, 53, 55, 65, 66, 75, 202, 204, 208–9
Holzer, Jenny, 213, 217–18, 224
Hopper, Edward, 189, 190
Houston, Tex., 30, 31, 39, 180, 186

Impressionism, California, 91, 94–103
Indiana, Robert, 128, 129

Jackson, Andrew, 20, 21, 24
Japan, 107–18, 119, 216, 225
Jefferson, Thomas, 14, 15, 17, 20, 21, 24, 57
Jenney, Neil, 130
Jess, 130
Jimenez, Luis, 184
Johns, Jasper, 121
Johnson, Ray, 127
Juarez, Roberto, 183

Kabakov, Ilya, 137–51
Kahlo, Frida, 185
Kane, Paul, 60
Kansas City, Mo., 16, 25, 29
Kienholz, Edward, 126, 129
King, Charles Bird, 59
Kleitsch, Joseph, 99
Knight Gallery / Spirit Square (Charlotte, N.C.), 242
Koons, Jeff, 213, 218, 224
Kostabi, Mark, 214
Krueger, Barbara, 202, 214
Kurz, Rudolph Friedrich, 60
Kuwait, 36, 37, 39, 64

Lauritz, Paul, 98
Lenin, V. I., 145, 146
Levine, Sherrie, 213–14, 219, 220, 224, 225
Lichtenstein, Roy, 122, 126
Lippard, Lucy, 167
Longo, Robert, 200–12, 214, 231
López, Félix, 184
Los Angeles, Calif., 54, 56, 68, 78, 89, 183, 184

Los Angeles Museum of Art, 213
Luján, Gilbert, 183, 184

Madison Avenue, 28
Magritte, René, 189, 191
Manifest Destiny, 14, 17, 18, 24, 26
Mannheim, Karl, 68, 78
Mapplethorpe, Robert, 214
Marcuse, Herbert, 4, 167, 169, 172, 242, 245–46
Marin, John, 70
Martínez, César Augusto, 184
Marx, Karl, 4, 177, 240
Marzán, Gregorio, 184
Merrill Lynch, 31
Metropolitan Museum of Art (New York), 30, 47, 68, 161, 162, 163, 164
Miami, Fla., 169, 179, 180, 186
Miller, Alfred Jacob, 59, 60
Missouri, 9–26
Mitchell, Alfred, 98
Moran, Thomas, 60, 98
Moroles, Jesús Bautista, 182
Mucha, Reinhard, 214, 216
Muir, John, 50
Mullican, Matt, 214
Museum of Contemporary Art (Chicago), 244
Museum of Fine Arts (Houston), 307
Museum of Fine Arts (Santa Fe), 186, 243
Museum of Modern Art (New York), 11, 154

Nashville, Tenn., 28
National Gallery of Art (Washington, D.C.), 47, 48, 68, 107, 110, 235, 238
Nicandro, Gulgio Gronk, 183
Neiman, Leroy, 143
Neri, Manuel, 182
New Mexico, 69, 70, 71, 72, 73–4, 75, 76, 77, 98, 181
New Museum of Contemporary Art (New York), 152
New York, N.Y., 11, 12, 13, 18, 30, 70, 71, 72, 74, 77, 152, 154, 155, 167, 186, 187, 197, 213, 225, 227
Nixon, Richard, 175, 188, 194, 196

O'Doherty, Brian, 230
O'Keeffe, Georgia, 3, 68–78, 189, 232
Oldenburg, Claes, 121, 122

Panama, 36, 39, 64
Paschke, Ed, 129
Payne, Edgar Alwin, 96, 98
Paz Octavio, 180
Perez, Pedro, 185
Phoenix, Ariz., 68, 78, 79–80, 88, 89, 90, 228
Phoenix Art Museum, 80, 239
Picasso, Pablo, 71, 225
Pollock, Paul Jackson, 225
Puthuff, Hanson Duvall, 98

Ramos, Mel, 126
Ranney, William T., 62
Rauschenberg, Robert, 121, 124, 131
Reagan, Ronald, 6, 26, 28–29, 30, 34, 36, 38, 39, 108, 116, 117, 135, 160–61, 169, 171, 175, 176, 177, 194, 196, 198, 226
Reiffel, Charles, 97
Remington, Frederic, 3, 27–39, 63–64, 98
Richmond, Va., 169, 228
Rider, Arthur Grover, 97, 98
Rifkin, Jeremy, 49
Rivers, Larry, 120, 122
Roanoke, Va., 52, 54, 55, 56, 57, 58, 66
Roanoke Museum of Fine Arts, 55, 56, 238
Rollins, Tim, 214
Romero, Frank, 184
Roosevelt, Theodore, 37, 48
Rose, Guy, 97, 98
Rosenquist, James, 121, 206
Rousseau, Henri, 186, 192
Rungius, Carl, 61
Ruscha, Edward, 125, 126, 127
Ruskin, John, 43
Russell, Charles, 62, 98

St. Louis, Mo., 9, 10, 11, 16, 29, 30, 63, 187, 228
St. Louis Art Museum, 9–11, 29, 236

Salle, David, 214
San Diego, Calif., 63, 80, 89
Santa Fe, N. Mex., 180, 186, 228
Sayre, F. Grayson, 98
Schnabel, Julian, 165, 214, 221–22
Schreyvogel, Charles, 64
Schuster, Donna Norine, 97
Scottsdale, Ariz., 80, 83, 91, 100, 102
Scottsdale Center for the Arts, 80, 102, 239
Segal, George, 125, 127
Sherman, Cindy, 214, 222, 223, 224, 225
Shingler, A. Zeno, 63
Smillie, David, 59
Smith, John Christopher, 99
Solomon R. Guggenheim Museum (New York), 152, 155, 156
Stanley, John Mix, 61
Steinbach, Haim, 214
Steiner, George, 232, 245
Stevens, May, 129
Stich, Sidra, 119, 133, 134
Stieglitz, Alfred, 70, 71, 72, 75
Strand, Paul, 75
Sullivan, Louis, 83
Symons, George Gardner, 98

Taliesin West, 80, 84, 85, 92
Tapia, Luis Elgio, 184, 185
Thatcher, Margaret, 164, 165, 169, 171, 176, 177
Tofft, Peter Peterson, 62
Trotsky, Leon, 145
Trotter, Newbold Hughes, 62
Tucson Art Museum, 80
Twain, Mark, 18, 19

Ukeles, Mierle, 214
Usonian Automatic House, 82, 83, 86, 88

Valdez, John, 184
Vietnam, 64, 119
Virginia Museum of Fine Arts (Richmond), 241
von Humboldt, Alexander, 41, 42, 46
von Schneidau, Christian, 103

Wachtel, Marion K., 97
Walker, James, 62, 65
Wall, Jeff, 214, 220, 221, 224
Warhol, Andy, 71, 121, 122, 123, 126, 128, 132, 222, 225
Warshawsky, Abraham G., 97, 103
Washington, D.C., 10, 28, 48, 59, 80, 89, 107, 109, 111, 133, 177, 180, 186, 187, 194, 228
Weir, Robert W., 63
Wesselman, Tom, 121, 122, 123
West, the American, 6, 9–26, 27–39, 52–67; the Old West, 10–26, 27–35, 91–103; the New West, 17–26, 35–39, 76–78, 88–90, 91–103, 236; Hispanics and the West, 183–188
Westermann, H. C., 123
Whitney Museum (New York), 213
Wimar, Charles, 59
Winter, George, 60
Wister, Owen, 35
Wodiczko, Krzysztof, 214
Wood, Grant, 189, 191
Woodside, John Archibald, 61
Wright, Frank Lloyd, 79–90, 92, 232

Yasumasa, Morimura, 214, 223, 224

About the Author

Timothy W. Luke is Professor of Political Science at the Virginia Polytechnic Institute and State University and the author of *Screens of Power: Ideology, Domination, and Resistance in Informational Society* and *Social Theory and Modernity: Critique, Dissent, and Revolution.*

Library of Congress Cataloging-in-Publication Data

Luke, Timothy W.
 Shows of force : power, politics, and ideology in art exhibitions / Timothy W. Luke.
 p. cm.
 Includes bibliographical references and index.
 ISBN 0-8223-1188-7 cl ISBN 0-8223-1123-2 pb (acid-free paper)
 I. Art—Political aspects. 2. Art—Psychology. I. Title.
N72.P6L84 1992
701' .18—dc20 91-20018
CIP